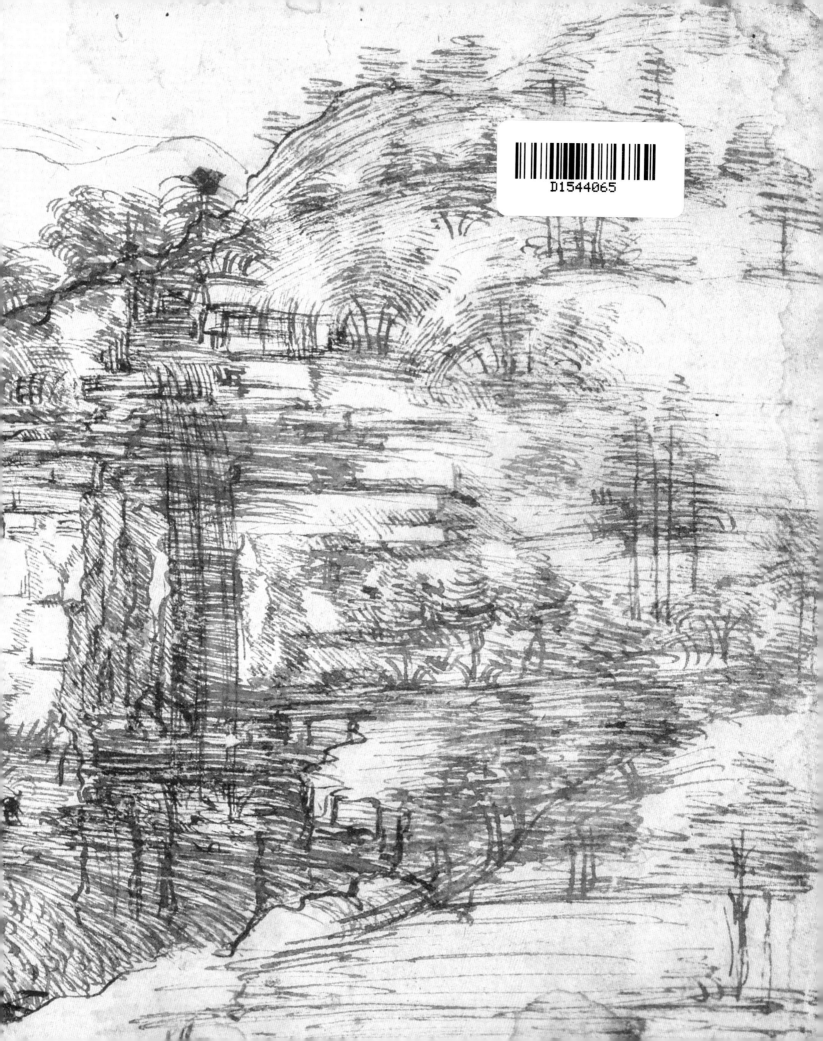

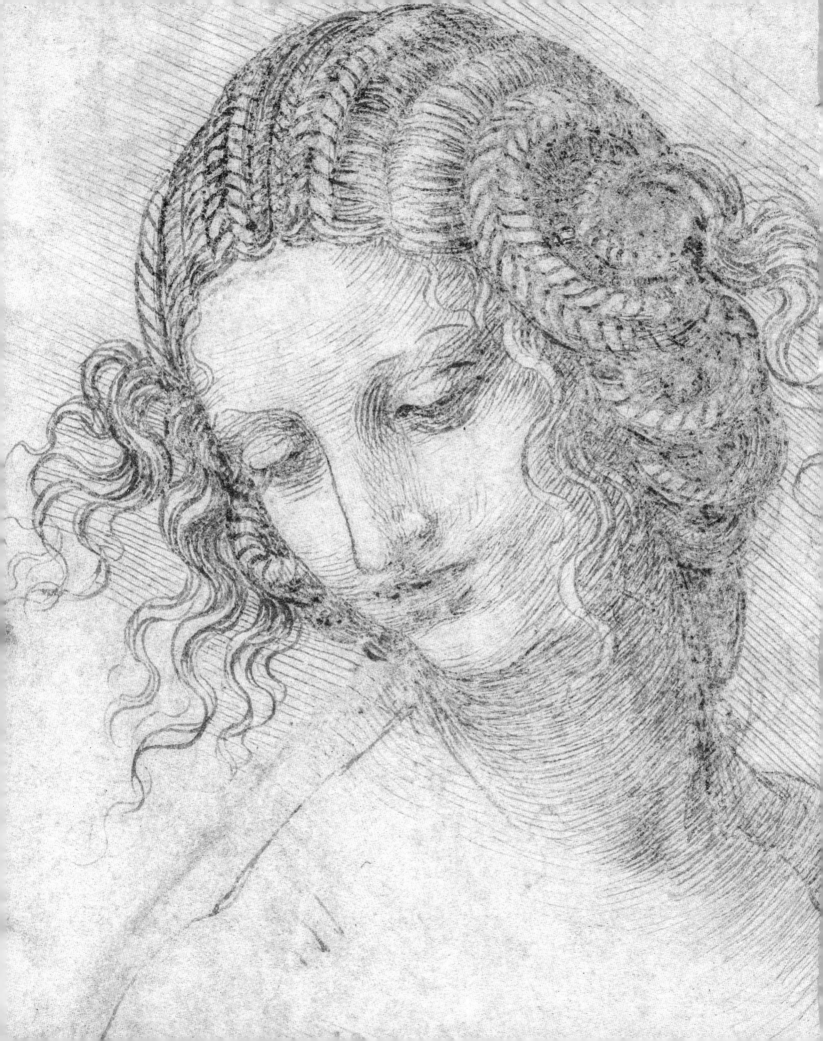

LEONARDO DA VINCI

THE 100 MILESTONES

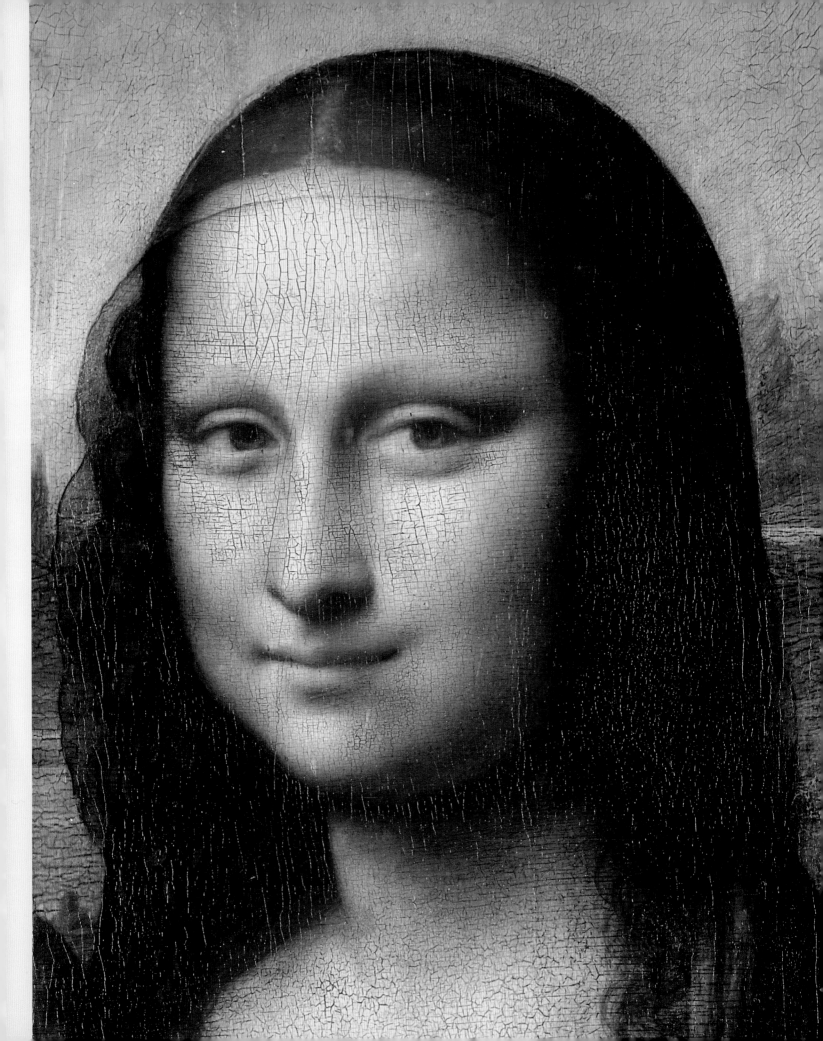

LEONARDO
DA VINCI
THE 100 MILESTONES

MARTIN KEMP

STERLING
New York

STERLING
New York

An Imprint of Sterling Publishing Co., Inc.
1166 Avenue of the Americas
New York, NY 10036

ISBN 978-1-4549-3042-6

Distributed in Canada by Sterling Publishing Co., Inc.
c/o Canadian Manda Group, 664 Annette Street
Toronto, Ontario M6S 2C8, Canada
Distributed in the United Kingdom by GMC Distribution Services
Castle Place, 166 High Street, Lewes, East Sussex BN7 1XU, England
Distributed in Australia by NewSouth Books
University of New South Wales, Sydney, NSW 2052, Australia

For information about custom editions, special sales, and premium and corporate purchases,
please contact Sterling Special Sales at 800-805-5489 or specialsales@sterlingpublishing.com.

Manufactured in the USA

2 4 6 8 10 9 7 5 3 1

sterlingpublishing.com

Interior design by Christine Heun
Cover design by David Ter-Avanesyan

Picture credits – see page 202

CONTENTS

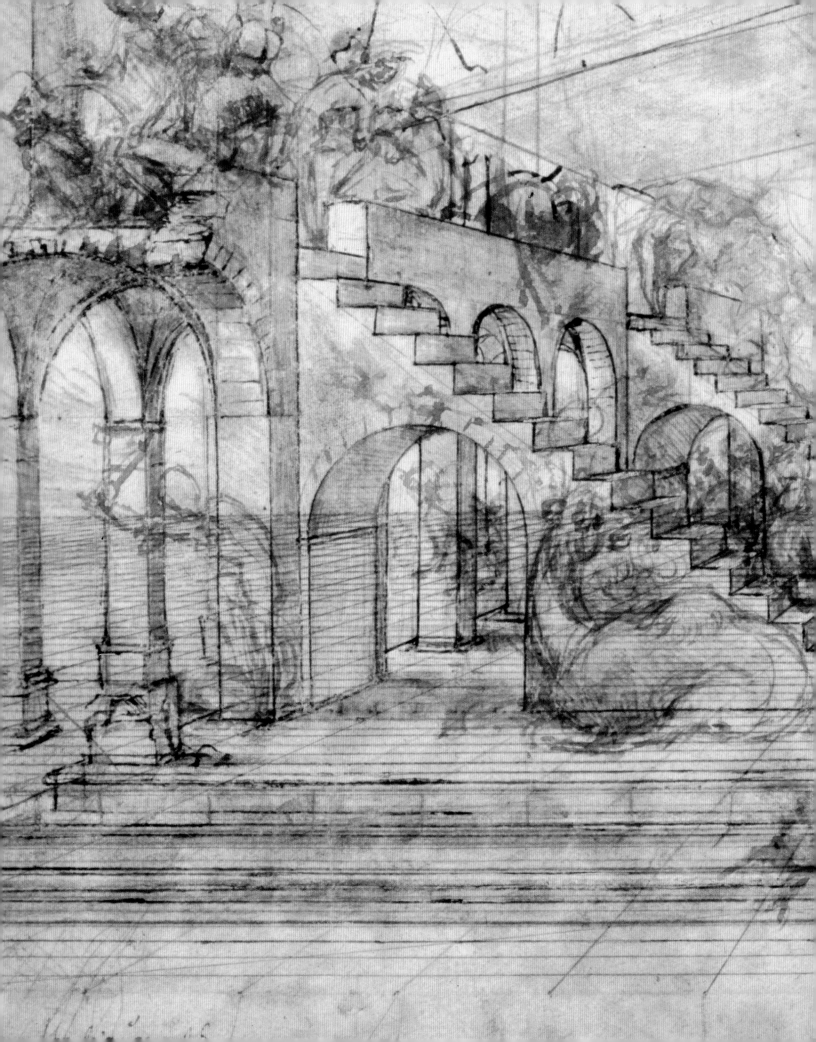

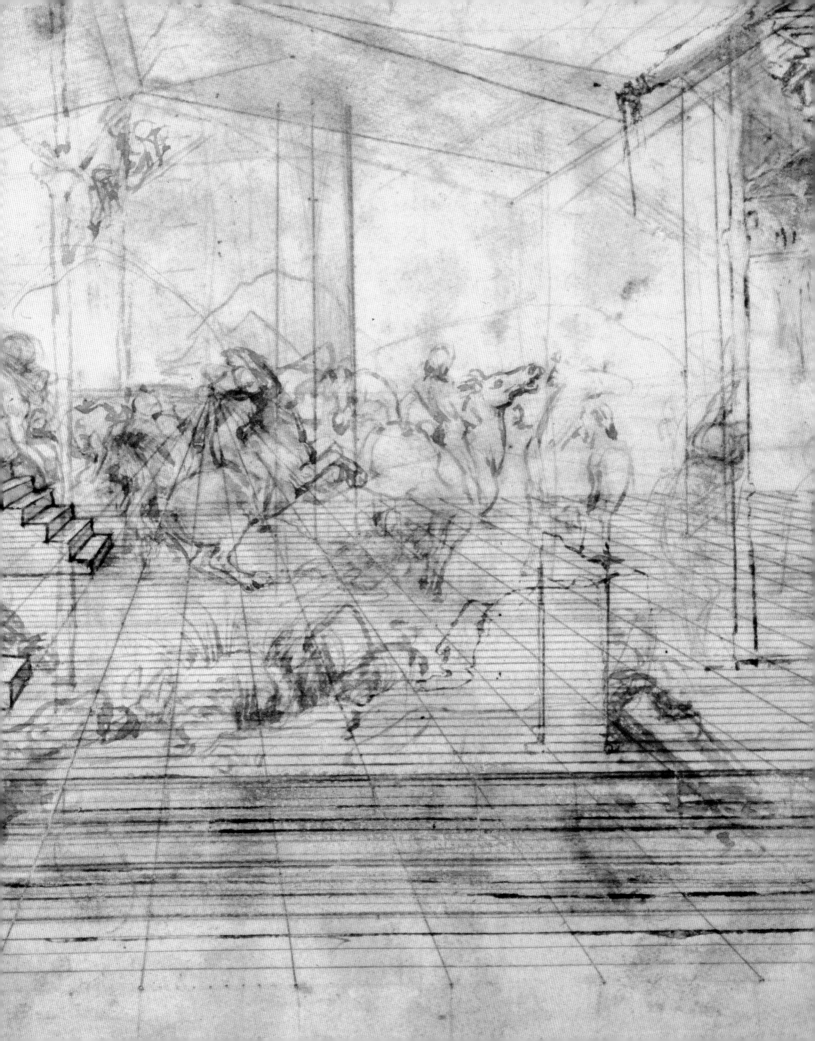

INTRODUCTION

The illegitimate son of a Florentine notary and a fifteen-year-old orphan, Leonardo was born in the small Tuscan town of Vinci in April 1452. He has risen over the years to become the most famous person in the history of world visual culture.

Brought up in his grandfather's household in Vinci, he entered the workshop of Andrea del Verrocchio as a teenager, where he would have witnessed the making of sculpture in marble, bronze, precious metals, and terracotta. The workshop also produced paintings and designs for textiles and parade armor, and undertook at least one engineering project. The young Leonardo became deeply immersed in the Florentine tradition of the "science of art," most notably linear perspective and anatomy.

He remained in the master's workshop at least until he was twenty-four, and his early paintings, such as the *Annunciation*, can be viewed as products of "Verrocchio & Co.," even if Leonardo was their sole author. As a rising star he was awarded commissions for two big altarpieces: a Virgin, Child, and Saints for the government palace in 1478; and an *Adoration of the Magi* for a Florentine monastery. There is no record of progress on the former, and the latter remained unfinished when he left Florence in 1482. This pattern of noncompletion was to become a feature of his career as a painter.

When Leonardo arrived in Milan, he wrote to Duke Ludovico Sforza ("il Moro") advertising his services as a military and civil engineer. At the end of the letter he mentions his abilities in painting and sculpture. His first commission in 1483 was to provide painted decorations with two colleagues for a large architectural altarpiece ordered by a confraternity. Leonardo's main contribution was the *Virgin of the Rocks*, which became mired in a dispute that was only resolved in 1508. His activities in Milan embraced painting, sculpture, architecture, and civil and military engineering, often as someone who generated ideas rather than as the hands-on executant. He progressively engaged with a range of sciences—anatomy, optics, dynamics, statics, geology, and mathematics.

He also served as a maestro of visual effects for major courtly celebrations, designing costumes and very expensive stage machinery. His grandest project was a massive bronze equestrian memorial to the duke's father, Francesco Sforza, which reached the stage of a full-scale model and the making of a mold for casting, but was not realized before the fall of his patron in 1499 when the French invaded Milan.

Leonardo's output of paintings during his period at the court is modest in quantity but high in innovatory quality. His two highly communicative portraits of the Duke's mistresses reworked the relationship between the sitter and the viewer. The famed *Last Supper* raised narrative painting to new levels of formal and emotional grandeur.

OPPOSITE **Portrait of Leonardo da Vinci by a follower, c. 1507.**

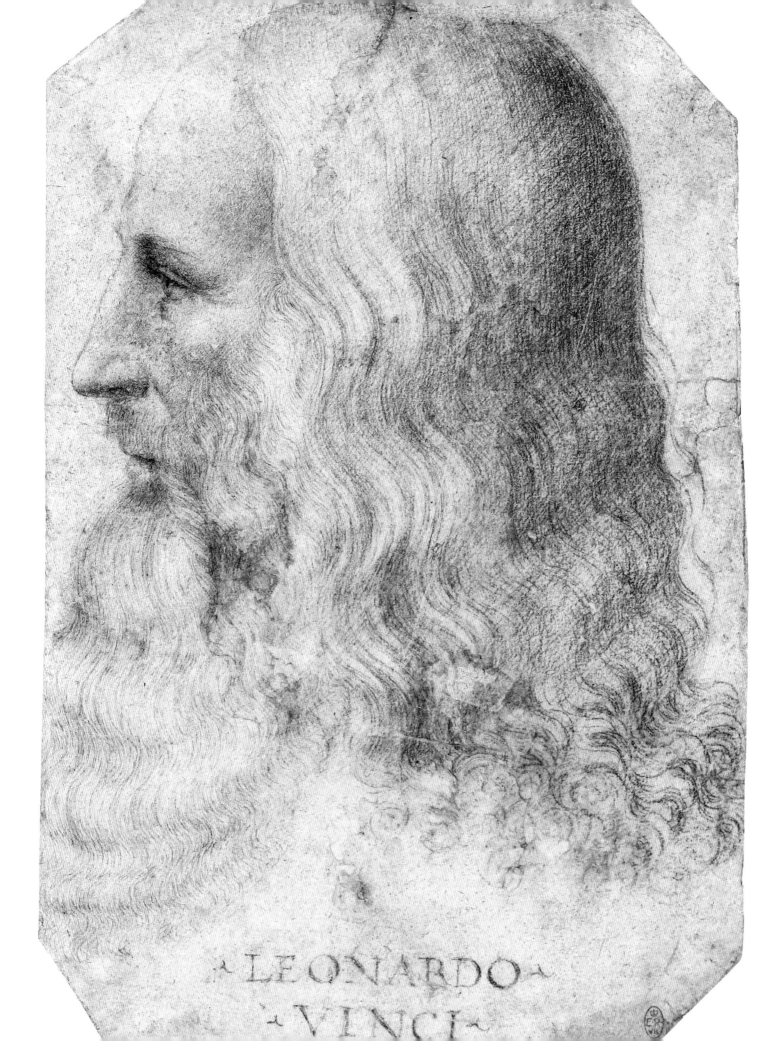

~LEONARDO~

~VINCI~

After his return to Florence, Leonardo embarked on some devotional pictures, including a *Virgin, Child, St. Anne, and a Lamb*. He was also engaged by Cesare Borgia and the Florentine government as an engineer. Leonardo's work on an Arno canal informed his studies of geology, and he decided that the earth had undergone vast transformations over deep periods of time. His great painting project was the *Battle of Anghiari* for the large new council hall, where he was joined by Michelangelo as a rival. Leonardo began to paint on the wall in an experimental technique, which caused problems, and the unfinished mural was abandoned when he was pressed to return to Milan to serve the French rulers.

During his second period in Florence, Leonardo commenced the *Portrait of Lisa del Giocondo*, the lost *Leda and the Swan*, the *Salvator Mundi*, and another version of *St. Anne*. He was also deeply engaged in geometry, optics, the science of water, and anatomy (particularly in the dissection of an old man in the winter of 1507–8).

Working for the French in Milan from 1507 onward, he resumed a range of courtly duties similar to those he performed for Ludovico Sforza. Leonardo seems to have been prized for his remarkable all-around qualities as much as for his practice as a painter. His studies of the skeleton and the muscular system around 1510 and his researches into the working of the heart are high points in the history of anatomical illustration. The records of his activities as a painter around this time are patchy, but the strange and engaging *St. John the Baptist* may have been begun in this period.

In 1513, he was drawn to Rome to work for Giuliano, the brother of the new Medici pope, again in an all-around capacity, working on a number of projects for his patron and continuing his own researches. His most significant impact was on Raphael, who translated Leonardo's innovations in narrative paintings, Madonnas, and portraits in such a way that they reshaped the mainstream of painting for centuries to come.

After three years in Rome, he was invited to France to serve Francis I, who was buying into Italian Renaissance culture. He was housed grandly in the manor house of Clos Lucé and paid a substantial salary. Francis regarded Leonardo as a magus, a wise man who was an ornament of the court. The master generated plans for a large palace complex in Romorantin, which exercised a considerable influence on French chateau design.

When Leonardo died in May 1519, his large and diverse stock of manuscripts and drawings were treasured by his aristocratic pupil, Francesco Melzi, who was responsible for assembling what is now called the *Trattato della pittura* (*Treatise on Painting*), much of which was drawn from texts that have not survived. An edited version was published in 1651 and served to transmit a selection of Leonardo's writings on art to successive generations. Melzi's original selection began with the *Paragone*, the comparison of painting with sculpture, poetry, and music, in which painting emerges triumphant. Although a great proportion of Leonardo's written and drawn legacy is now lost, what remains is one of the most remarkable testimonies to what visualization and representation can achieve.

REASONS FOR THE CHOICES

It is a challenge to select 100 images from Leonardo da Vinci's vast range of work. The paintings are not a problem; there are no more than 19 or 20 of them. There is also a selection of those drawings that relate most closely to the surviving and lost works of art. To represent the full range of manuscripts adequately is very much another matter; there are over 6,000 surviving pages, covering an extraordinary range of topics. In the fields of engineering and anatomy alone, 100 images would still demand strict selection.

My emphasis is upon those areas in which his achievements bear comparison with any in the history of science and technology. His anatomical studies are extraordinary for their sense of form and function. His researches into water are equally notable, particularly when he looks at the role of water in the "body of the earth," which leads him to formulate revolutionary views about the ancient history of our planet. His architecture, engineering, and mechanical inventions are less well represented in numerical terms, but something of their range and extraordinary visual quality should be apparent. His beloved mathematics is directly represented in its pure form only three times. In the context of this book it is difficult for diagrams and numbers to compete with more pictorial images, but the presence of geometry is explicit in many of the illustrations, most conspicuously in his studies of the behavior of light.

The clustering of images of science, nature, and technology in ways that resonate with each other gives an idea of how Leonardo perceived fundamental analogies across fields of study that we now assign to separate disciplines. He saw commonality where we see diversity. The broad progress of the 100 images is chronological, disrupted to a degree by the clustering. The most conspicuous disruption is the placing of the wonderful sheets of horses and cats (62 and 63) with his other studies of motion in man and animals, rather than much later in his career. Another is the placing of the *St. John the Baptist* at the very end, when it may well not be his last painting; the Saint and the *Deluge Drawing* at 99 seem to bring Leonardo's life to a fitting conclusion. Generally, the placing of his paintings in chronological order is problematic. The majority underwent protracted evolution over a number of years. The dates assigned to them in the captions are permissive rather than definitive.

Leonardo was much interested in fame. I think he would have been gratified by the close attention he is receiving in the year that marks the five-hundredth anniversary of his death.

ACKNOWLEDGMENTS

The idea for this project came from Barbara Berger, executive editor at Sterling Publishing, and she has acted as an enthusiastic and creative parent for the book throughout.

Also at Sterling, I am grateful to Christine Heun, art director, for the stunning interior design; David Ter-Avanesyan, senior designer, for the beautiful cover design; Linda Liang, photography editor; Elizabeth Lindy, senior art director, covers; and Fred Pagan, production manager. Thanks also to Susan Welt, layout designer, and Joanie Eppinga, who has acted as copy editor with exemplary care.

As is the case with all my activities, Caroline Dawnay, my agent, and Judd Flogdell, my personal assistant, have performed crucial roles with high professionalism. I owe a broad debt to the community of Leonardo scholars, including those who work in museums and galleries, and to librarians and archivists. Over the course of fifty years, the number I should be thanking far outstrips the available space. I would however wish to make special mention of Carlo Pedretti, who died in 2018. His knowledge of Leonardo's legacy, above all the drawings and manuscripts, has provided a platform on which we all stand.

I wish to make special mention of my daughter, Joanna, and my son, Jonathan, who in person and in company with their families bring very special dimensions into my life.

LIST OF ILLUSTRATIONS

THE 100 MILESTONES

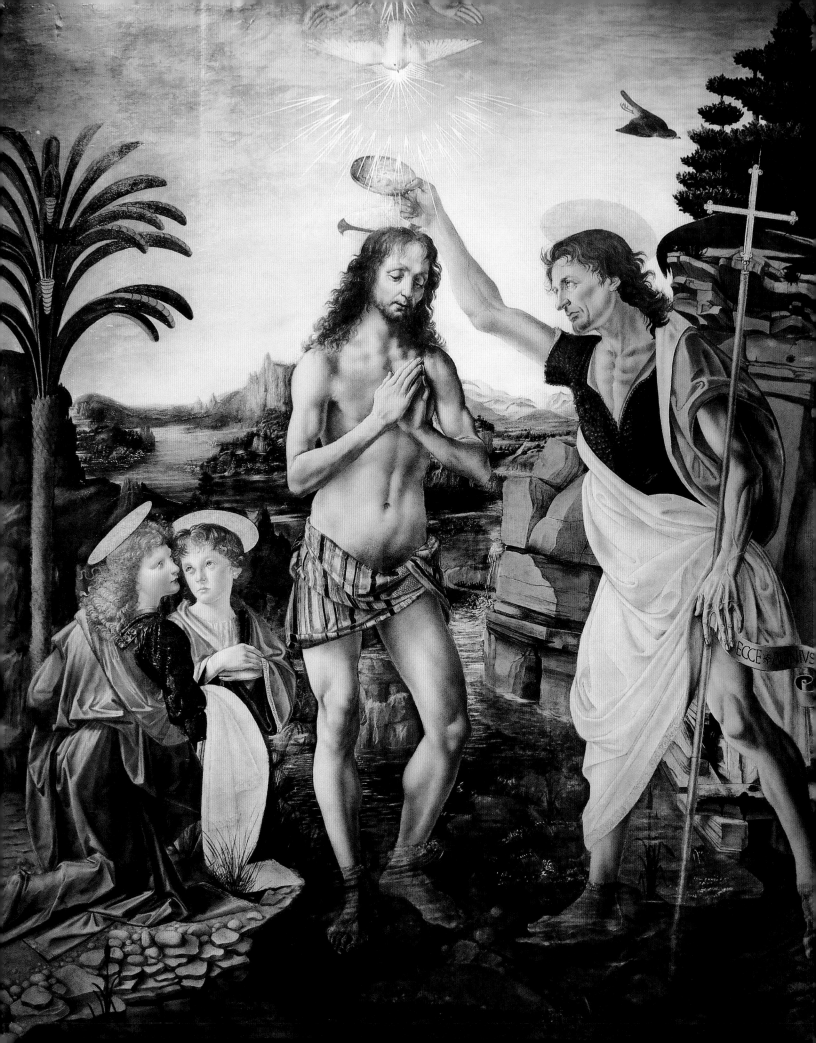

1. Baptism of Christ, *Andrea del Verrocchio and Assistants*

c. 1474–76, Florence, Uffizi

Andrea del Verrocchio (c. 1435–88), in whose Florentine workshop Leonardo was trained, was a major sculptor in a wide range of media. He also undertook paintings, in which studio assistants participated extensively. We know that Leonardo was still working with Verrocchio in 1476, when he was twenty-four. Early sources record that Leonardo painted an angel in Verrocchio's *Baptism* (opposite), once housed in the church of San Salvi in Florence, which was largely destroyed in 1529.

The two main figures in the painting, Christ and St. John the Baptist, are constructed in Verrocchio's muscular and sinewy manner. The angel on the far left is clearly by Leonardo. The figure's nervous intensity, the vibrant highlights of his hair, the radiant glass beads on the upper border of his tunic, and the incisive rendering of light and shade on the angular folds of his garment are early hallmarks of Leonardo's style. The angel's pious companion is prettily portrayed, but in a more conventional Florentine mode.

We can go further, assisted by technical analyses, and see that Leonardo has actually intervened more widely in the picture. The painting was first undertaken in the egg-based medium of tempera, but the later interventions are in the relatively new medium of oil. The figure of Christ and perhaps the legs of St. John have been finished in oil, rendering the anatomy more subtly than the linear description of St. John's hand and arm, which have something of the quality of unyielding sculpture. The optical potential of the new medium is also exploited in the cascading, rippling, and bubbling waters of the River Jordan, in the blurred atmosphere of the lake, and in the rocky prominences in the landscape above the angels' heads. These also speak of Leonardo. Others aspects of the picture, such as the schematized palm tree, indicate that at least one other assistant was involved.

In his *Lives of the Artists*, Giorgio Vasari (1511–74) tells how Verrocchio felt humiliated by the accomplishment of his young assistant, vowing never to touch a brush again. This may just be a story, but it accurately reflects the gulf between Verrocchio and the youthful Leonardo as painters of nature.

"The figure's nervous intensity, the vibrant highlights of his hair, radiant glass beads on the upper border of his tunic and the incisive rendering light and shade on the angular folds of his garment are early hallmarks of Leonardo's style."

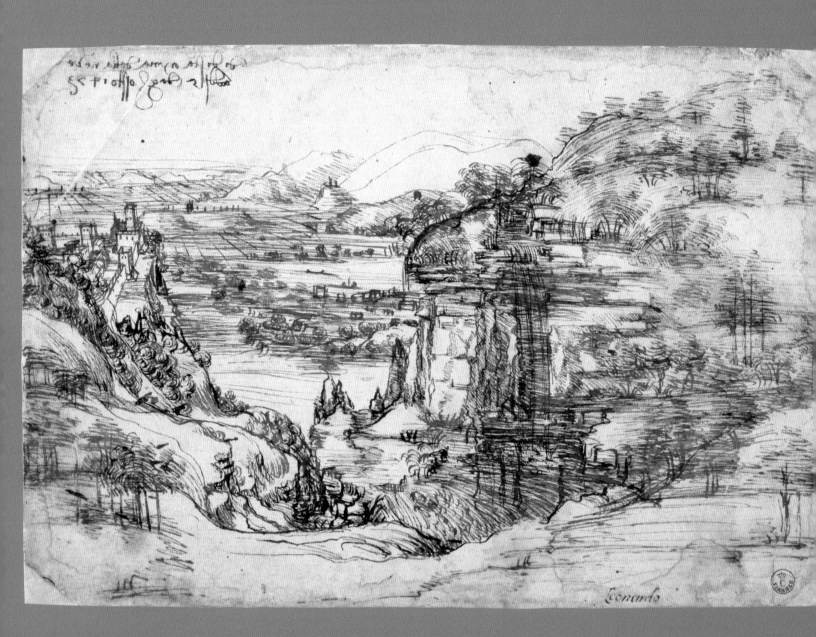

2. "Val d'Arno Landscape"

1473, Florence, Uffizi

Leonardo's inscription on the top left tells us that this drawing was made on "the day of S. Maria delle Neve [Holy Mary of the Snows] on the 5 August 1473." Leonardo was twenty-one. This is the first dated landscape drawing in the history of art. The reference is to the miraculous snowfall in fourth-century Rome that, according to legend, had outlined the ground plan of the major basilica Santa Maria Maggiore.

We are presented with the plunging panorama of a fertile plane and distant mountains, framed dramatically by precipitous hills. On the right a waterfall bursts from a high source, crashing initially onto a flat ledge. On the left a belligerent castle thrusts into space from the prow of an abrupt hill. The setting up of an extensive landscape as viewed from a lofty position was not novel in itself, but the energy of Leonardo's topographical drama was unprecedented.

The impulsive penwork is full of febrile motion. We seem to be urgent witnesses to what the artist saw on that particular fifth of August. This is what has generally been assumed. But can we be sure that this is the case?

The construction of the landscape is full of illogicalities. What are the spatial relationships between the cliff on the right, where we are standing, and the castle on the left? Would a waterfall really emerge like that from so close to the top of a mighty hill? The foreground trees are on the same scale as those quite far away.

It may be that the landscape is a wonderful product of Leonardo's imagination, based generically on the topography of Tuscany. We know that the Gherardini (the family of *Mona Lisa*) had been patrons of an oratory dedicated to Holy Mary of the Snows on a hill above Greve in Chianti. The Gherardini family also once owned a grand castle in the region (demolished when they fell foul of the Florentine government). Is this a fantasy about the history of the Gherardini?

Whether fantastical or real, Leonardo's landscape is something new.

3. The Annunciation

C. 1473–74, FLORENCE, UFFIZI

This painting comes from the sacristy in the convent of San Bartolomeo at Monte Oliveto, high above the south bank of the Arno. It is not the right shape for an altarpiece and was probably built into an item of furniture, such as a large chest, in the sacristy.

The Virgin sits outside her rather grand house, reading—as had become customary in depictions of Mary in the Annunciation—in this case from a sacred book protected by a diaphanous cloth. The decorative motifs of the improbable pedestal of her lectern are closely related to Verrocchio's tomb for Piero and Giovanni de' Medici in the Basilica di San Lorenzo, Florence. The scene's "enclosed garden" (*hortus conclusus*) refers to that in the Song of Songs in the Bible, where it symbolizes Mary's virginity—as does the white lily, visible to the right of the angel's face.

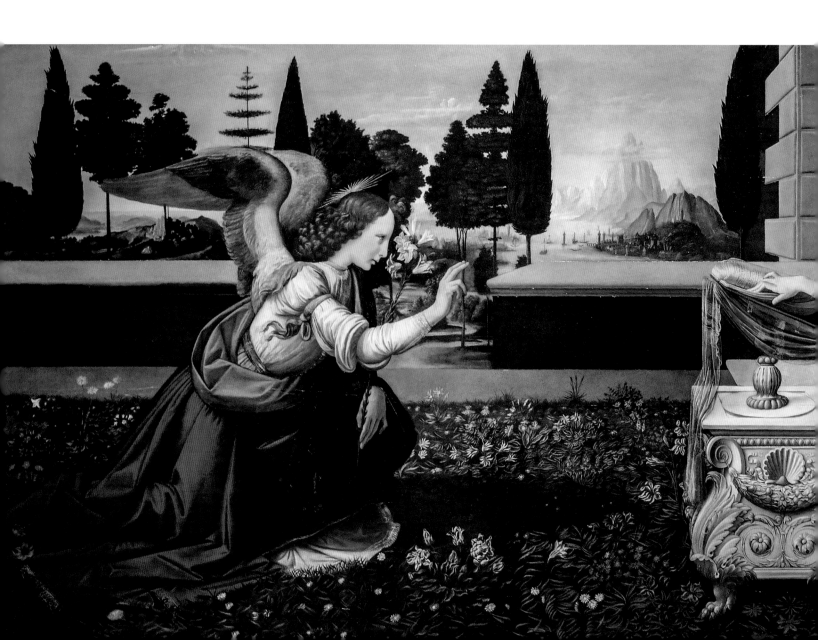

The painting is saturated by youthful ambition. The assertive sculptural qualities of the outer garments of the two participants show that they were studied from draperies placed over model figures and set with clay, as in the drawing in the Louvre (see page 8). The remarkably dense carpet of flowers seethes with superabundant life. The angel's wings testify to Leonardo's close studies of birds, although the paint in the nearer wing has deteriorated in the row of feathers that taper to its tip. The distant seascape flanked by vertiginous mountains fades with consummate delicacy into the mists.

The perspective of the tiled pavement, lectern, and house has been drawn out with pedantic care, using lines incised into the priming of the panel. We know that Leonardo originally planned a nonforeshortened wall with a window behind Mary. For all his efforts, the space does not really cohere, and the position of Mary's right arm in relation to the book defies the logics of space and anatomy. In all respects, this appears to be Leonardo's earliest known painting.

Technical examination has revealed a number of changes in the poses of the figures. Such instinctive adjustments made during the course of painting and after the design stage are characteristic of Leonardo throughout his career, diverging from the standard Florentine practice.

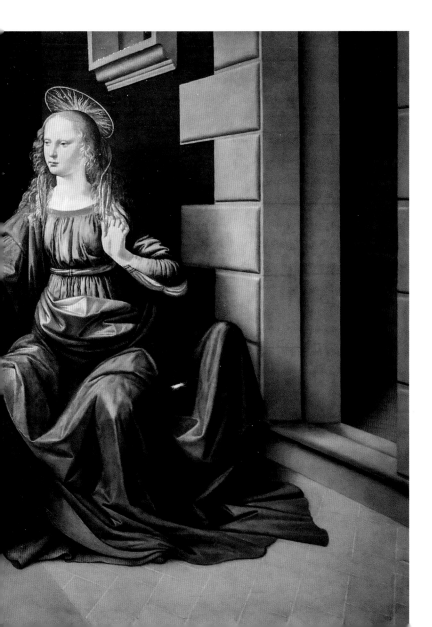

"The scene's 'enclosed garden' (hortus conclusus) refers to that in the Song of Songs in the Bible, where it symbolizes Mary's virginity—as does the white lily, visible to the right of the angel's face."

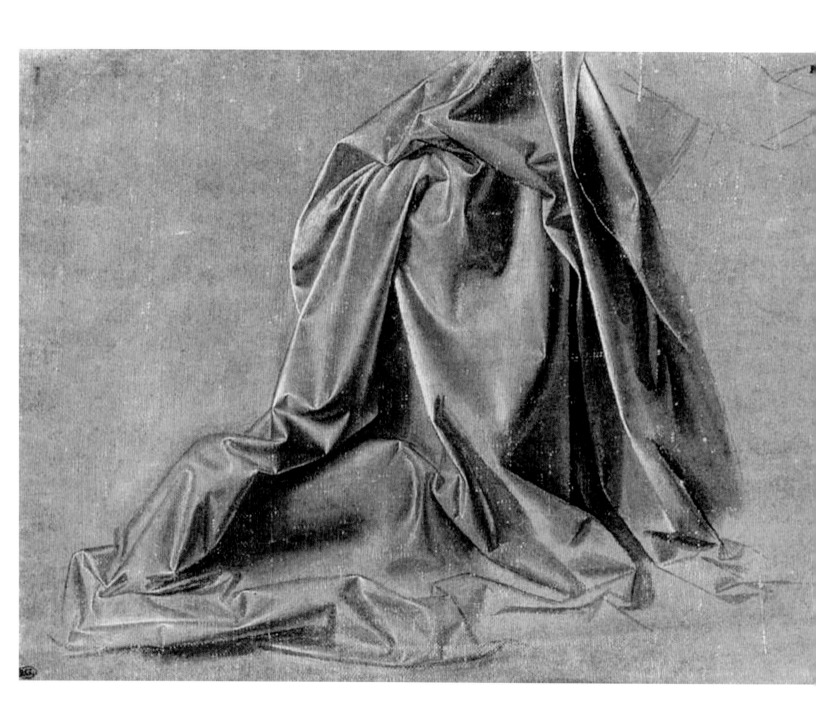

4. Drapery of a Kneeling Figure
c. 1473–74, Paris, Musée du Louvre

This is probably a study for the angel in an Annunciation, or perhaps for a Baptism, but it does not correspond to either of the known paintings. There is a series of drawings from the circle of Verrocchio executed in this technique—drawn very delicately with a fine brush on prepared linen with white heightening. Some can be attributed with some confidence to Domenico Ghirlandaio (1449–94), a fellow pupil of Leonardo, but it is generally difficult to match the studies precisely with actual paintings, and the very careful technique makes it difficult to differentiate the "hands" of the various artists responsible.

Vasari wrote in 1568 in *Lives* that he personally owned examples by Leonardo: "[Leonardo] often made models and figures in clay on which he placed rags infused with clay. Then he set out patiently to portray them on certain fine canvases of Rheims linen or on treated cloth, on which he worked with black and white using the point of a brush. These were miraculous works, as those that I have in our book of drawings still testify." Vasari's book contained prime examples of drawings by various masters, a good number of which now survive as separate sheets. Looking at the angular intricacies of the drapery in this particular drawing, we can well believe Vasari's account of Leonardo's methods. The angularity of the folds supports the idea that the cloth was dipped into liquid clay and allowed to dry on a model.

The best criterion for recognizing which drawings are by Leonardo is his treatment of light as a radiance transmitted through the air rather than as a layer of lighter and darker modeling adhering to the surfaces of forms. Leonardo's light rebounds from illuminated surfaces to strike areas that are in shadow. The illustrated drawing combines great conviction of sculptural structure with an active light that plays in a scintillating manner across and within the folds. In this it shares more with Leonardo's angel in the *Baptism of Christ* than with *The Annunciation*.

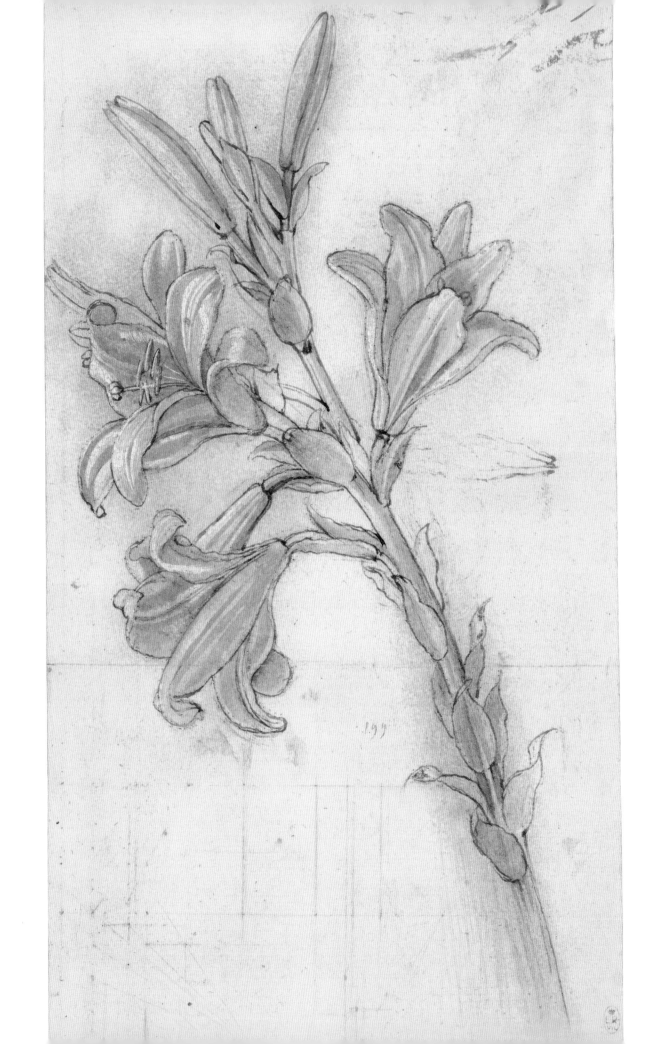

5. Study of a Lily (*Lilium candidum*) with the Ground Plan of a Building

C. 1473–74, FLORENCE, UFFIZI

The white blossoms of the lily symbolize the purity of the Virgin and allude to the gospel of St. Matthew (6:25): "Consider the lilies of the field, how they grow; they toil not, neither do they spin: And yet I say unto you, That even Solomon in all his glory was not arrayed like one of these." The lily was a common attribute in an Annunciation and sometimes appeared in images of the Madonna and Child.

This carefully prepared drawing in pen and ink over black chalk with brown wash and white heightening has something of the wiry quality of the bronze plants that Verrocchio used as decorative motifs in his sculptures. Leonardo had also been looking at the portrayal of nature in Netherlandish oil painting, most notably the flowers in an altarpiece by Hugo van der Goes (c. 1440–82) that was in Florence. Leonardo's emphatic *Lily* was surely studied from life.

The drawing's function as a cartoon is clear, because some of the outlines have been pricked through to facilitate the transfer of the design to the surface of a painting. This would be accomplished by dusting powdered charcoal through the perforations. The pricking does not extend to the upper stem and buds. The outlines do not provide a precise match with the lily held by the angel in *The Annunciation* (see pages 6–7), but the pricked sections are quite close. It is possible that the drawing was indeed used by Leonardo in his painting, and that he made characteristic adjustments during the actual positioning of the flower between the angel's face and upraised hand.

Before the lily appeared on the sheet, Leonardo had been drawing a ground plan in pen with a ruler. To judge from the fan of converging lines toward the bottom of the sheet (which has been substantially trimmed all round), he was working out the perspective projection of the plan. This is much in keeping with his rather pedantic efforts to provide the Virgin in the painting with a perspectively rendered house.

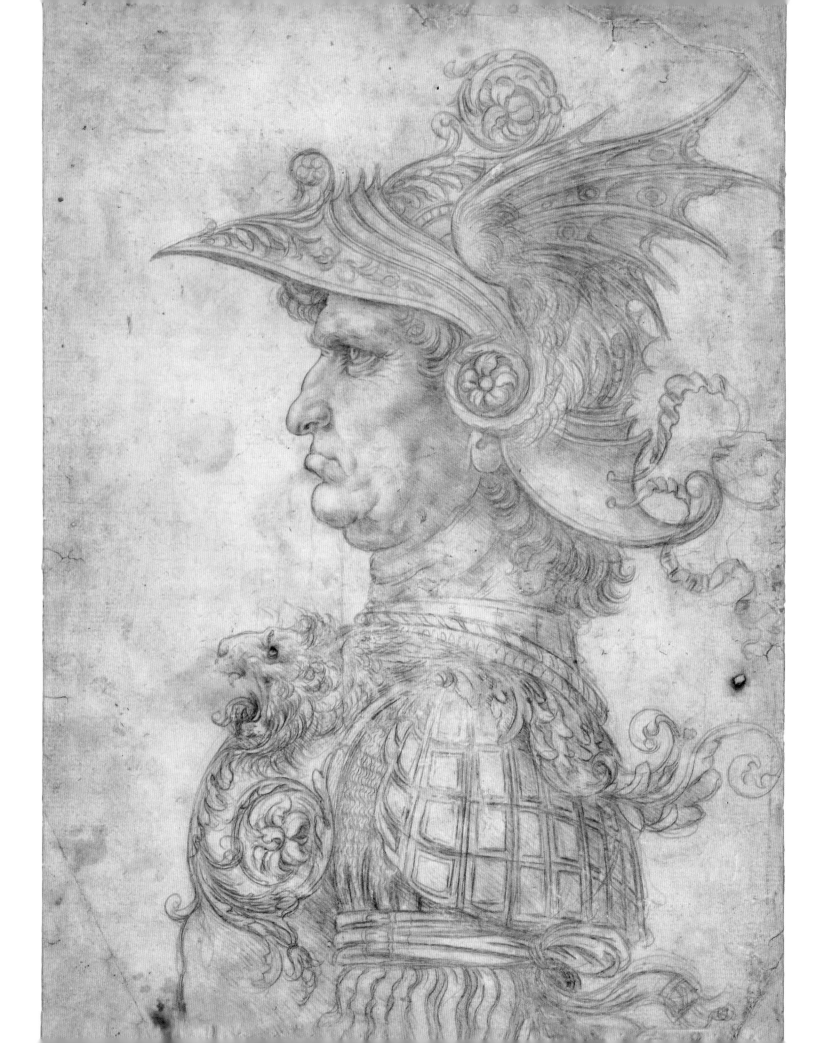

6. Bust of a Helmeted Warrior in Profile

c. 1476, London, British Museum

Nothing better illustrates the close relationship between Verrocchio as a sculptor and Leonardo as a draftsman than this highly finished drawing. It is a graphic variation on Verrocchio's pair of bronze reliefs depicting the Persian king Darius and Alexander the Great, both made for Lorenzo de' Medici (1449–92) as a gift for the Renaissance monarch of Hungary, Matthias Corvinus. The bronzes are lost but we know of versions in other media. Alexander was characterized as a youthful hero, while Darius was seen as older and more gnarled, as in Leonardo's drawing.

The armor and the extravagant helmet are fantastically compounded from motifs drawn freely from ancient Roman decorative arts and are endowed with an almost living vitality. The floral motifs and dragon's wing are portrayed as if they are studied from natural forms. The exuberance is reminiscent of bronze decorations on Verrocchio's tomb of Piero and Giovanni de' Medici in San Lorenzo (see page 6), while the gruff warrior recalls one of the aggressive soldiers in Verrocchio's silver relief of the *Beheading of St. John the Baptist* (1477–80).

The profile head of the roaring lion on the breastplate of the armor, apparently taken over from Verrocchio's *Darius*, not only underscores the king's intransigent valor but also makes specific reference to the ancient science of physiognomy, in which human faces were aligned with those of specific animals for their supposedly shared characters. According to the doctrine of the four temperaments, a brave man of choleric disposition shares the attributes of warlike Mars and the magnanimous fierceness of the lion. (See also pages 71 and 113.)

Executed meticulously in silverpoint on cream prepared paper, with some white heightening, the drawing does not have an obvious function. It does not appear to be a preparatory study. It seems to be a virtuoso, independent demonstration by the young Leonardo, boasting of his mastery in a way that both pays homage to his master and aspires to surpass him.

"The armor and the extravagant helmet are fantastically compounded from motifs drawn freely from ancient Roman decorative arts and are endowed with an almost living vitality."

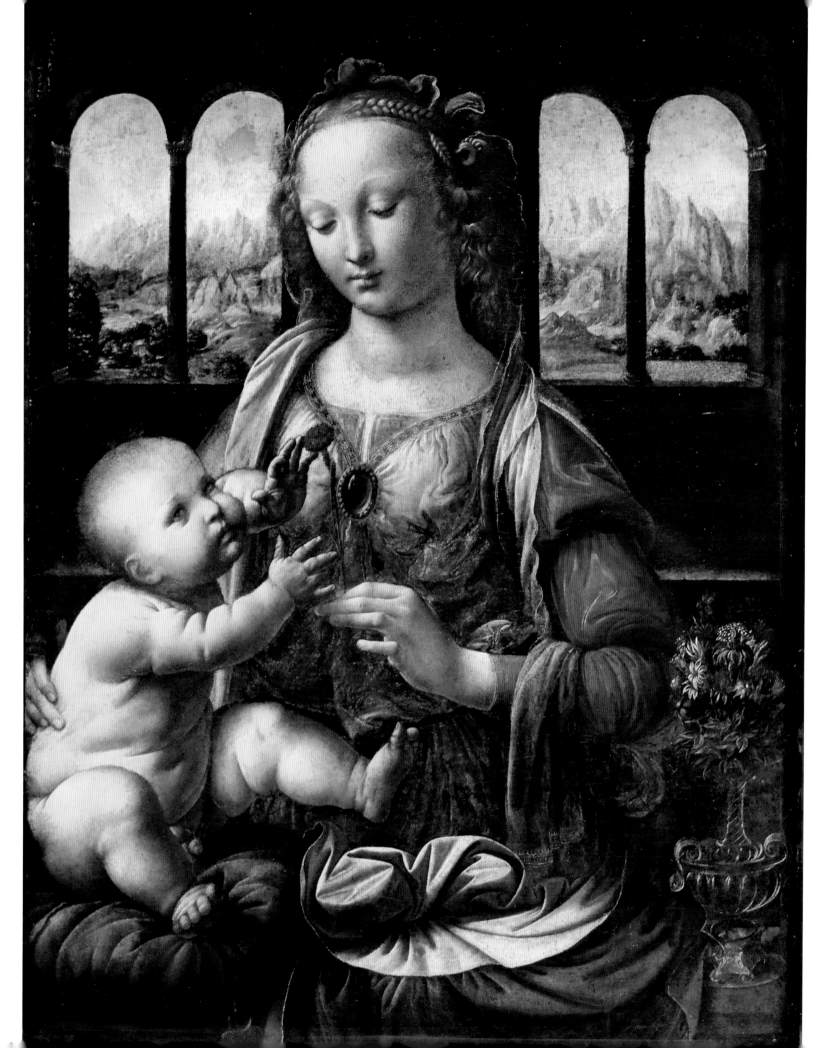

7. Madonna and Child
with a Vase of Flowers (*or* with a Carnation)
C. 1475, MUNICH, ALTE PINAKOTHEK

Small-scale pictures of the Virgin Mary and the infant Jesus were a stock-in-trade for Renaissance workshops, often involving young painters who realized the master's designs in saleable form. A number of such Madonnas originated from the Verrocchio studio.

Although the Munich *Madonna and Child* is probably not based directly on a known Verrocchio design, it shows every sign of being a Verrocchio & Co. picture. The Madonna's facial type is very close to that in a drawing by Verrocchio in the British Museum. Master and pupil also share a delight in complex intertwined plaits of hair offset by falling cascades of curls.

As in the *Baptism* (see page 2), the young Leonardo is striving throughout to achieve something beyond the norm. The composition is ambitious. The Virgin stands behind a ledge, with her colorful drapery piled up in dynamic array, while the pudgy and active child leaves a marked impress on his cushion. The intensity of the child's somewhat clumsy focus on the carnation held by his mother, reinforced by her acquiescent glance, is nicely observed. The carnation was a symbol of love, and there was a legend that it sprang from the tears shed by Mary on the road to Calvary. Its red color may also allude to the blood of Christ.

Where Leonardo departs most radically from the standard Madonnas is in his efforts to exploit the newish medium of oil to create novel optical effects. The glassy sheen of the vase with its vivacious flowers, and the light on the oval jewel clasping her dress—reflected at the top and refracted below—show that he has been enjoying the naturalistic wonders of Netherlandish paintings. Leonardo used the oil medium to paint the landscape in a suggestive way that is more "impressionistic" than the styles seen in Northern prototypes. He also attempted to soften the flesh tones by applying multiple layers of pigment saturated in oil, which caused wrinkles in the Virgin's skin as various layers dried at different rates. Leonardo's levels of early ambition result in an uneven picture that is full of potential.

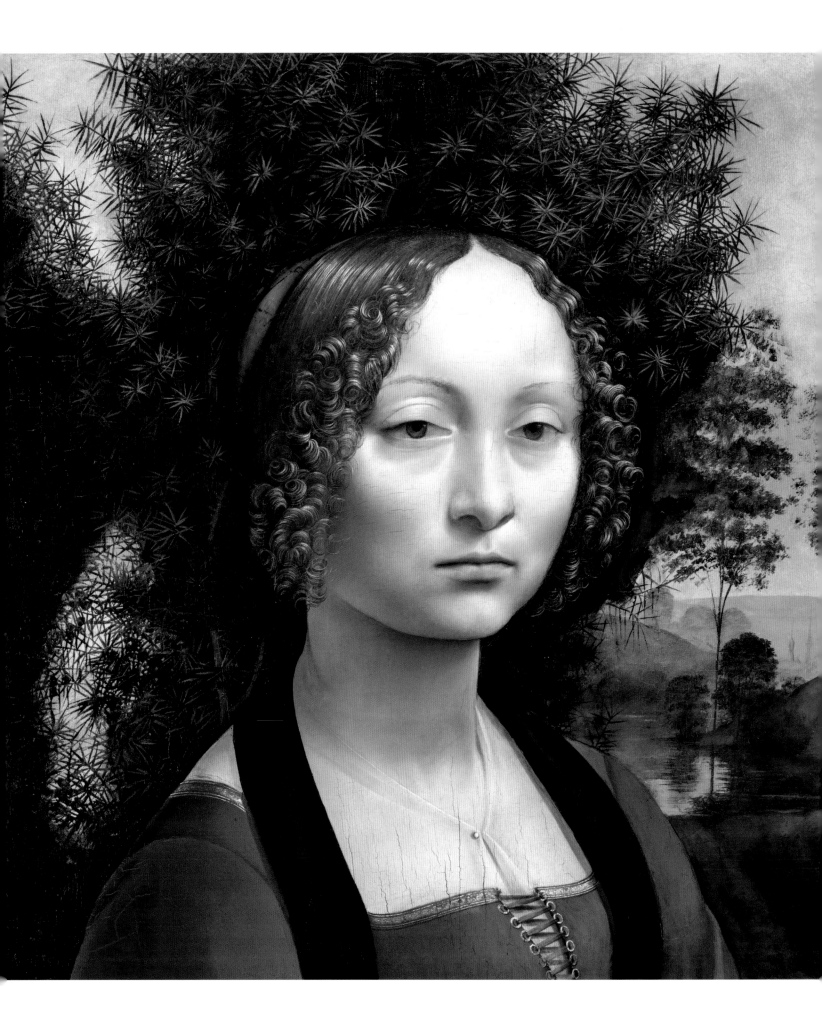

8. Portrait of Ginevra de' Benci

c. 1478, Washington, DC, National Gallery of Art

9. Studies of a Woman's Hands

c. 1478, Windsor, Royal Library, 12558

The identity of the sitter as Ginevra de' Benci (1457–1520) is confirmed by the presence of the spiky juniper (*ginepro*, in Italian) that frames her head. Portraits of women often celebrated notable events in their lives. One possibility in regard to this portrait is Ginevra's marriage with a substantial dowry to Luigi Niccolini in 1474 at the age of seventeen.

Ginevra was praised as a writer of poems (none survive) and belonged to a circle of cultivated Florentine women in the courtly circle of Lorenzo de' Medici, who composed two sonnets in her honor. A series of poems from various authors was commissioned as a celebration of the courtly love directed toward her by Bernardo Bembo, the Venetian "ambassador" in Florence, probably around 1478. Bembo may well have commissioned the portrait, since the wreath of palm and laurel painted on the reverse, with a sprig of juniper and the motto *virtutem forma decorat* (beauty adorns virtue), is adapted from Bembo's personal emblem. The flowery verses celebrate such delights as Ginevra's neck, which surpasses "white snow," and her "beautiful lips," which eclipse "red flowers in the spring that glow like fire." This is to say nothing of her "snow-white brow" and her "teeth like ivory."

There is nothing tentative about Leonardo's first known foray into portraiture. The assertive directness of the sitter, daughter of the banker Amerigo de' Benci, would be unusual in the portrait of a man and is exceptional, even shocking, in the image of a woman. In polite society, a well-bred young lady was not expected to offer sustained eye contact to men. The norm for Florentine portraits of women was to show them in reticent profile. Ginevra must have been complicit in this directness and it speaks of her self-aware presence in Medicean Florence.

We know from the severing of the emblem on the reverse that the panel has been cut down, and it is likely that the sitter's hands were included. The original format would be close to the marble half-length portrait of a *Lady with the Primroses* (1475–80) by Verrocchio, in the Museo Nazionale del Bargello in Florence. Leonardo seems to be saying that painting can achieve visual effects far beyond those seen in the hard and monochrome stone. He delights in the textural and coloristic contrasts between the dark sharpness of the juniper and the young woman's gleaming hair, the scintillating vortices of her curls, the soft opacity of her shawl, and her subtly diaphanous undershirt, drawn tightly across her "snowy" bosom by a tiny button.

The retreating landscape, a feature derived from Netherlandish portraits, is no less remarkable. Painted so richly in oil that its surface has puckered, it is suffused with atmospheric elusiveness, drifting distantly into a blue haze through which we can discern two towers. It recalls the flickering suggestiveness of the "*Val d'Arno*" drawing (see page 4).

Technical examination has revealed that Leonardo repeatedly pressed the edge of his hand into the drying paint, most notably in the flesh tones, to achieve the blending of transitions between light and shade. This was a signal feature of his technique before 1500. We also know that he laid in the juniper with dark-toned smears of paint, applied with surprising vigor.

THE WONDERFULLY OBSERVED DRAWING *Studies of a Woman's Hands* (opposite) at Windsor is very likely to have been made for the Ginevra portrait. It is executed with great virtuosity in the traditional Florentine medium of silverpoint on prepared and tinted paper with white heightening. The main modeling is hatched by Leonardo's left hand in delicate parallel lines, while the less focused elements are laid in with a freedom that is unusual in silverpoint. The bony structure of the hand is firmly described without compromising the elegance that would be required.

The end result in the portrait, even if all the effects are not wholly resolved, is startling in its originality, and not a little unsettling in the unabashed ambition shared by the artist and sitter to achieve something new.

OPPOSITE *Studies of a Woman's Hands*, c. 1478

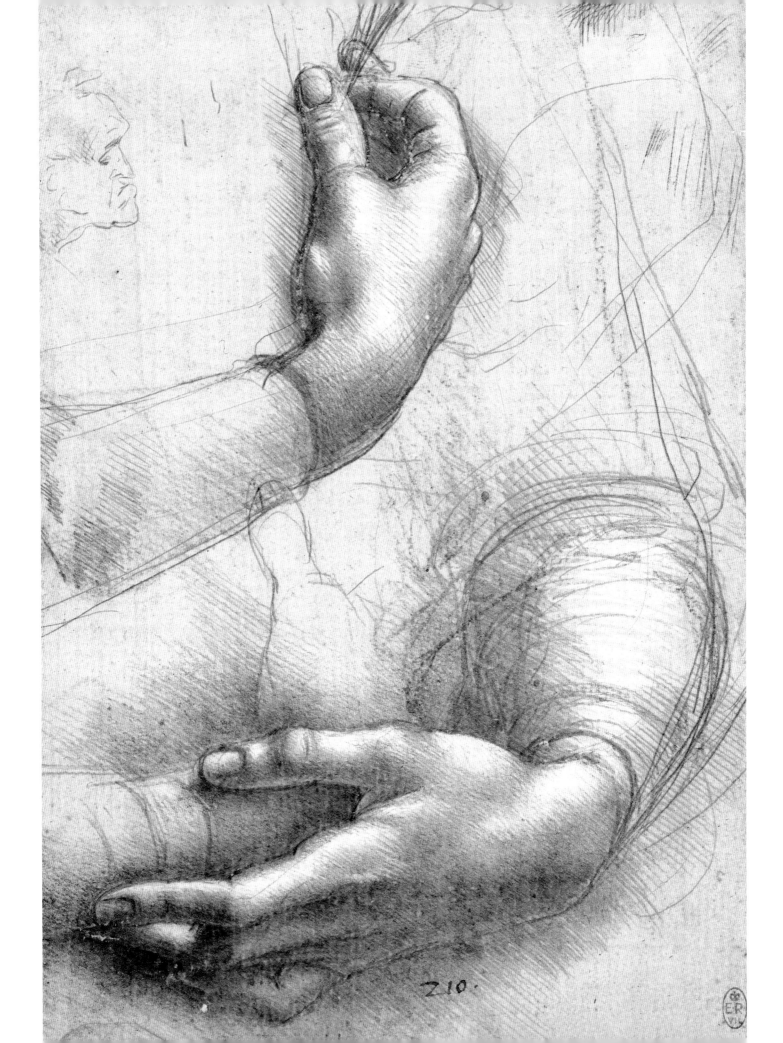

210.

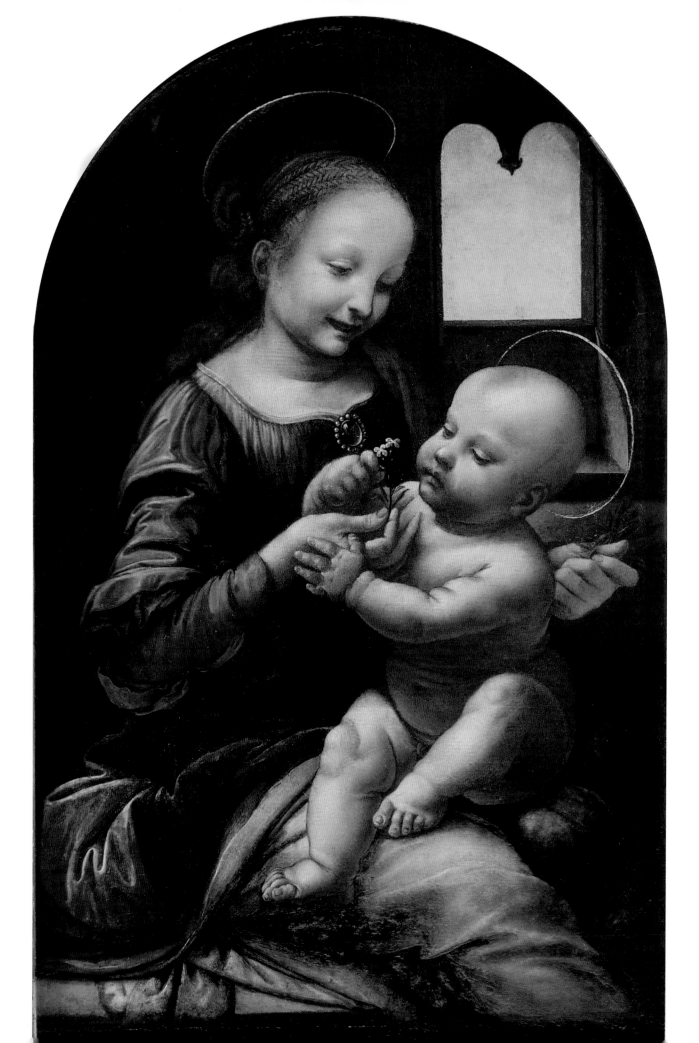

10. Madonna and Child with a Flower (the "Benois Madonna")
c. 1478–80, St. Petersburg, Hermitage

This amused Virgin belongs to a world that is quite distinct from that of the *Madonna* in Munich (see page 14). Mother and child are now integrated rhythmically in a lively exchange of actions, which involves the drapery no less than the poses of the figures. The Virgin's garments simultaneously encircle her limbs and have an ancillary life of their own.

The colors are attuned in such a way that they do not disrupt the basic scheme of light and shade that defines the structure of her pose. The light falling from the upper left has a different source—perhaps divine—from the natural light that slants through the window. It may be that the window once opened on to a landscape. Again Leonardo is attracted to the shiny gleam and diffused radiance in a glass or crystal jewel at the neckline of the Virgin's dress.

The emotional interplay is also harmonized to a much greater degree than in the Munich painting. The two hands of Christ and the right hand of his mother, clasping the stem of two delicate four-petaled flowers between her finger and thumb, form a little arabesque of fingers. The Virgin's glance and delightful smile are set off by the child's eyes, downturned to contemplate the little white blossoms from close range, as infants do.

In addition to the flowers, the Virgin holds a sprig of leaves behind the child's back, having apparently extracted the flowering stem from the bunch. Identifying the flower is not easy. White flowers with five petals are more common than those with four. What cannot be in much doubt is the symbolic reference. The four petals, arranged in a cross, prefigure Jesus's sacrifice. His mother's reaction is apparently unclouded by any premonition, but her son's sober attempt to grasp one of the blooms may well signify his precocious acceptance of his fate.

The name "Benois" refers to the architect Leon Benois (1856–1928) from the noted Russian family, who owned the painting before it was donated to the Hermitage.

"The emotional interplay is also harmonized to a much greater degree than in the Munich painting. The two hands of Christ and the right hand of his mother, clasping the stem of two delicate four-petaled flowers between her finger and thumb, form a little arabesque of fingers."

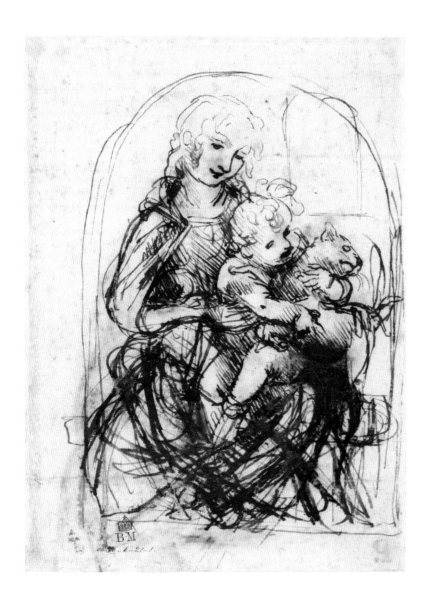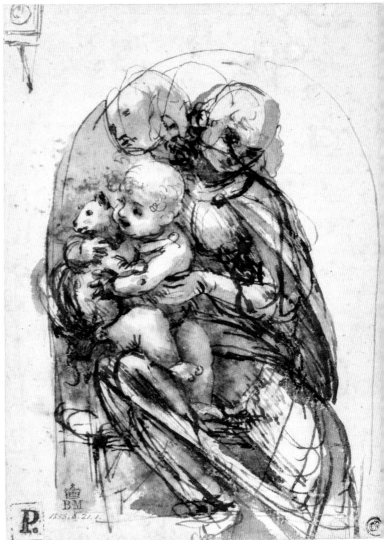

11. Studies for a Madonna and Child with a Cat, *recto and verso*
C. 1478–80, LONDON, BRITISH MUSEUM

This small sheet of studies—5.2 × 3.8 inches (132 × 96.5 mm) in its trimmed state—is one of the most significant drawings in the history of art, although Leonardo's project for a painting of the Mother and Child with a cat never seems to have been realized (see also page 25). It signals a new way of designing compositions. Artists had made free and sketchy drawings before, but no one had overlaid multiple alternatives in a single drawing. This not only is a way of brainstorming interlocked poses but also allows new arrangements to emerge by chance from the maelstrom of lines, using a form of imaginative projection.

In a paragraph drafted for his proposed *Treatise on Painting*, Leonardo asked:

> Have you ever reflected on the poets who in composing their verses . . . think nothing of erasing some of the verses in order to improve upon them? Therefore, painter, decide broadly upon the positions of the limbs of your figures and attend first to the mental attitudes of the living beings in the narrative rather than to the beauty and quality of the limbs. . . . I have in the past seen in clouds and on walls stains that have inspired me to beautiful inventions in many things.

On one side of the sheet, within an arch-topped frame, he impetuously used a pen and a blank stylus with a sharp point to dash down the main outlines of the three participants, with particularly dynamic alternatives for the Virgin's legs. The cat is portrayed with notable vigor, writhing in the child's overeager embrace, tail thrashing, as cats are wont to do.

Clarification was needed. Leonardo transferred the designs to the rear of the sheet (using a stylus or holding it up to the light?) and resumed brainstorming. The Virgin's head was inclined to the right, away from the mini-drama, and the frame was repositioned. The cat became less agitated. Appearing more or less content, Leonardo used a dark wash applied with a brush to pull forms out of the scribbling. The "*Benois Madonna*" (see page 20) is closely related to this campaign of drawings for the standard subject that he has so dramatically reformed.

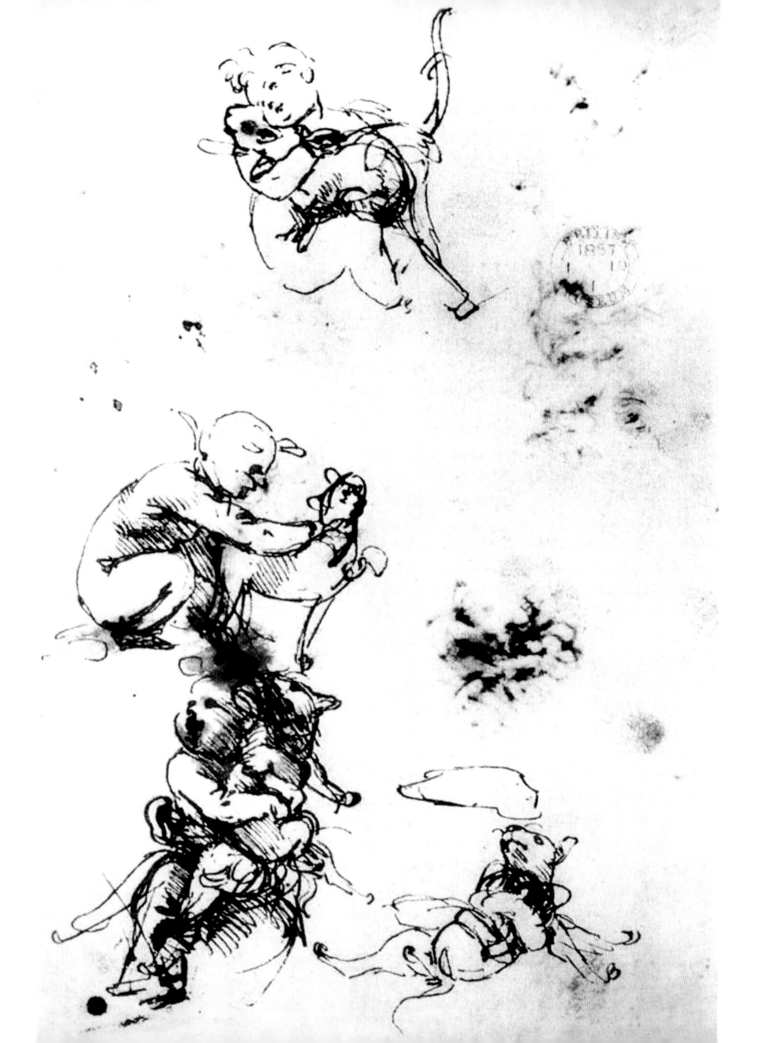

12. Studies for a Child with a Cat

c. 1478–80, London, British Museum

Obviously related to his project (probably unrealized) for a small painting of the Madonna and Child and a cat, this series of studies shows how Leonardo's creative imagination could be captured by a particular motif, expanding beyond the functional demands of the envisaged picture. The relationship of the child and the cat has assumed a high degree of independence from the Virgin. It is difficult to see, for example, how the central motif of the stroked cat could be fitted into the planned composition. We may also doubt whether a cat in obvious discomfort would have worked within the framework of a devotional image.

In the upper and central studies, the cat is having a nice time, submitting to the child's hug—at least for the moment—and clearly enjoying a gentle stroke, with arched back and raised paw. In the studies below, the cat is progressively turned over, which is bound to result in the kind of struggling that we witness, miraculously described with a few scratchy strokes of the pen, after some light sketching with a leadpoint and blank stylus.

The more-or-less illegible smudges on the upper and middle right have resulted from the seepage of ink from the other side of the sheet, on which the studies are the other way up. The scribble beside the stroked cat is caused by a dense tangle of undecipherable motions as the cat reacts with furious agitation to the unwanted attention.

It cannot be doubted that the entertaining studies result from intensely careful and sympathetic observation of how infants and cats interact. It is unlikely that such transitory motions are drawn from life, but they are certainly based on vivid memories of seen interactions.

Why should a cat have been introduced at all in a Madonna painting? There was a legend that a cat gave birth in the manger at the very moment when the baby Christ emerged into the world.

"This series of studies shows how Leonardo's creative imagination could be captured by a particular motif, expanding beyond the functional demands of the envisaged picture."

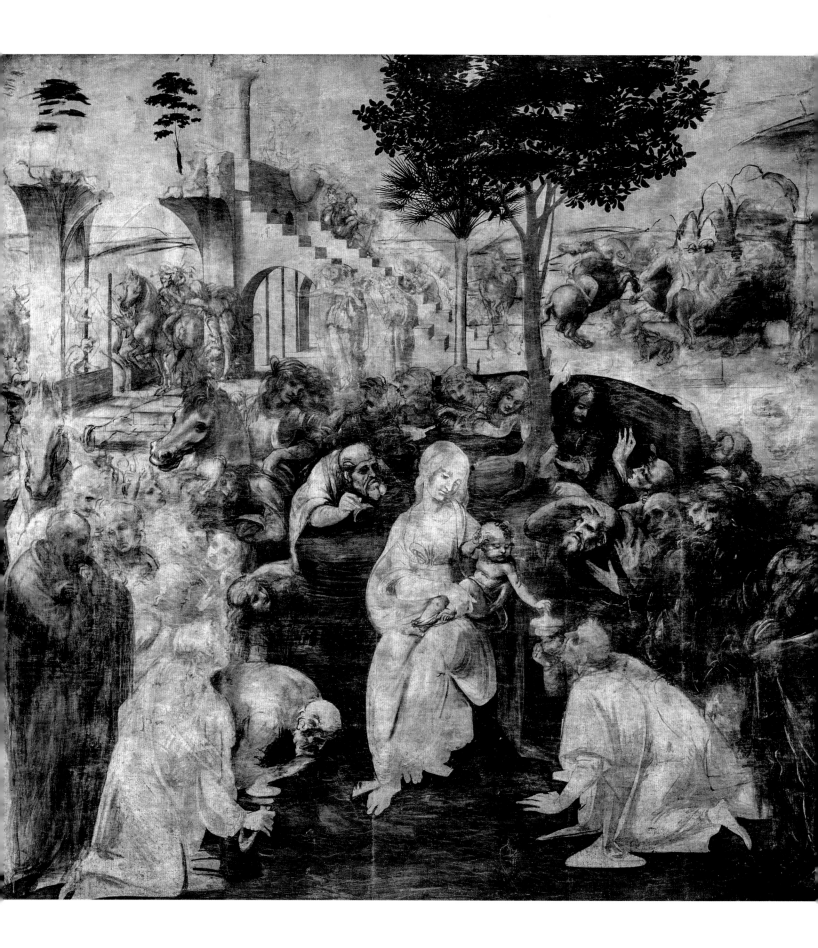

13. Adoration of the Kings (*or* Magi)

C. 1481–82, FLORENCE, UFFIZI

14. Perspective Study for the Adoration of the Kings

C. 1481–82, FLORENCE, UFFIZI

The *Adoration of the Kings* was not Leonardo's first large-scale commission. In 1478, he was asked to paint the altarpiece for the Chapel of San Bernardo in the government palace in Florence, but he does not seem to have made substantial progress on what was a prestigious contract.

The large square altarpiece of the *Adoration* was assigned to Leonardo in March 1481. It was a strange commission. Simone, father of Brother Francesco—an Augustinian monk in the monastery of San Donato a Scopeto, outside the city walls to the south—had bequeathed a property to the monks. A third of this was to be granted to Leonardo as a "fee" for painting the altarpiece. The painter, having received his share of the property, was then obliged to deposit a sum in the dowry bank for the daughter of a certain Salvestro, which he failed to do.

The unfinished painting, on a crude assembly of ten narrow planks, is one of the great feats of imagination in Western art. The tranquil Virgin and her calm child are surrounded by a cacophony of awed figures, who sense the momentous birth of the new world order from the visible ruins of the old. The kings kneel and stoop at the Virgin's feet with intense reverence, the one to the right receiving Christ's blessing as he presents a fine chalice.

The other figures within the curved throng, with the strange exception of a slumbering Joseph (directly below the horse's head at left), react with vividly varied emotions: amazement, awe, bewilderment, fear, reassurance, and piety. On either side stand two intermediaries: to the left, a contemplative elder meditates on the mystery, and the young man on the right turns to a realm beyond the pictorial field.

The background is no less tumultuous. A once magnificent structure of piers, arches, vaults, and stairs has largely collapsed. It provides a stage set for female figures (sibyls?), men, and lively horses, while at the top of the steps two or more men seem to be involved with some initial rebuilding. To the right, two warriors on rearing horses fight with unbridled ferocity. Above them, in a lower level of paint, is the surprising outline of a distant elephant.

The emotional tenor is very different from the tradition of Adorations in Florence. The change does not involve the large press of figures who accompany the Magi or the ruined pagan architecture. Florentine paintings of the subject had become very densely populated in a processional manner. Leonardo's break is to portray the arrival of the Redeemer as something beyond our comprehension.

All this emerges from a painting that not only is unfinished but is in a chaotic state of varied levels of definition. On the panel primed with gesso, Leonardo laid in the scaffolding of his composition and drew the first outlines of the active figures and animals. One or more layers of underpainting were to follow across the picture. Sections that were to be predominantly dark were painted in very deep brown, from which figures emerge as ghosts. The Virgin and Child with their three kings were exempted from the dark underpaint. The shadows of their garments are signaled in pale blue-green and they await bright glazes of color, probably using organic dyes. There remain areas of startling lack of resolution. It is difficult to see how the mélange of gesturing hands and urgent faces could all be endowed with convincing bodies, particularly on the right.

The stage on which this chaos unfolds was constructed with cool calculation. A drawing in the Uffizi, opposite, elaborately constructed with a straightedge and compass using a blank stylus, metalpoint, charcoal, pen and ink, dilute ink wash, and traces of white, constructs the perspective of a tiled pavement with minutely designed precision to regulate the geometrical space occupied by the desperate participants. One of the foreground tiles is marked with ten tiny horizontal subdivisions. Nowhere in Leonardo's drawings do we see a more vivid demonstration of the way that his vision merges *scienza* and *fantasia* in the remaking of nature in his works of art.

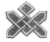

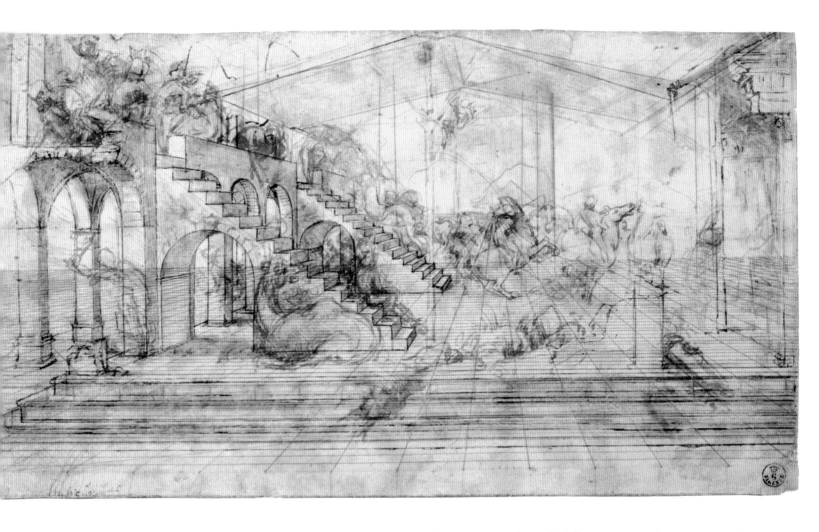

Perspective Study for the Adoration of the Kings, c. 1481–82.

"Nowhere in Leonardo's drawings do we see

a more vivid demonstration of the way that

his vision merges scienza *and* fantasia *in the*

remaking of nature in his works of art."

15. St. Jerome

C. 1481–82, ROME, VATICAN

Another unfinished painting, this one very much aligns with the *Adoration* (see page 26) in its level of finish, style, and intensity of expression. It was presumably abandoned at the same time Leonardo left for Milan in c. 1482.

A long list of works (mainly drawings) that Leonardo jotted down on a sheet of paper dating from shortly after his arrival included "certain St. Jeromes," in addition to "many throats of old women, many heads of old men, many complete nude figures, many arms, legs, feet and poses . . ." These studies are entirely in keeping with the emphasis placed upon anatomical painting in Florence. St. Jerome was a popular Florentine subject and provided ample opportunity for the demonstration of a painter's command of the human body as a vehicle for spiritual expression.

The saint is portrayed in a barren, rocky landscape of unrelieved harshness, where he lived for four penitential years. As recounted in legends of his life, he is about to strike his breast with a stone in extreme remorse for his previous allegiance to pagan culture and his sexual desires. The subject of his agonized stare is a vision of the crucified Christ, barely visible at the right edge of the panel. He is accompanied by the lion that continued to reside with him after he had removed a thorn from its foot. Jerome's companion echoes the level of fierce resolution that drives the saint's spiritual valor—rather like the roaring lion in the drawing of a *Helmeted Warrior* (see page 12).

In the unpainted section to the right of the saint's head, Leonardo has sketched the outlines of a church. It is unclear if he intended this to become visible in the distance under the overhanging rock formation, or if it was an unrelated sketch, like the unexpected asides that appear in his notebooks.

That the panel survives at all is a miracle. At one point it was cut into five sections in such a way that the head and neck of the saint comprised a separate picture. The fragments were reunited in the nineteenth century.

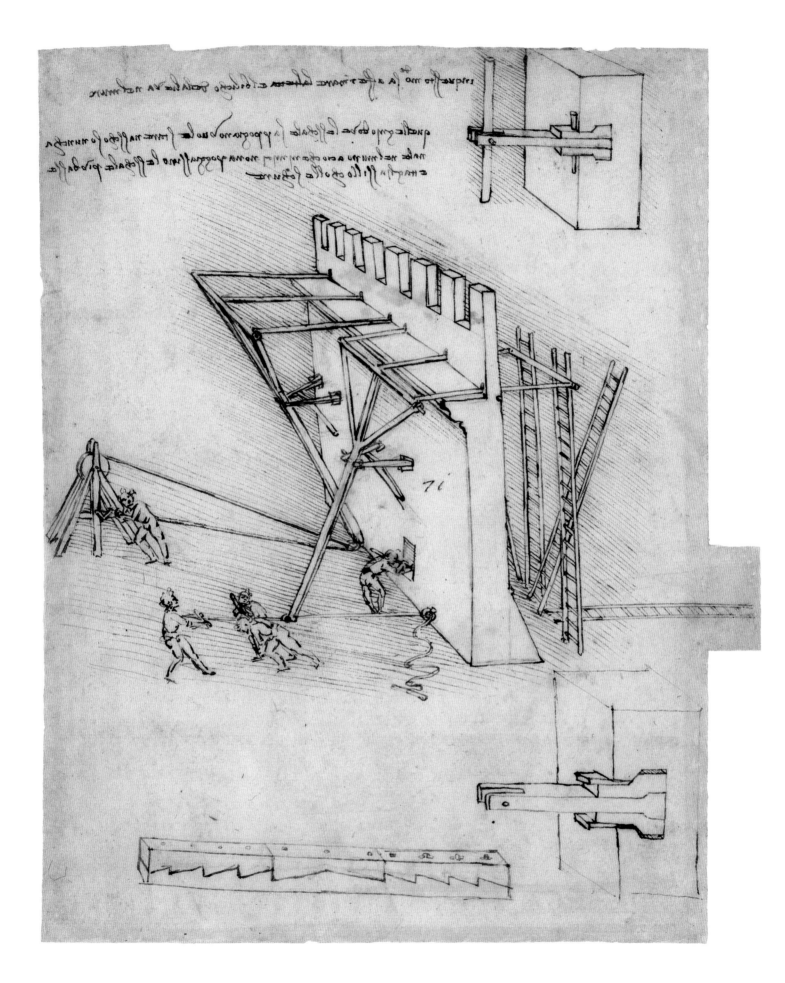

16. Studies of a Mechanism
for Repelling Scaling Ladders

c. 1475–80, Milan, Biblioteca Ambrosiana, Codice atlantico, 139r

After Leonardo arrived in Milan, probably in 1492, he boasted in a letter of introduction to Ludovico Sforza (1452–1508) that he had devised an extensive range of "instruments for war . . . beyond the common usage," and many civil designs for use "in time of peace." He laid out his inventions under ten headings, ranging from "easily portable bridges" to "boats that will resist the fire of all the heaviest cannon." Only at the end of the letter did he mention that he was able to produce paintings and sculpture as well as anyone.

There was a strong tradition in Tuscany of artist–engineers. Verrocchio was involved in at least one engineering project, and the great Florentine architect Filippo Brunelleschi (1377–1446) was renowned as an engineer. However, it is unlikely that Leonardo could demonstrate hands-on experience of most of the techniques he claimed to have at his command. There are a limited number of engineering drawings that can be attributed to his first period in Florence.

Leonardo is here illustrating a way to dislodge the ladders used by an enemy to scale a castellated wall. Each section of a pole running near the top of the outside of the wall is thrust outward by three horizontal poles attached to a lever that is operated either by two men pulling on a rope or by one man turning a windlass. Whether this is his own invention or illustrates a known device is unclear.

Leonardo's methods of illustrating the mechanism already exhibit some novel features, compared with standard engineering drawings of the time. He has shown a schematic section of the wall in succinct perspective. He has added cutaway details of how the pole that extends to the fulcrum of the levers is anchored into the wall by joints that expand when the pole is driven in. The lowest study appears to show a system of lamination, perhaps for the wooden beam that runs along the edge of the platform.

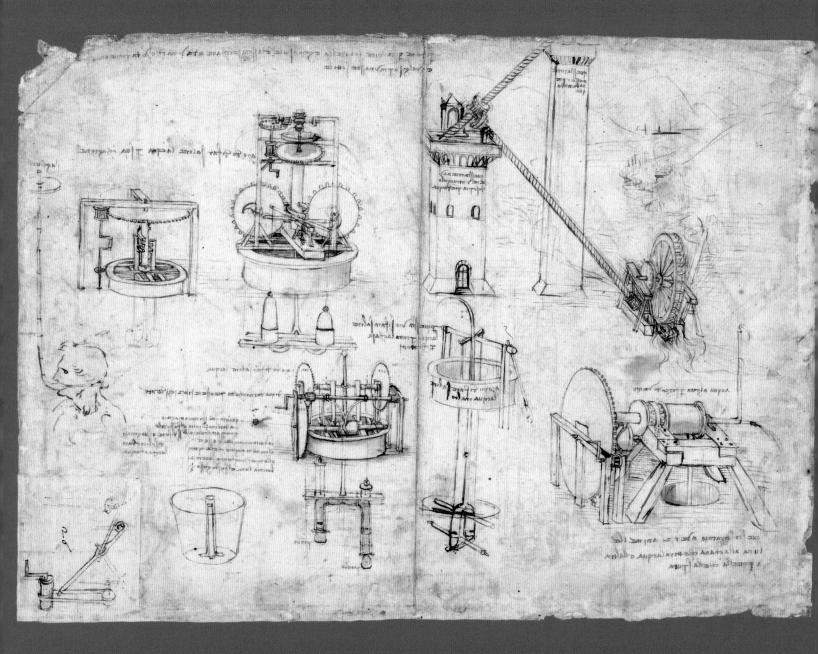

17. Studies of Archimedean Screws, Wells, and Pumps and an Underwater Breathing Device

C. 1475–80, Milan, Biblioteca Ambrosiana, Codice atlantico, 1069r

The management of water was a major economic and social concern in all Renaissance societies. Engineers who could facilitate safe and reliable water supplies in urban settings were well rewarded for their services.

One of the prime needs was to be able store water in high tanks or reservoirs to produce a head of water to generate the pressure needed to transmit water from one place to another. One device for lifting water, credited to the Greek inventor Archimedes, was a pipe arranged as a helix and placed at an angle so that when the axle of the screw is rotated, the water in one part of the pipe will run into the next part of the pipe. In effect, the water is being wound uphill.

The system involving two towers (on the top left of the right sheet, opposite) shows two screws feeding reservoirs at the top of short and tall towers. The lower screw is turned by a waterwheel, drawing water from an onrushing stream. The top of this screw is geared to turn a second screw that draws water from the reservoir at the top of the shorter tower, which is fed by the first screw. There is no indication of how the screws are to be supported.

The other main devices on the sheet involve the raising of water from wells or deep reservoirs, either with conventional systems of buckets or with the use of pumps. The precise operation of the devices is difficult to determine. Again the method of demonstration, involving the perspectival rendering of the components and transparent views of sections underground, surpasses the methods of conventional drawings in engineers' treatises.

Characteristically, while thinking about devices for water, Leonardo squeezed a sketch into the left-hand margin of the sheet that shows how to breathe underwater. A flexible breathing tube is kept aloft by a circular float so that air can be drawn into the diver's mouth. Similar devices were found in earlier notebooks by fifteenth-century engineers.

"Characteristically, while thinking about devices for water, Leonardo squeezed a sketch into the left-hand margin of the sheet that shows how to breathe underwater."

35

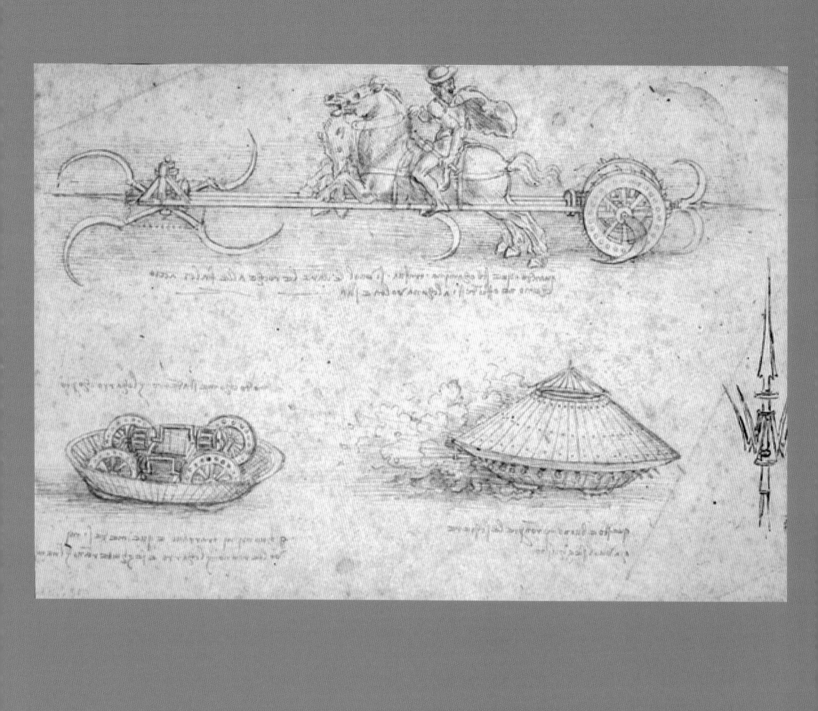

18. Studies of a Scythed Chariot, an Armored Wagon, and the Point of a Halberd

c. 1483–85, London, British Museum

This sheet presents entertaining examples of the war machines designed to demonstrate Leonardo's prowess as an inventor for his patron in Milan, Ludovico Sforza. They can be regarded as exercises in "visual boasting," typical of the kinds of extravagant inventions paraded in presentation treatises by engineers. Practicality does not seem to have been uppermost in the inventor's or patron's mind.

The upper study of the chariot emulates ideas in the treatise *De re militare* (*On Military Matters*, 1472) by Italian engineer Roberto Valturio (1405–75), who delighted in a range of inventions of modern and ancient kinds. Leonardo's study, beautifully drawn in fine pen and ink, with a spirited pair of rearing horses and a horseman with a fluttering cloak, goes far beyond the functional. The spiked wheels of the chariot engage a lantern gear that turns a central axle. This axle drives the paired blades and spike at the rear and provides the motive power for the four whirling scythes. The apparatus appears to be high in visual intimidation and low in applicability to actual war.

The same is true of the "tank" on the lower portion of the sheet. The study on the left, showing the wagon without its conical roof, reveals four spoked wheels driven by two camshafts with four lantern gears. Leonardo tells us that it is to be operated by eight men and is to be used to penetrate the ranks of the enemy. Were the gears to be located as he shows, the front and rear wheels would be driven in opposite directions! The drawing on the right shows the scuttling wagon dispersing a spray of missiles from the small cannons around its periphery. Leonardo did not take account of how the cannons might be loaded and what effect they would have on the occupants.

In the right margin, drawn in different ink, is a spear or halberd with a collar of secondary spikes, one of many elaborate and seemingly inexhaustible variations by Leonardo on the basic form.

"Leonardo's study, beautifully drawn in fine pen and ink, with a spirited pair of rearing horses and a horseman with a fluttering cloak, goes far beyond the functional. . . . The apparatus appears to be high in visual intimidation and low in applicability to actual war."

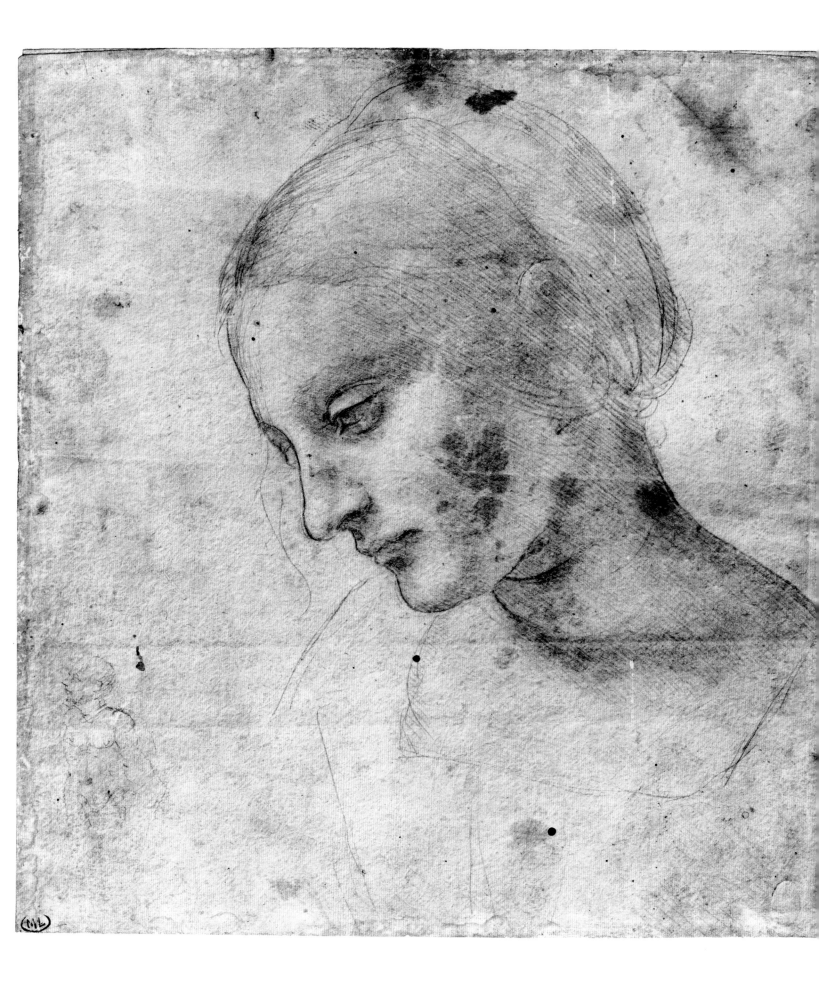

19. Study of a Woman's Head in Profile

C. 1481–82, PARIS, LOUVRE

In the list of works he apparently compiled after his move to Milan (see page 31), Leonardo included "an Our Lady finished / another almost which is in profile." The only known candidate for the "Madonna in profile" is the *Madonna Litta* painting in the Hermitage (below), named after the Milanese family who owned it in the nineteenth century.

The wonderfully refined if somewhat damaged metalpoint drawing on greenish paper shown here is preparatory for the *Madonna Litta*. It is surely done from life, using a model who has bound her hair in a plain scarf. Leonardo has handled the refined medium with incredible delicacy, above all in the parallel hatching that renders the shadows on the woman's face, neck, and hair. The hint of the top of her ear under her hair is notably subtle. The lines are rather softer in texture and more blended than would normally be the case with silverpoint, suggesting that the artist may have used a softer metal. The outlines appear to have been inscribed more emphatically with a metalpoint (or even with a pen) that is less pointed at its tip. There is also a little unrelated figure in the lower left corner.

IS THE *MADONNA LITTA* ACTUALLY BY LEONARDO? Once assumed to be by Leonardo himself, it is now generally recognized as being painted by Giovanni Antonio Boltraffio (c. 1467–1516), who was Leonardo's most technically accomplished assistant in Milan. Although a little abraded, the painting of the flesh tones is very slick, giving the forms a smooth, rather generalized quality, particularly noticeable in the Virgin's hands. Most decisively, a study for the Madonna's drapery in the Staatliche Museen in Berlin is skillfully drawn with silverpoint in Boltraffio's pedantically polished and precise manner. It is tempting to attribute the awkwardly twisting pose and disconcerting stare of the suckling child to Boltraffio, but the bold torsions and direct communication are characteristic of Leonardo's early ambitions. It seems that Leonardo willingly handed over his unfinished panel to be completed by his amanuensis.

RIGHT *Madonna Litta*, c. 1495, attributed to Giovanni Antonio Boltraffio, St. Petersburg, Hermitage.

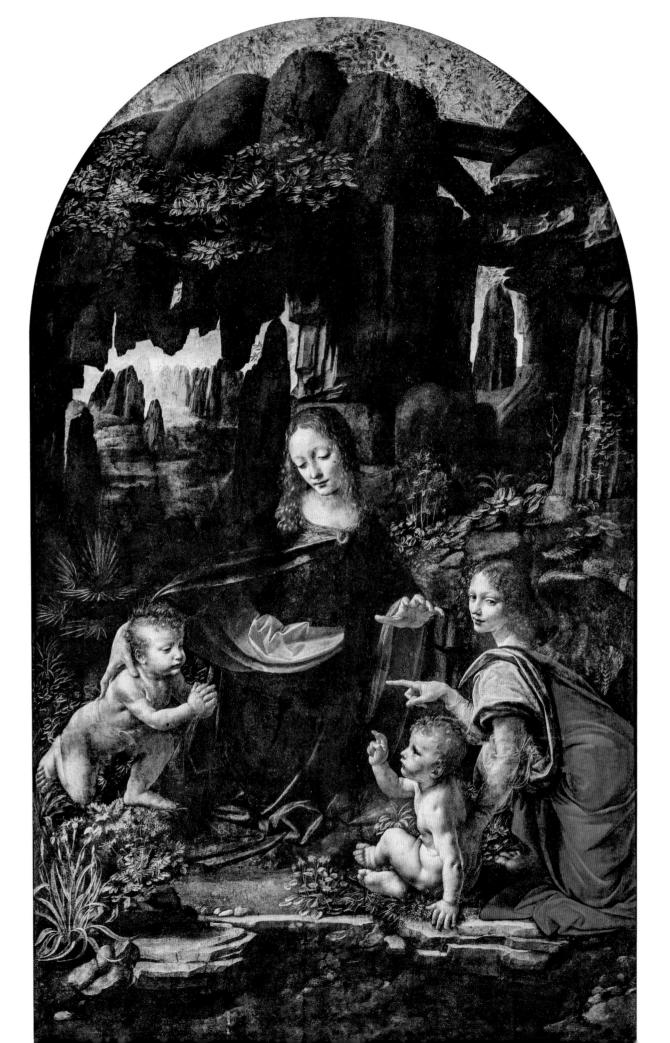

20. Virgin of the Rocks

c. 1483–93, Paris, Louvre

21. Head of a Young Woman Looking Outward

c. 1483–84, Turin, Biblioteca Reale

22. Cartoon for the Head of the Infant St. John the Baptist

c. 1483–96, Paris, Louvre

The story of the commission for the *Virgin of the Rocks* is one of the most convoluted in the history of art, involving a complex contract awarded to Leonardo and two brothers in 1483, a dispute about payment, the apparent sequestration of the picture by Ludovico Sforza, the commencement of a substitute and its abandonment, prolonged legal action by the commissioners, and the painting's eventual completion twenty-five years later. Into this story we need to fit two prime versions of the picture, one in the Louvre and the other in London's National Gallery (see page 152).

On April 23, 1483, Leonardo and the brothers Evangelista and Giovanni Ambrogio da (or de) Predis were commissioned to provide the painted components for a very large and complicated architectural and carved altarpiece for the Confraternity of the Immaculate Conception in the Milanese church of San Francesco Grande. The tasks included the costly gilding and painting of statues, including important wooden sculptures of the Virgin and God the Father; and a series of reliefs and architectural components, most of which were to be colored in the "Greek [i.e. Byzantine] style." There were also "flat surfaces" to receive paintings, including four angels. The middle panel, as specified in the contract, was "to be painted on the flat surface [with] Our Lady and her Son with the angels all done in oil to perfection . . . in colors of fine quality as specified above." The painters were given about twenty months to complete the substantial assignment.

Things did not go according to plan. The extensive tangle of documentation leaves plenty of room for alternative explanations. Leonardo and Ambrogio claimed in a letter, apparently to Duke Ludovico Sforza, that they had been underpaid, and asserted that they should have received 100 ducats for the painted panel at the center of the complex. They announced caustically that the "blind cannot judge colors." It is probable that the Duke took advantage of the dispute to commandeer the Madonna in 1494 as a wedding gift for the Holy Roman Emperor Maximilian I and Bianca Maria Sforza (the duke's niece). This left the painters to fulfill their obligation, which they did not do before Leonardo left Milan in 1499. We will pick up the story after 1500 when we look at the second version on page 152.

Leonardo interpreted the brief for the central panel quite freely. Rather than a Madonna and Child with angels, he has shown Mary and her Son in exile in the wilderness meeting the infant St. John, who is chaperoned by the angel Uriel. This story is one of the legendary accretions surrounding the early years of Jesus. Leonardo tells of the meeting of the infants through a network of spatial gestures and glances under the shelter of Mary's cloak and outstretched hand. There is no doubt about the identity of the children. John prays in supplication, receiving Christ's blessing. Uriel's pointing hand, added to the picture quite late, points emphatically to her charge. Clearly, a lovely metalpoint drawing in Turin of a young woman (opposite, left) turning to look at us served as the basis for the angel's tender and knowing glance.

The setting is pregnant with science, meaning, and mystery. Leonardo's study of nature is vividly apparent throughout: the foreground strata at the edge of what may be a pool; the formations of angular and rounded rocks in the grotto; the variety of precisely characterized plants; and the atmospheric distance. The flowers are likely to carry symbolic meanings. The iris at the lower left stands alongside the lily as a symbol of the Virgin, and its pointed leaves signal the swords of sorrow that will pierce her heart. The flower of the columbine in the center above the pool can be seen as referring to the dove of the Holy Spirit, perhaps also alluding to the description in the Song of Songs of the Virgin as a "dove in the cleft of rocks." The rocky setting combines science and spiritual presence in equal measure. Leonardo's pioneering naturalism and traditional symbolism are melded into an imaginative compound that speaks of the supreme mystery of the sacred encounter in the wilderness.

Leonardo's individualistic handling of light, shade, and color gives us some idea of how the *Adoration of the Kings* (page 26) and *St. Jerome* (page 30) might have looked if completed. Although the Paris *Virgin of the Rocks* was damaged when it was transferred from panel to canvas in 1806, we can still see how remarkable Leonardo's method is. He is practicing what was later called tonal painting; that is to say the colors operate within an overarching system of light and shade, in which they are all subject to the same process of darkening in the shadows, finally losing almost all their independent color.

In the unfinished *Adoration*, the shaded areas were underpainted as a dark substratum from which the illuminated forms would have emerged. Leonardo was above all aiming to create what he called *rilievo* (three-dimensional relief) by setting spotlit forms against dark backgrounds. The result can be readily seen in the *Virgin of the Rocks,* in which the individual colors rise into the light, progressively declaring their inherent nature. The dark blue of the Virgin's dress remains quite deep in tone, while the yellow fabric leaps into radiance. The red of the angel's garment catches the light in a way that is between these extremes.

Set in its heavily gilded altar, Leonardo's penumbral cavern must have looked very cavernous.

Finally, it is good to report the exceptional survival of a pricked cartoon, not for the whole painting but for the charming head of St. John (opposite, right), drawn with skilled economy. Perhaps Leonardo used a series of separate cartoons for key parts of the painting. We know the head was replicated by at least one senior assistant in the workshop to make a small painting of the Madonna and Child.

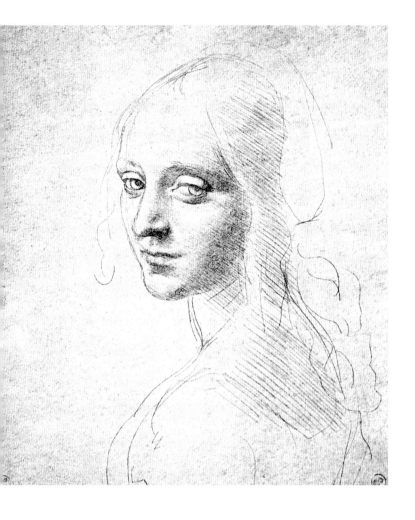

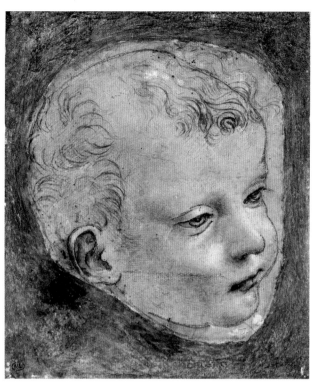

"A lovely metalpoint drawing in Turin

of a young woman turning to look at us

served as the basis for the angel's tender and

knowing glance. The setting is pregnant with

science, meaning, and mystery. Leonardo's study

of nature is vividly apparent throughout."

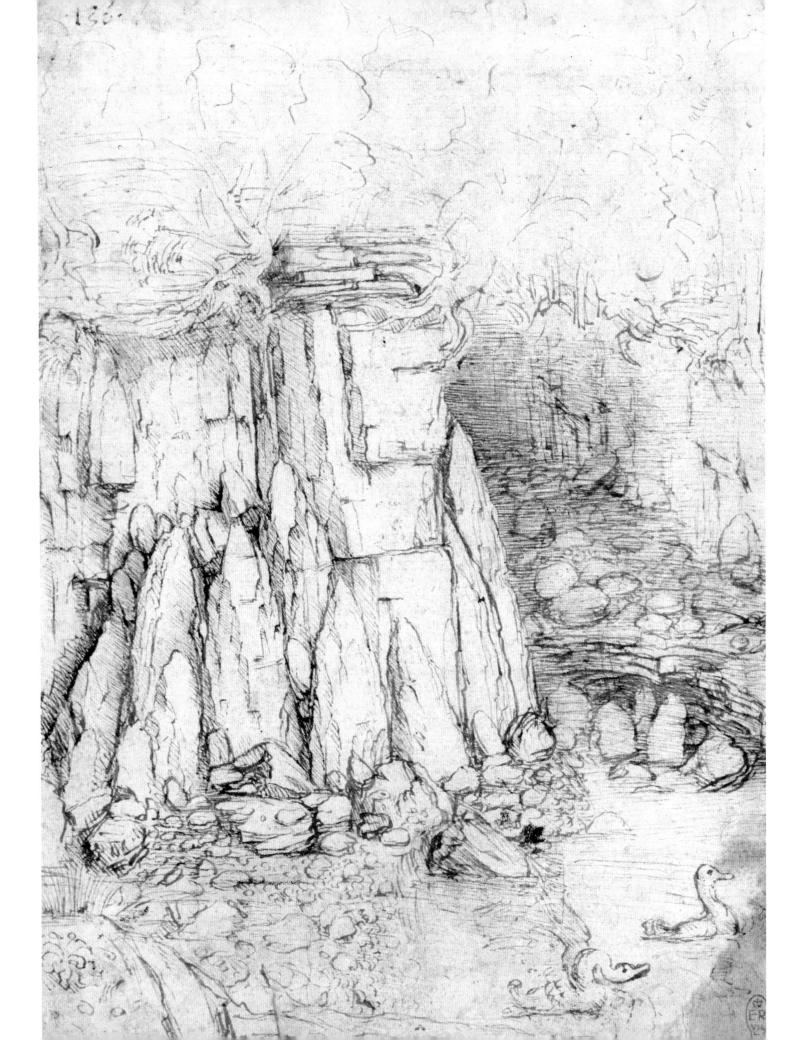

23. Study of a Rocky Cliff and Ravine

C. 1481, WINDSOR, ROYAL LIBRARY, 12255

Artists before Leonardo must have made landscape drawings. Netherlandish art is full of landscapes that must have been directly observed and recorded. Leonardo's master, Verrocchio, followed the Northern artists in this respect, as did Domenico Ghirlandaio (1449–94) and Pietro Perugino (c. 1450–1523), fellow pupils of Leonardo. But none approached landscape with Leonardo's analytical and narrative eye.

Although the locale has not been identified, the drawing here is based on hard observation and systematic thinking about form and process in nature. A jagged cliff stands on the left, composed from the reddish limestone that is plentiful in Tuscany. The vertical splitting and horizontal fracturing of the rocks has been faithfully recorded. At the top, two trees have desperately insinuated their roots between horizontal strata. At the base of the cliff, smaller fragments and boulders have been cast down by the waters. A vertical ravine has been cut by a watercourse that has reshaped boulders and broken rocks into stones. At the mouth of the ravine, the waters have uncovered a small stack of strata, partly dammed by collapsed blocks of stone. At the foot of the cliff, rocks have been progressively broken down into gravel, and in the left-hand corner plants begin to grow from the first layer of fertile soil.

Later, in the Codex Leicester (c. 1506–13), Leonardo was to write about this graded geological process: the splitting of rocks, the shattering and erosion of boulders into pebbles, the formation of sand, and the deposit of soil. There is no indication that Leonardo was developing a framework of geological theory at this time, but he was clearly aware of the embedding of time in rocky topographies. There is already a powerful sense of the "body of the earth" as a living and changing entity, in which inert materials become infused with life.

It might be tempting to identify the out-of-scale waterfowl in the foreground as additions made by a cheery pupil. However, the dynamism of the flapping swan (?) is typical of Leonardo himself.

"He is clearly aware of the embedding of time in rocky topographies.

There is already a powerful sense of the 'body of the earth' as a living and

changing entity, in which inert materials become infused with life."

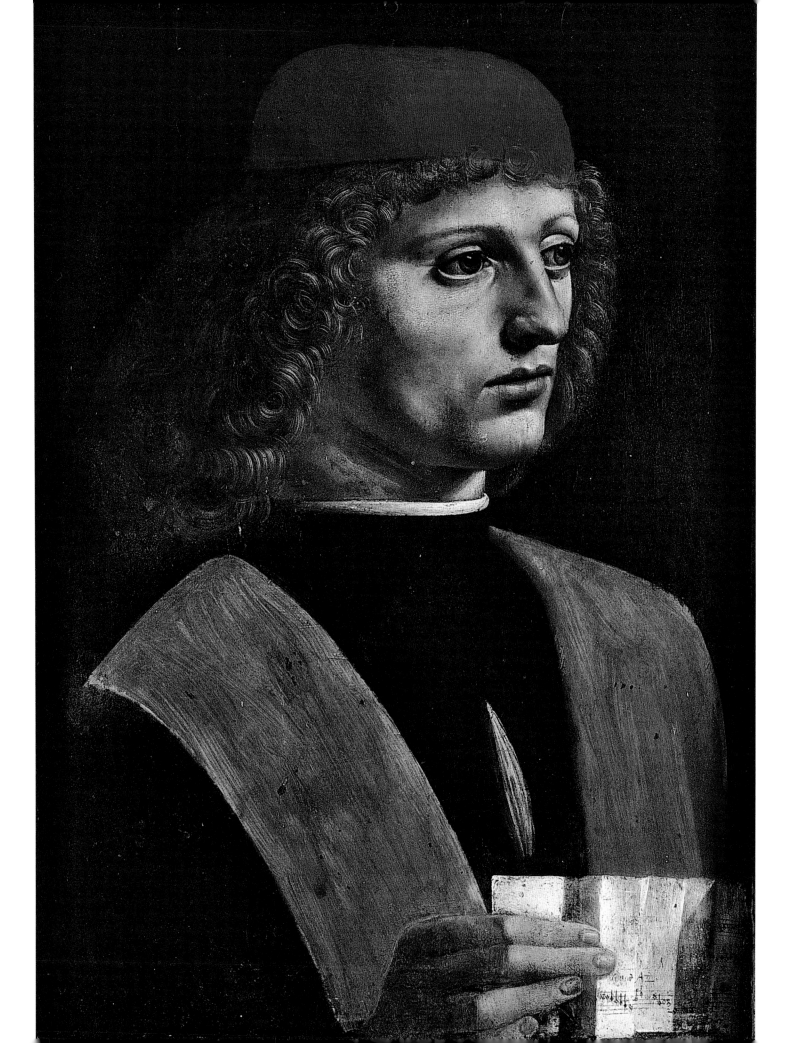

24. Portrait of a Man with a Sheet of Music

c. 1483–86, Milan, Pinacoteca Ambrosiana

The fixed pose and stare of this sitter have been cited as reasons why the portrait seen here is not by Leonardo. The modeling of the head aligns reasonably well with that of the angel in the Louvre *Virgin of the Rocks* (see page 40). The scintillating vitality of the sitter's vortical hair and the incisive use of light and shade on his lean face speak of Leonardo's analytical naturalism. But the most decisive factor is the sense of intense intelligence and sensitivity in the young man's eyes and mouth.

The head and hair have been brought to a full level of finish, but the other parts of the picture are incomplete to various degrees. The man's stole is no more than a rough underpainting. The hand and sheet of music are both unfinished and badly damaged. The way the man's fingers grasp the folded paper is strange spatially, and we must assume that it has been folded very stiffly. The music on the paper has been heavily abraded and the remaining fragment tells us little. The paper also bears the inscription *Can . . . An . . .* , normally read as *Cantum Angelicum* (angelic song), but if it is in Italian, *Cantore Angelico*, it would tell us that the man is an "angelic singer," which seems to make best sense.

Franchino Gaffurio, the leading musical theorist in Italy at this time and a colleague of Leonardo at the Sforza court, has been suggested as the sitter. The great French composer Josquin des Prez, who was in Milan at more than one point in the 1490s, has also been identified as the musician. The intimate feel of the portrait makes it most likely that it portrays Atalante Migliorotti, the Florentine singer, master of the *lira da braccio* (an early form of violin) and maker of stringed instruments. It seems likely that Atalante and Leonardo traveled together from Florence. In Leonardo's list of drawings from c. 1482, he mentions "a head portrayed from Atalante who raises his face."

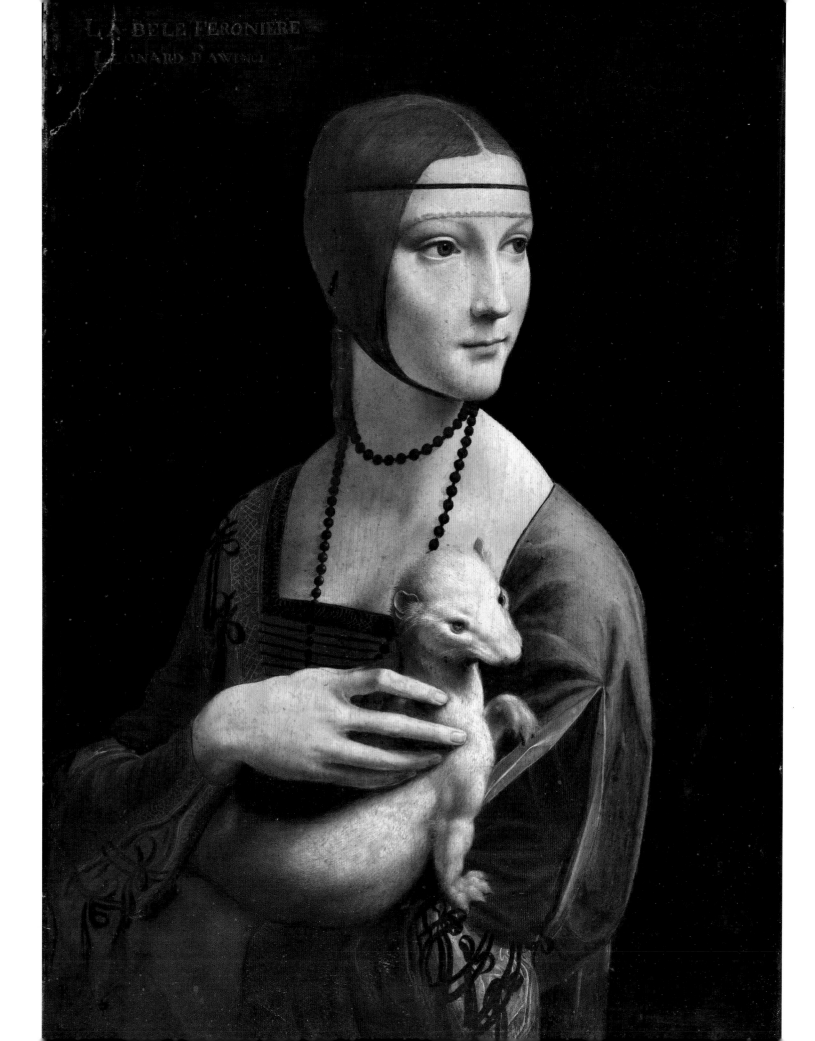

25. Portrait of Cecilia Gallerani (*or* Lady with an Ermine)

c. 1491, Kraków, Czartoryski Collection

26. Emblematic Drawing of an Ermine and a Hunter

c. 1490, Cambridge, UK, Fitzwilliam Museum

The identity of the sitter is in little doubt. She is Cecilia Gallerani (1473–1536), a Milanese courtier of recognized accomplishments who became the mistress of Ludovico Sforza during her teenage years, giving birth to a son in 1491, the year in which the duke married Beatrice d'Este from Ferrara. Cecilia was married to Count Ludovico Carminati the following year at the age of nineteen. The portrait is likely to have been a gift from the duke at the time of her betrothal or marriage.

The painting was the subject of a laudatory sonnet by poet Bernardo Bellincioni (1452–92), Leonardo's Tuscan colleague at the Sforza court. Bellincioni's ingenious poem asks why Nature is envious of Leonardo's achievements. The poet reminds Nature that "the honor is yours" because the enduring portrait "allows you to partake in posterity." The poet instructs us that we should give thanks to both Leonardo and the duke (who is the unseen recipient of Cecilia's modest smile). "She seems to listen and not to tell," as Bellincioni says. He concludes that "everyone who sees her thus, even later seeing her alive, will say, that this is enough for us to understand what is nature and what is art." The narrative triangulation between the implied duke, the refined sitter, and the person in front of the picture (Bellincioni, Leonardo, or ourselves) is entirely novel in a Renaissance portrait.

In 1498, Beatrice's sister, Isabella d'Este of Mantua, wrote to Cecilia asking to borrow the portrait to compare it with ones by Giovanni Bellini (c. 1430–1516), the Venetian master. Cecilia reluctantly acceded, noting that the portrait no longer resembled her since she had changed in appearance since it was painted. Two years later, with the fall of the duke's regime, Leonardo was welcomed by Isabella at the Mantuan court.

The portrait probably remained in the sitter's family until it was acquired in Italy around 1800 by the Polish prince Adam Jerzy Czartoryski, who gave it to his mother, the great collector Izabela. It was around this time that the misleading inscription "La Belle Ferronière / Leonardo D'Awinci" was added at the upper left. It is Poland's most famous painting.

"The lady and the animal share their mellifluous poise and svelte elegance—underscored by the silvery play of direct and reflected light on white fur and pale skin."

THE ANIMAL CRADLED IN CECILIA'S ARMS has been the subject of much contention. It has been claimed that it is too big to be an ermine. If we strictly applied this criterion of size, most infant Jesuses would not be of human origin. It may be that the ermine was originally smaller and was enlarged for the sake of pictorial and symbolic effect. According to the legends of the medieval *Bestiary*, the ermine represents moderation, since it eats only once a day, and also signifies purity because it "would rather die than soil itself," as Leonardo wrote in one of a series of notes on the symbolic meaning of animals. In his little emblematic pen sketch of the ermine, opposite, he shows the animal surrendering to an aggressive hunter rather than crossing a muddy morass below the rocky ledge on which it stands. Again, the animal is oversized to underline its allegorical meaning.

Leonardo's beautifully painted ermine embodies the sacrificial fastidiousness for which it was famed. The lady and the animal share their mellifluous poise and svelte elegance—underscored by the silvery play of direct and reflected light on white fur and pale skin. It so happens that Ludovico Sforza was a member of the Order of the Ermine, and that the Greek for ermine, *galée*, puns on Cecilia's surname. Renaissance culture much enjoyed such multiple allusions.

The refinement of expression, pose, lighting, color, texture, and costume was hard won. Technical examination has revealed many adjustments after the design was transferred from the cartoon and during the course of the actual painting. The costume, with its elegant interlace patterns and the knotted ribbons that hold the sections of the lady's sleeves in place, was subject to particularly radical changes. We also know that Leonardo's handprint technique was used on the heads of the lady and the ermine.

OPPOSITE *Emblematic Drawing of an Ermine and a Hunter*, c. 1490.

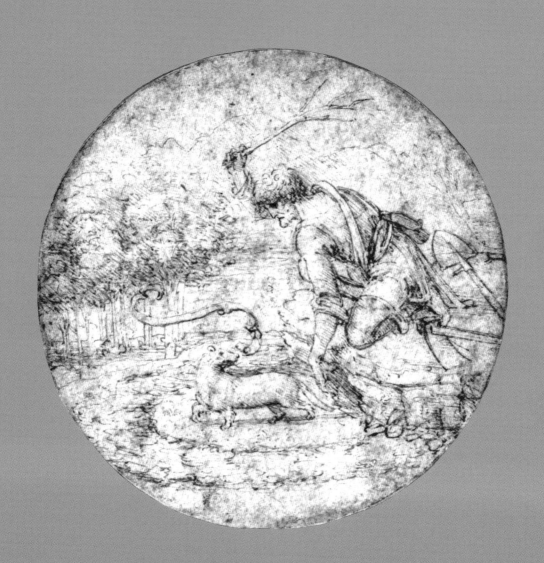

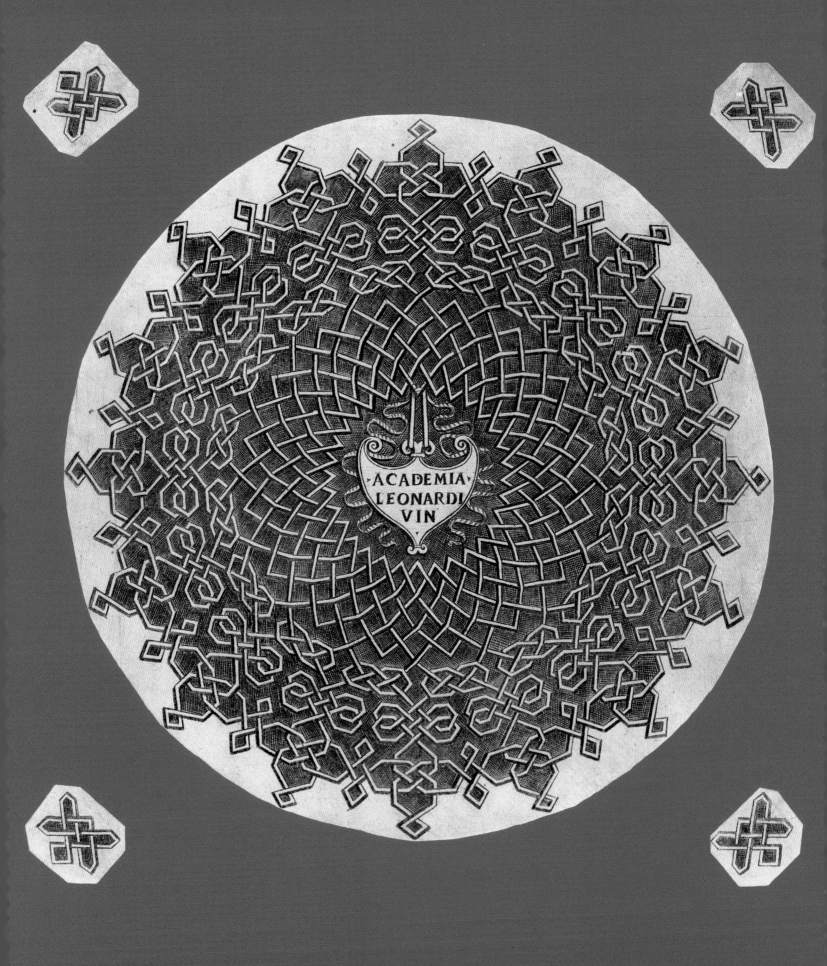

ACADEMIA
LEONARDI
VIN

27. Knot Design for Leonardo's "Academy"

c. 1495, Washington, DC, National Gallery of Art

Leonardo enthusiastically took up the challenge of designing elaborate interlaces and knots of the kind that were popular in North Italian courts, particularly in women's costumes. Intricate interlaces feature in Leonardo's *Portrait of Cecilia Gallerani* (see page 48). The interlace pattern was appropriated as a personal motif by Isabella d'Este, Marchioness of Mantua. In 1493, her sister, Beatrice, who had married Ludovico Sforza, deemed it prudent to write from Milan to seek permission to use it on her own behalf.

This is one of six knots that were reproduced as engravings, each accompanied by variants of the motto or caption ACADEMIA LEONARDI VINCI. There was a cultural "academy" in Milan that met in the Milanese palace of the courtier Henrico Boscano. Members included the poets Gaspare Visconti and Bernardo Bellincioni, as well as the artists Leonardo and Donato Bramante, together with eight musicians and a number of philosophers. Leonardo's formal knot designs may signal his intention to promote his own courtly "academy." He may also have been exploiting a pun on his own name, in which *Vinci* loosely puns with *vincolo*, a binding, both of a physical kind as in the weaving of baskets, and metaphorically as in the bonds of friendship. The design "patented" by Isabella was known as the *fantasia dei vinci*.

The rhythmic geometry of knots fascinated Leonardo as a kind of visual music, and he worked patiently on many variations of curvilinear and rectilinear motifs in his notebooks, always ensuring that the threads obeyed a regular under-and-over rule. It is often assumed that all the knots are composed from a single thread. This is not the case with the most elaborate examples. The knot illustrated here comprises six discrete components locked together in a symmetrical array.

The origin of the engravings is not known, but it is likely that they were made under Leonardo's supervision, as testaments to his skill and intellectual ambitions. They were reproduced influentially in woodcut by Albrecht Dürer (1471–1528), but without the captions.

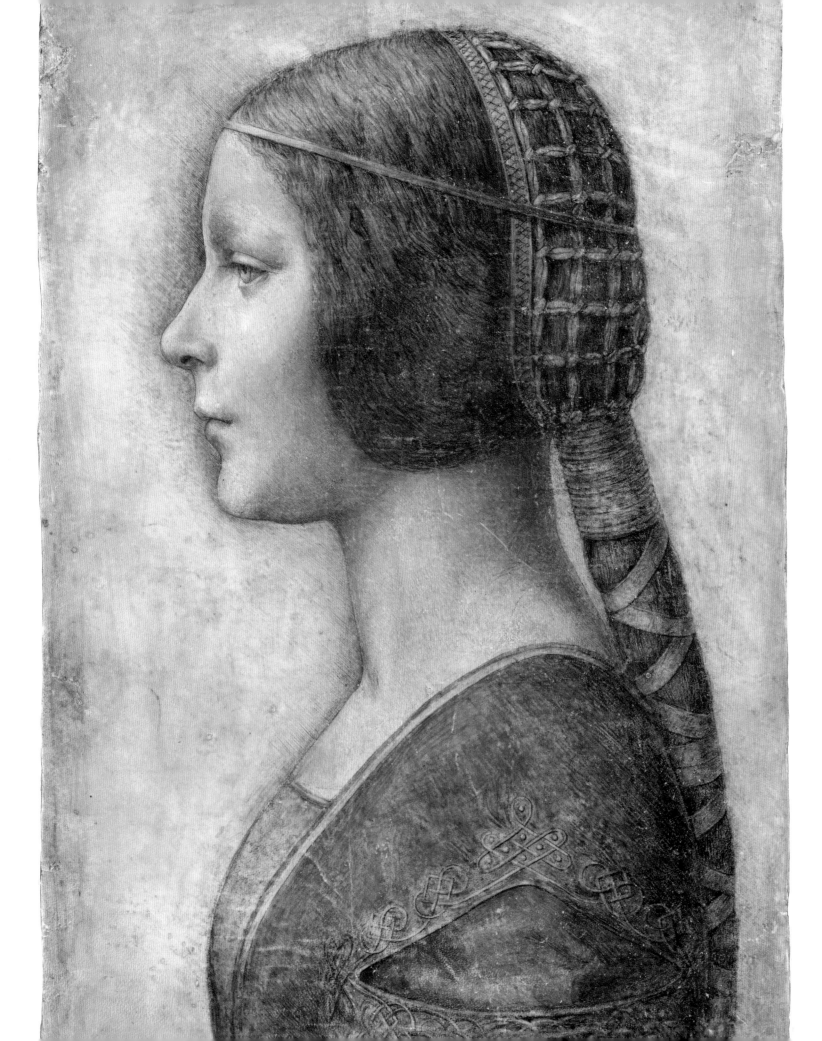

28. Portrait of Bianca Sforza ("La Bella Principessa")
1494, Private Collection

Sold at Christie's in 1998 as an imitation of a Renaissance work by a German nineteenth-century artist, this portrait has been controversially attributed to Leonardo. Scientific examinations, above all the identification of the white lead pigment as older than 225 years, have disproved claims that it was created in the nineteenth century or is a modern forgery.

Drawn on vellum (parchment) in ink and colored chalks, the portrait has been quite extensively restored. The technique is unusual, and Leonardo noted that he intended to consult Jean Perréal (c. 1460–1530), artist to the French king, about how to use "dry colors" on vellum. The portrait's origins lie in a book printed on parchment in honor of the wedding in 1494 of Bianca Sforza, Ludovico Sforza's illegitimate daughter, and Galeazzo Sanseverino, commander of the duke's army. The book, now in the National Library of Poland in Warsaw, recounts the life of Francesco Sforza, Ludovico's father. It contains an illuminated frontispiece alluding to the union of Bianca and Galeazzo, who are accompanied by rabbits that signal the bride's anticipated fertility. We can see where the portrait was excised from the book, to be transformed into an autonomous work of art, probably at the request of Izabela Czartoryska, Polish owner of the *Portrait of Cecilia Gallerani* (see page 48).

Bianca is portrayed in profile, as was the norm for aristocratic women in the North Italian courts, and her hair is dressed in what was the standard fashion in Milan: an elaborately bound *coazzone* (pigtail) emerging from a knotted *trenzato* (net). The convincingly characterized "engineering" of her headdress supports Leonardo's authorship, as do the very delicate, left-handed shading in pen and the tender delineation of her eyes and profile. For good measure, Leonardo's handprint technique is apparent in Bianca's neck. The interlace on her simple and modest dress is discernibly Leonardesque, although much restored.

Bianca was married at the age of fourteen but died within months. The portrait, in its precious volume, was transformed from a celebration of her marriage into a memorial of her early death.

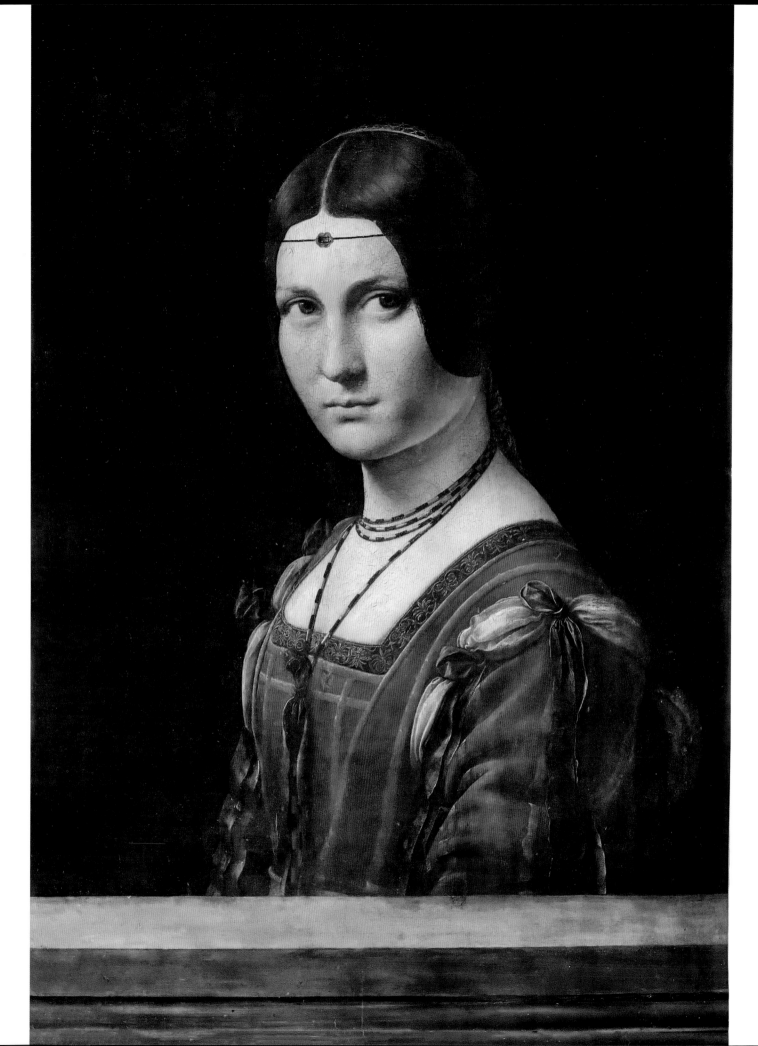

29. Portrait of Lucrezia Crivelli (?) ("La Belle Ferronière")

c. 1498, Paris, Louvre

Three poems recorded in Leonardo's notebooks in the form of Latin epigrams testify that Leonardo painted a portrait of Lucrezia Crivelli (c. 1452–1508), who became Ludovico Sforza's mistress after the death of his wife, Beatrice d'Este, in 1497. One of the poems reads,

> She whom we see is called Lucrezia, and to her the Gods
> Gave everything with generous hand.
> How rare her beauty; Leonardo painted her, Maurus loved her:
> The one, first among painters, the other, among princes.

The presentation of the sitter follows *Cecilia Gallerani* (see page 48) in exploiting the freedom of a nonprofile portrayal for a woman who was not an aristocrat. The sitter cannot at this date have been one of the Sforzas of Milan, the d'Estes of Ferrara, or the Gonzagas of Mantua. It is difficult to understand why there has been a reluctance to identify the painting in the Louvre with Lucrezia.

The locating of the lady behind a parapet, which grants her image the air of a sculpted bust that has been painted, may seem surprising, but this is a feature of Venetian portraits, and we may recall that Isabella in Mantua had sought to compare *Cecilia* with one or more examples of Bellini's mastery.

The features of Lucrezia's costume are characterized with compelling subtlety. We can linger on the nicely foreshortened jet and ivory beads of her necklace; the floral arabesques of her neckline; the soft puffs of white muslin that extrude between the knotted ribbons that secure her sleeves to her bodice; and the fugitive hints of the net cap and fashionable pigtail behind her head.

At first, Lucrezia seems less communicative than Cecilia. However, she is looking submissively at someone slightly to her left and more elevated than ourselves. That person can be none other than the Maurus referred to in the above poem—Ludovico Sforza, whose nickname was "il Moro" ("the Moor").

The traditional appellation "La Belle Ferronière" was inherited from a different painting in a seventeenth-century inventory of the French Royal Collection. It would be good if it fell out of use.

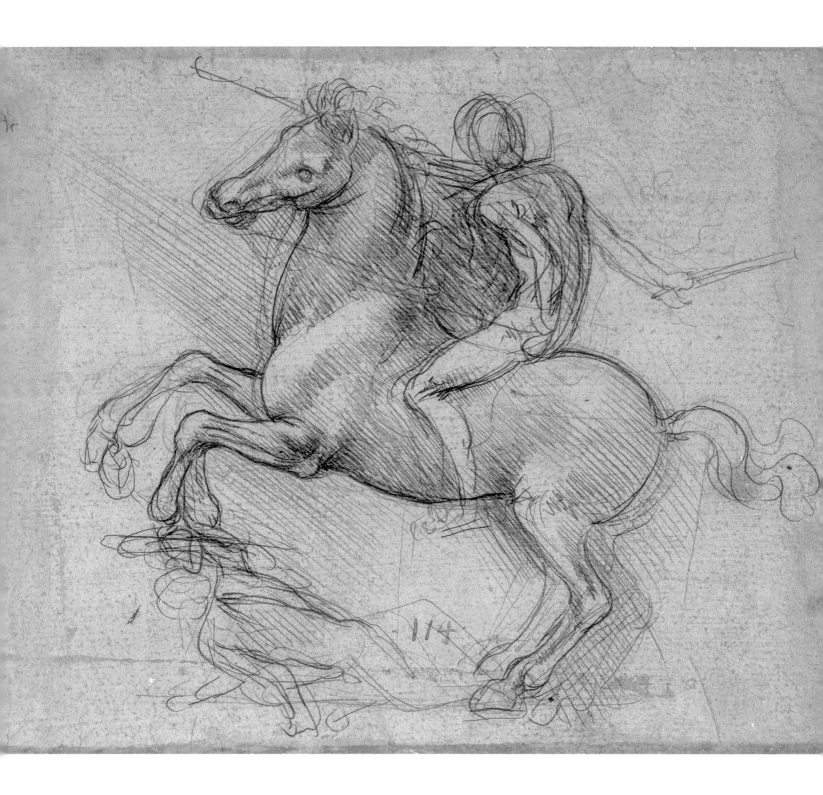

30. A Rider on a Horse Rearing over a Prostrate Enemy

C. 1490, WINDSOR, ROYAL LIBRARY, 12358R

31. Study of the Proportions of a Horse in the Stables of Galeazzo Sanseverino

C. 1493, WINDSOR, ROYAL LIBRARY, 12319

When Leonardo advertised his accomplishments as a military engineer in his introductory letter to Duke Ludovico Sforza (see page 33), he was aware of plans to create a great bronze equestrian memorial to Francesco Sforza, Ludovico's father: "Work could be undertaken on the bronze horse, which will be to the immortal glory and eternal honor . . . of the illustrious house of Sforza." He could also claim to have witnessed the making of the model by Verrocchio for the bronze equestrian memorial to the general Bartolomeo Colleoni in Venice.

Leonardo's engagement with the project probably occupied his intermittent attention during his time in Milan from 1482 to 1499. We know that in 1489, Ludovico was losing confidence in Leonardo's ability to undertake the mighty task. A year later Leonardo wrote that he had "restarted the horse."

The earliest drawings for the project indicate that he was considering a rearing horse. The drawing opposite, executed with incisive energy in metalpoint on blue paper, shows that he was considering placing a fallen warrior with a shield under the horse's front hooves to support the weight of the horse's forelegs, head, neck, and torso. The rider has seemingly been repositioned. He was originally pointing his baton forward, but later turns to gesture rearward, presumably to his following troops.

Later drawings show that Leonardo abandoned the idea of a rearing steed, which would have become impossible to cast as the scale of the projected monument grew in size. Fra Luca Pacioli (c. 1445–1517), Leonardo's mathematician friend, recorded that Leonardo was intending his horse to be 23 feet (7 meters) high. This was considerably larger than any Renaissance bronze and would have been one of the wonders of the world. The artist strove mightily to devise a workable plan to melt the mass of bronze, using multiple furnaces placed in such way as to permit the liquid metal to flow into the more remote parts of the mold. He debated whether to cast the horse upside down or on its side—and whether to cast it with or without its tail. The rider is rarely included in the drawings or discussions.

Leonardo devoted considerable effort to mastering the anatomy and proportions of horses. Two of the surviving drawings specifically record measurements taken from fine horses owned by Galeazzo Sanseverino, husband of Bianca Sforza. One shows a Sicilian horse, while the drawing opposite was made from "the large jennet [a compact Spanish horse] of Messer Galeazzo." The finely calibrated measurements are minutely recorded in units of one head and a sixteenth of a head, which is then broken down into sixteenths, with further subdivisions of sixteenths. Leonardo was looking to extract a kind of visual music from nature's design of an exemplary horse. None of his drawings of the proportions of the human figure exceed in detail those of Galeazzo's prized stallion.

In the second of the Madrid codices, he promised on May 17, 1491, that "here a record should be kept of everything related to the bronze horse, presently under construction."

By 1493, the clay model of the huge horse (without a rider?) was displayed in Milan Cathedral during the celebrations of the marriage of Bianca Maria Sforza to the emperor Maximilian, and it seems that the mold was subsequently made. The large quantity of bronze was set aside, and it looked as if the casting would be attempted. However, military matters intervened. The bronze was sent to Duke Ercole I d'Este in Ferrara for the casting of cannon in the face of the French invasion of Northern Italy. Things dragged on. Leonardo wrote resignedly to Ludovico that he "knows of the times." In 1499, the French, under King Louis XII, entered Milan. Leonardo recorded that "the duke lost the state, his property, and liberty."

The massive model was shot to pieces by invading Gascon archers. The failure of this greatest of artistic projects was to color his contemporaries' view of Leonardo's career.

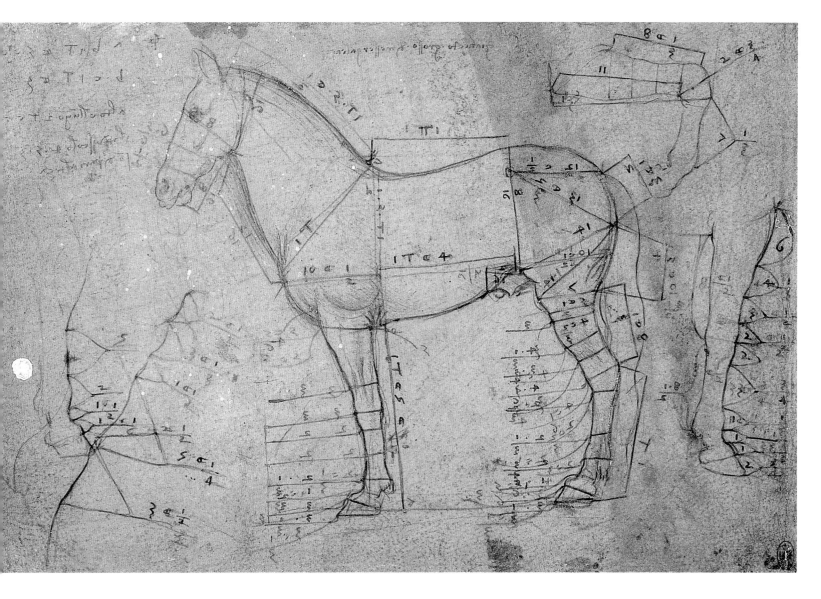

Study of the Proportions of a Horse in the Stables of Galeazzo Sanseverino, c. 1493.

"*Leonardo was looking to extract a kind of visual music from nature's design of an exemplary horse. None of his drawings of the proportions of the human figure exceed in detail those of Galeazzo's prized stallion.*"

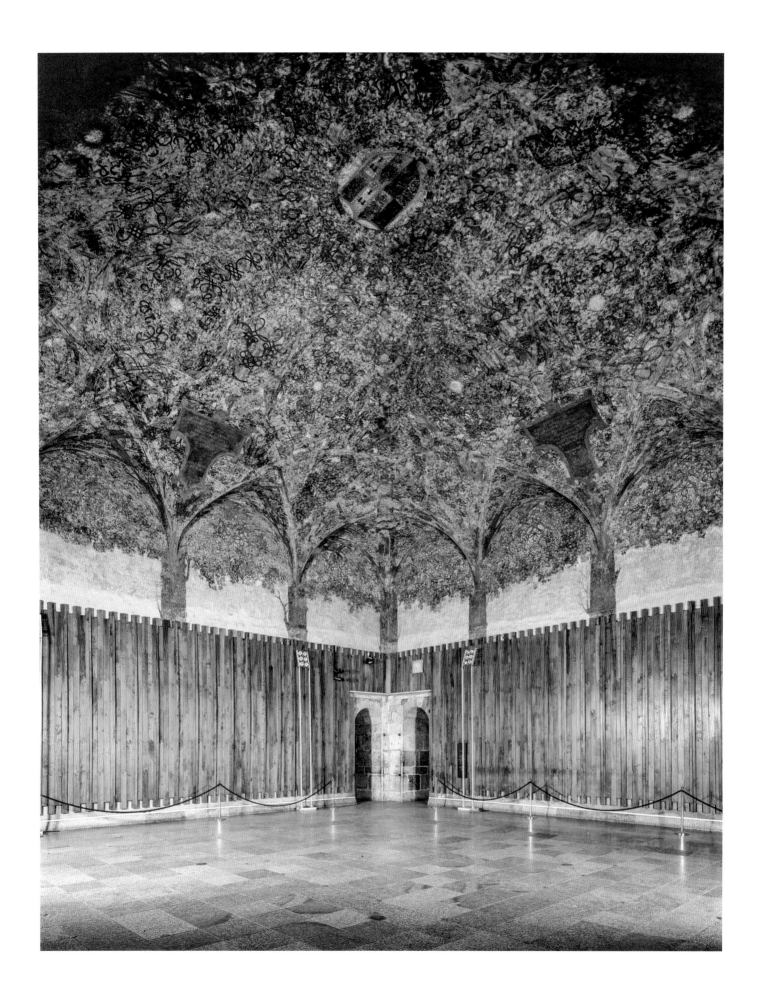

32. The Sala delle Asse (Room of the Boards)

1498, Milan, Sforza Castle

Interlaces of trees featured in vault decorations in North Italy before Leonardo, but none had approached his level of inventive and intellectual ambition. Leonardo's all-embracing scheme of wall and vault decorations was part of Ludovico's campaign late in the century to create appealing rooms in the northeastern corner of his rambling castle. We have letters from court officials in spring 1498 about work in the "large room of the boards." They express impatient hope that Leonardo will be finished by September.

The immersive scheme depicts roots of trees insinuating themselves into strata of rocks on the lower part of the sidewalls, with hints of landscapes and distant buildings on the land above. Trunks of eighteen trees emerge from the rocks; those in the middle and corners of the walls pass across the vaulted ceiling toward the round central oculus. Four trees are bent and "pruned" around the two windows, while the other ten ramify into the vaults. The branches intertwine as a complex bower with symmetrical interlaces of gold thread. The shield at the center combines the arms of Ludovico il Moro and his d'Este wife, Beatrice. Their conjugal union was symbolized by the interlocking of the mulberry trees (the mulberry is genus *Morus*, while "mulberry" in Italian is *moro*) and the gold interlace of the d'Este court. The four shields on the mid-axes of the walls record key events in Ludovico's rise to power from 1493 to 1496, with particular emphasis upon his allegiance to the Holy Roman Emperor, Maximilian.

Today we are faced with impressive ghosts of Leonardo's conception. The roots and strata survive only as underdrawings, while the trunks and branches were overpainted, later uncovered, and subjected to more than one radical campaign of restoration and repainting. A recent restoration has disclosed some lovely, vivacious leaves in some areas in the ceiling, of a quality to match those in the lunettes of *The Last Supper*. The original effect must have been breathtaking in its airy lightness, compelling naturalism, geometrical complexity, and imaginative brilliance.

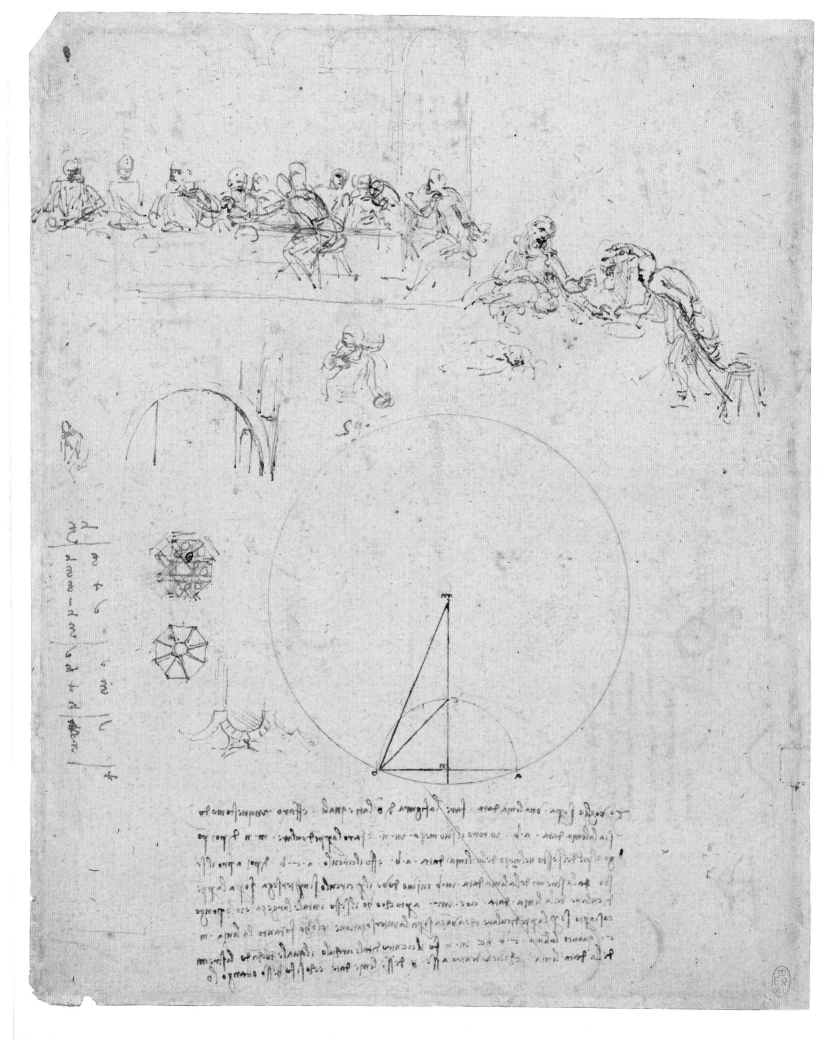

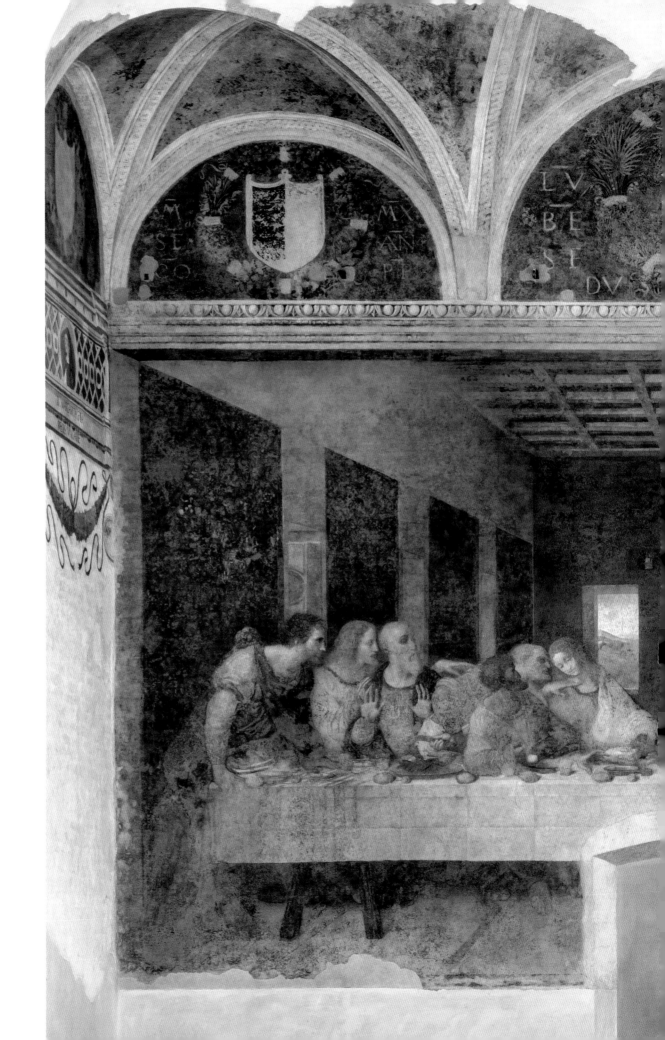

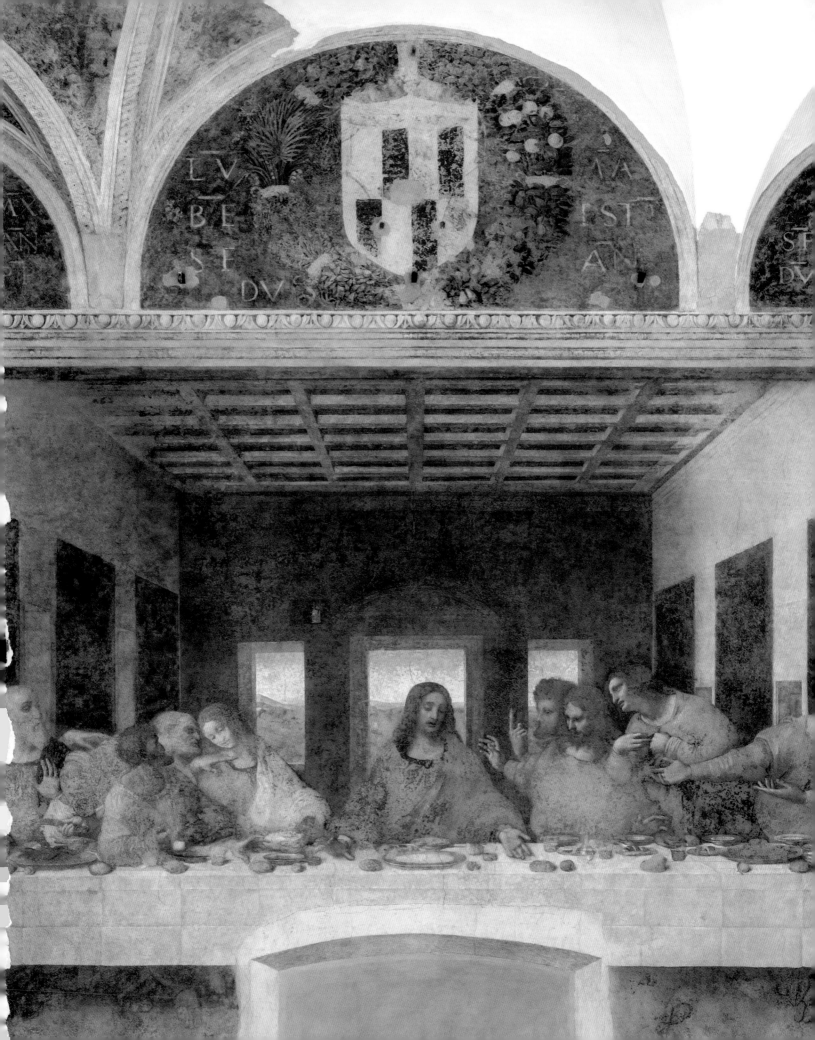

33. Studies for The Last Supper, Architecture, the Construction of an Octagon, and Two Columns of Numbers

c. 1496, Windsor, Royal Library, 12542

We do not know when Leonardo was told to paint a *Last Supper* on the end wall of the refectory in the monastery of Santa Maria delle Grazie in Milan. In June 1497, Ludovico Sforza wrote to Leonardo, expressing his hope that the work would soon be finished. In March of the following year, similar hopes were still being expressed by one of the duke's administrators.

The decoration of the refectory was part of a campaign by the duke to aggrandize the Dominican monastery, which was close to Sforza Castle. In 1495, Giovanni Donato da Montorfano (c. 1460–c. 1502) had painted a large fresco of the *Crucifixion* on the opposite wall in the refectory, to which the portraits of Ludovico, Beatrice, and their two sons were later added, probably under Leonardo's supervision. The great architect Donato Bramante (1444–1514) was adding a massive centralized crossing and dome to the rather old-fashioned church.

Few drawings for *The Last Supper* survive. These rapid sketches on a sheet at Windsor represent some of the artist's earliest thoughts. The study at the top left shows that he was planning to separate Judas from Christ and the disciples in a conventional manner, placing him on the near side of the table. To the right of this sketch, Leonardo considers the incident in which Judas rises to dip his bread into the same bowl as Christ, which serves to announce that it is Judas who will betray him. Such narrative fluidity in planning the standard subject is highly unusual for the time.

The large geometrical construction of an octagon from a given line using a circle, below the figure sketches, was the first drawing on the page. It probably reflects Leonardo's collaboration with Luca Pacioli and relates directly to the two small architectural sketches to the left, for a vault on an octagonal base. The two columns of numbers do not make obvious sense as a sum or sums, or as a proportional series. Might they be measurements? Similar sets of numbers are on the reverse of the page, together with some mechanical and architectural sketches.

"To the right . . . Leonardo considers the incident in which Judas rises to dip his bread into the same bowl as Christ, which serves to announce that it is Judas who will betray him. Such narrative fluidity in planning the standard subject is highly unusual for the time."

65

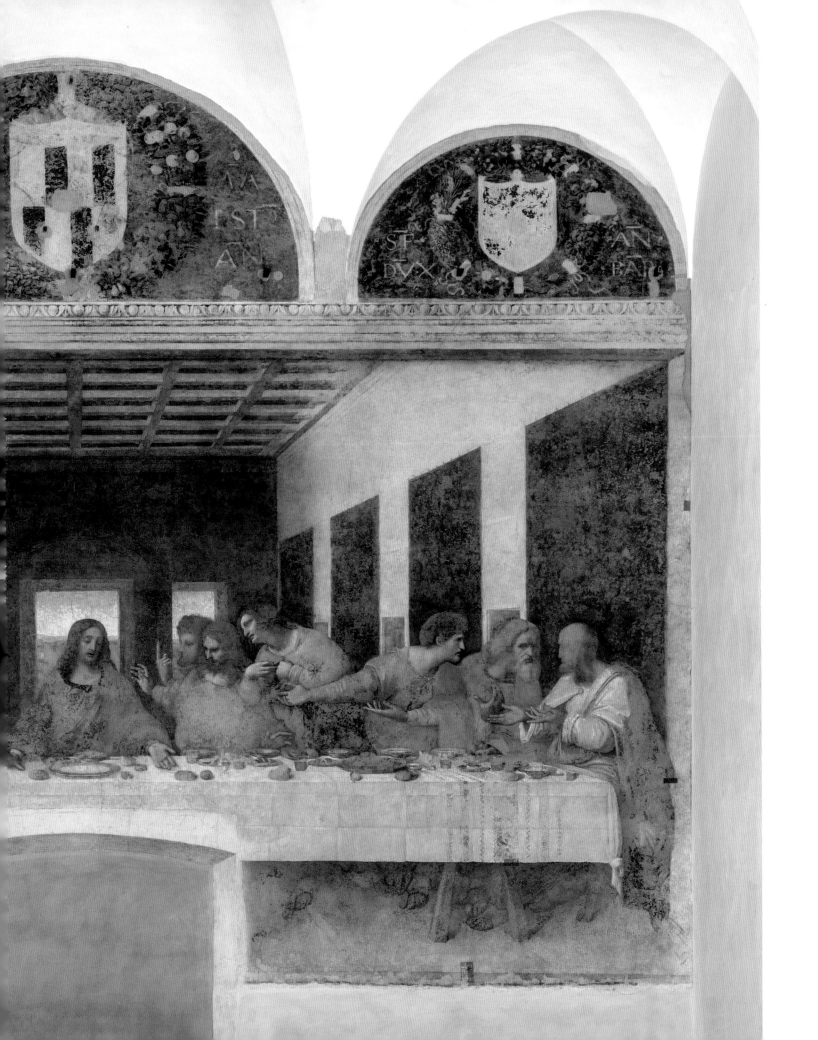

34. The Last Supper

C. 1495–97, MILAN, REFECTORY OF SANTA MARIA DELLE GRAZIE

35. Saints Thomas, James the Greater, Philip, Matthew, Thaddeus, and Simon (*detail from* The Last Supper)

36. Study for St. James the Greater and Designs of a Domed Corner Pavilion for a Castle

C. 1496, WINDSOR, ROYAL LIBRARY, 12552

37. Study for the Head of St. Bartholomew or Matthew

C. 1496, WINDSOR, ROYAL LIBRARY, 12548

Leonardo's majestic composition has been recognized as *the* definitive *Last Supper*, even though it had begun to deteriorate badly soon after its execution and became more widely known through drawn, painted, and engraved copies than via the original.

High on the wall, Leonardo has created a perspectival stage set for the profound drama. The geometric framework of the coffered ceiling and receding tapestries plunge into depth, perspectively converging on Christ at the calm focus of the spiritual turmoil. On either side, each of the disciples reacts with individualized shock to Christ's terrible pronouncement that one of their number will betray him. In the Gospel of St. Mark, this incident is followed by the institution of the Eucharist, in which Christ informs his followers that the bread is his body and the wine his blood. Leonardo signals both pronouncements, as a kind of extended moment.

We seem to be presented with an illusion of the "large upper room" described in Mark 14, in which the disciples and Christ met on the eve of Christ's arrest, but the space relates to that of the refectory in an ambiguous manner. The ideal viewpoint of the perspective construction is inaccessibly high above our heads. The coffered ceiling passes upward behind the screen of the three lunettes to an undetermined height, while the sidewalls cannot be continuous with those of the actual room if two disciples are to be seated at either end of the table. This ambiguity reduces the problem of the incongruous perspective of the painted space when it is viewed from a variety of positions in the refectory. We might also notice that there is not enough room for thirteen figures to be seated behind the table. Leonardo's mural is a compelling contrivance and is not pretending to be a piece of literal reportage.

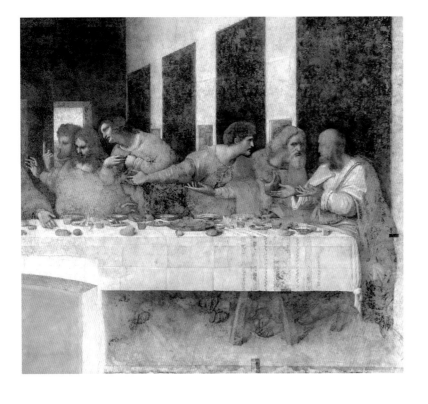

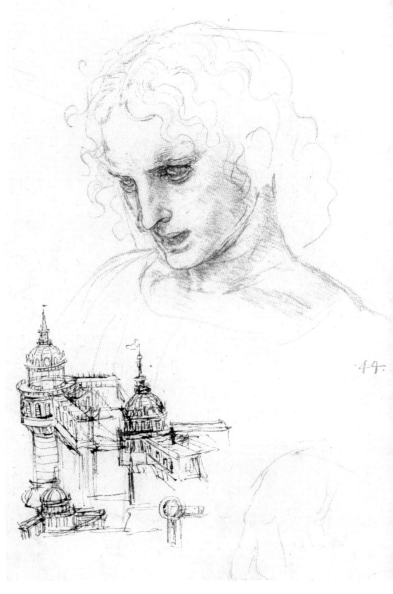

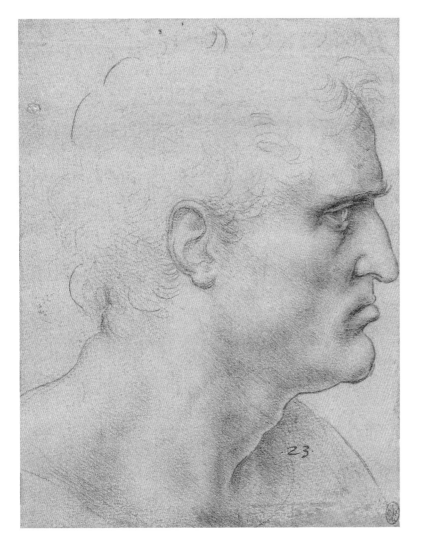

ABOVE LEFT *Saints Thomas, James the Greater, Philip, Matthew, Thaddeus, and Simon* (detail from *The Last Supper*).

ABOVE RIGHT *Study for St. James the Greater and Designs of a Domed Corner Pavilion for a Castle*, c. 1496.

LEFT *Study for the Head of St. Bartholomew or Matthew*, c. 1496.

In the years before painting *The Last Supper*, Leonardo was much engaged with the dynamic systems of human motion and emotion in which the nerves convey sensory information to the central clearinghouse of the mind, which then transmits the resulting impulses of motion to the face, limbs, and body. Every individual expresses his or her own *concetto dell'anima*, the intention or purpose of one's mind or soul, through a system of neurological plumbing that generates facial expressions, speech, and bodily actions. In *The Last Supper*, Leonardo has orchestrated the individualized reactions in groups of three in a brilliantly rhythmic manner.

Drawings for four of the disciples' heads survive. They show how Leonardo was striving for sharp characterization and vivid spontaneity of reaction, probably sketching from life. The red chalk drawing for St. James the Greater (opposite page, top right) captures the young saint's anxious terror. He starts back in revulsion at the thought of betrayal—"Is it I?" he asks—but inclines his head forward to see clearly Judas's hand closing in on the bread that will signal his companion's treachery. In the mural (see detail, opposite page, top left, second figure from the left) James's arms are thrown wide, as if in anticipation of the Crucifixion. Accounts of Leonardo at work record that he spent many hours contemplating his creation, working out exactly these kinds of profound resonances.

The ink drawings on the bottom left of the same page as the red chalk portrait of St. James the Greater show Leonardo's plans for what looks like a domed pavilion at the corner of a castle. Was this a feature planned for the suite of rooms in the *castello* that Ludovico was remodeling in the later 1490s, which was to include the Sala della Asse?

The deterioration of *The Last Supper* mural was recorded in the sixteenth century. The cause was Leonardo's experimental technique. The traditional medium for murals was fresco, in which successive areas of paint are applied to fresh patches of moist plaster, bonding securely as the layers dry. Fresco demanded fast-paced execution of preplanned designs. It was also limited to those pigments that were compatible with the fresco medium. Leonardo's contemplative pace of painting, his tendency to change his mind during the course of execution, and his personal way of handling light, shade, and color predisposed him to seek an alternative way of painting on a wall.

He decided on a technique that was close to that employed on wooden panels. He laid down an upper layer of fine plaster, on top of which he added a surface of white lead. Once this had dried, he painted in vivid colors, using egg as a binder. The original effect must have been sensational, but over the longer term, adhesion broke down between Leonardo's layers of paint and priming on a wall that was subject to Milanese dampness.

Successive restorations over the centuries strove to rescue Leonardo's visionary image, often involving much repainting. The most recent conservation effort, conducted over long years from 1977 to 1999, aspired to strip off all the added paint, leaving bright fragments of the artist's original paint layers floating in softly tinted zones of added color that lend some overall coherence to the composition. Some remarkable effects emerged: the wonderfully succinct still life on the table; the embroidery and crisp folds of the tablecloth; the hooks from which the floral tapestries hang; and the facial expressions of those disciples' heads that are least damaged.

We can supplement what is visible with the few drawings, such as that for St. James the Greater, and the wonderfully characterized profile study in red chalk on red paper (opposite page, bottom left), which is for St. Bartholomew at the extreme left of the mural or, less probably, for St. Matthew, third from the right.

That the mural should have survived at all is remarkable. In 1943, during an Anglo-American air raid, an incendiary bomb exploded nearby, demolishing the vault of the refectory and one sidewall. *The Last Supper*, protected by planks, sandbags, and scaffolding, somehow remained reasonably intact, as did the three lunettes, decorated with brilliantly naturalistic floral wreaths, surrounding the heraldic shields of Ludovico and Beatrice and their firstborn son, Massimiliano.

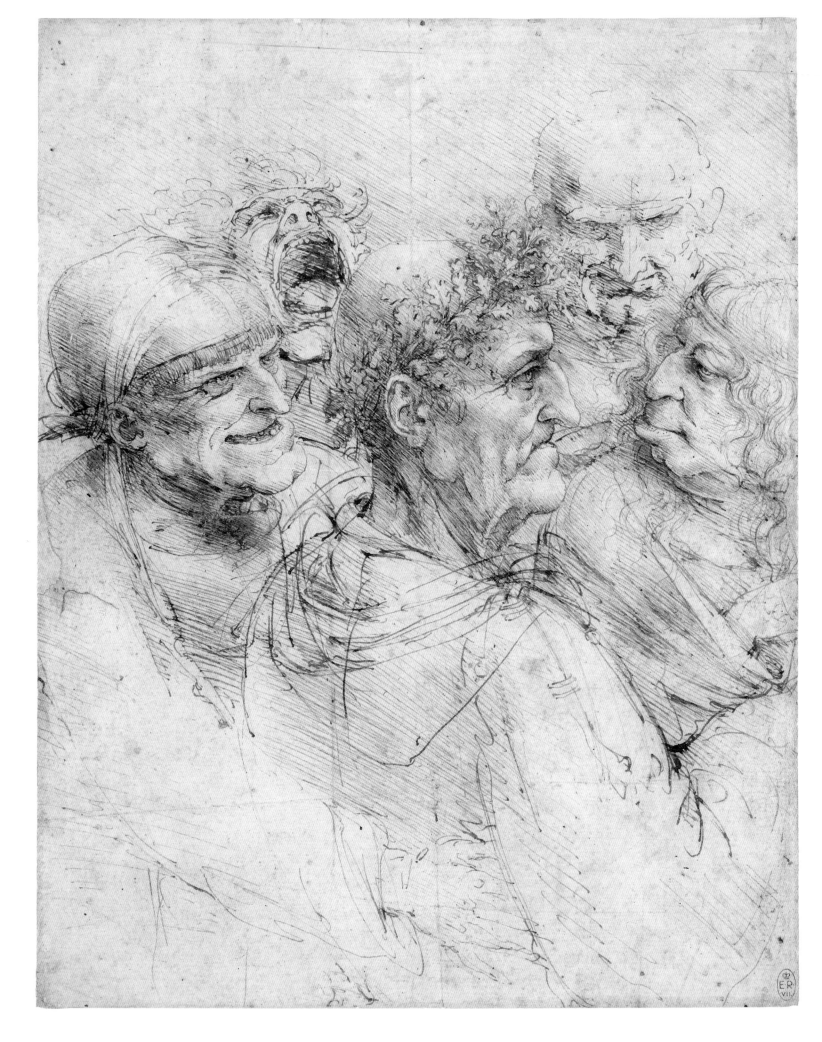

38. Four Grotesque Characters Mocking an Old Man

c. 1495, Windsor, Royal Library, 12495r

As a teller of painted stories, Leonardo was fascinated by the use of faces to convey appropriate characters and emotions. There were two factors involved: the fixed features or "signs" of the face; and the passing expressions that convey someone's reaction to particular events. The fixed "signs" were the subject of the classical and medieval science of physiognomy, which typically drew parallels between human faces and those of animals (see also pages 13 and 113). Although Leonardo did not apply the formulas of physiognomics in a dogmatic manner, he was convinced that the workings of our minds could be reliably read from the combination of fixed and mobile features.

In tandem with his desire to capture the harmonic proportions of beautiful faces, Leonardo also made very extensive studies of physiognomies that departed radically from the norm. Quick pen sketches of grotesque heads of men and women, many elderly, proliferate erratically across his drawings and notebooks. Sometimes they are little more than impetuous scribbles; at other times they are closely observed, often pairing a man who exhibits bizarre features with a female counterpart. Leonardo recommended that the artist carry a small notebook to record extravagantly unusual characters. His grotesques were once very popular and were in tune with burlesque humor in Renaissance literature.

The drawing here is unusual in that it combines five elaborately characterized men in a way that implies a narrative. The central man, portrayed in Roman profile like an emperor on a coin, is crowned with a wreath of oak. He adopts a bemused air of dignity, like a king of fools, while his companions mock him in a variety of ugly ways. There is a drawing at Windsor in which an aged and pug-faced crone, accompanied by a grinning man, is reaching leftward, just as the central man here is reaching out to the right. Was Leonardo planning to unite them in a grotesquely improbable marriage? He once wrote rather unpleasantly that "there is no woman so ugly that she does not find a lover, unless she is monstrous."

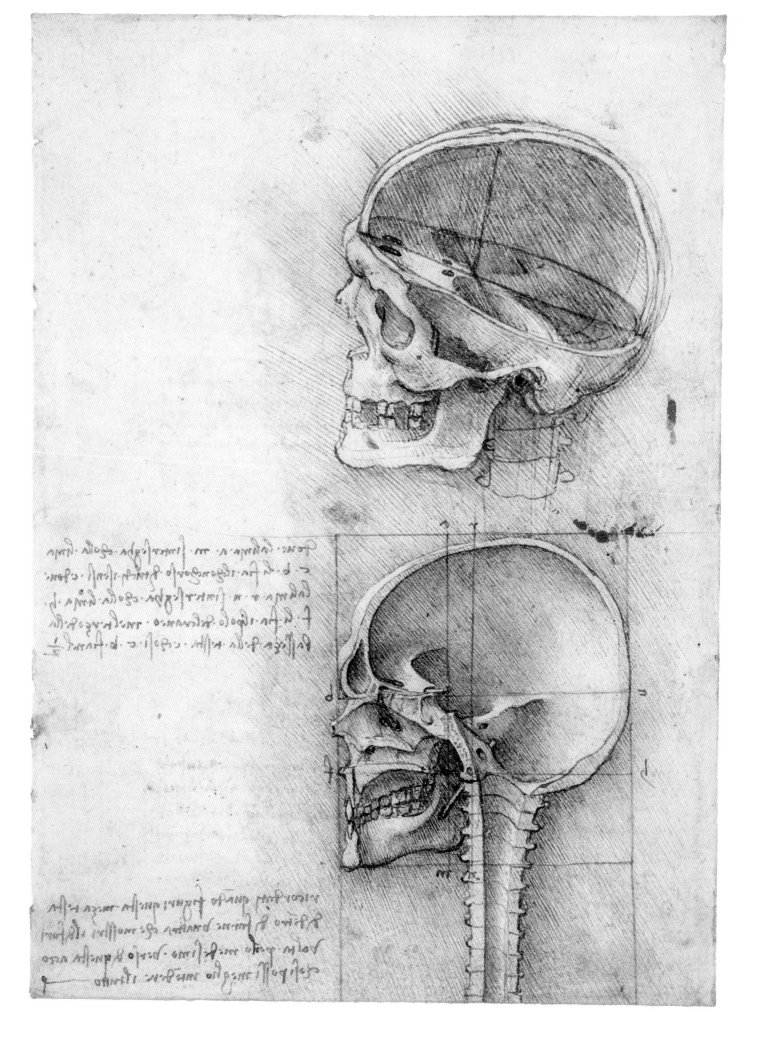

39. Two Human Skulls, Sectioned, with Proportional Analyses

1489, WINDSOR, ROYAL LIBRARY, 19057R

A set of eight skull studies on five pages at Windsor comprise the most coherent and purposeful of Leonardo's early anatomical illustrations. One of them is dated 1489. It cannot be doubted that the drawings are based upon one or more actual skulls that Leonardo had sawn through and to which he added a schematic vertebral column. The bony structures are recorded with nuanced subtlety in parallel shading with a fine pen and brown ink.

The sectioning technique he employed in the studies is very remarkable, presenting an unprecedented view of exterior and interior morphology of the cranium and jaw. No one had yet demonstrated the frontal sinus in this way. The studies are not, however, straight exercises in descriptive anatomy, but are concerned with the divine "architecture" of the cranium and its relationship to the mental functions within.

In the upper drawing the artist was exploring the central "pole" of the cranium and its conjunction with the horizontal axis that runs diametrically across its equator. The proportional analysis exhibits a strong affinity with the system of geometry that underlies his architectural studies of centralized "temples" (see pages 86–87). We are invited to admire the "dome" of the skull as created by God, the supreme *artifex* (maker or designer) of all things in nature.

In the lower drawing Leonardo turned in more detail to the proportional music of the cranium. He wrote in the upper note that "where the line *am* is intersected by the line *cb*, there is the confluence of all the senses, and where the line *rm* is intersected by the line *hf*, there the pole of the cranium is located, at one-third of the base of the head, and so *cb* is one half."

At the bottom of the page he added one of his characteristic notes of instruction: "remember when you represent this half head from inside make another shown from the outside oriented in the same direction as this one so that you may be better able to comprehend the whole."

"The sectioning technique he employed in the studies is very remarkable, presenting an unprecedented view of exterior and interior morphology of the cranium and jaw. No one had yet demonstrated the frontal sinus in this way."

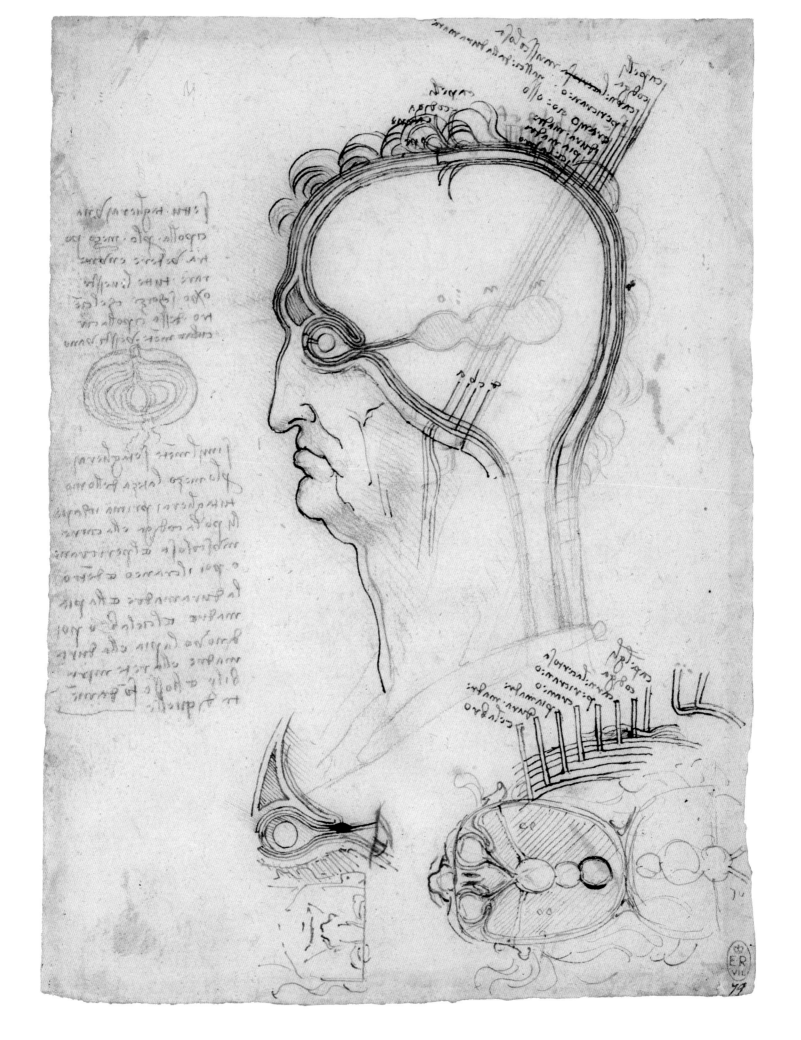

40. Vertical and Horizontal Sections of a Human Head with a Vertical Section of an Eye and a Vertical Section of an Onion

c. 1489, Windsor, Royal Library, 12603r

At first sight, this highly schematic demonstration of the brain, eye, and cranial nerves in pen and red chalk seems to have little to do with the observational accuracy of the 1489 skull studies on page 72. However, Leonardo's efforts to understand the internal functioning of the brain and senses are at one with his search for the structure and proportions of its protective container. On one of the skull studies (see page 72), he noted that the "confluence of all the senses" lies at the intersection of two of the key axes in the cranium.

His conception of the brain reworked traditional ideas, most notably that the ventricles or cavities were taken as the sites of mental activity. Without modern microscopy, the "gray matter" seemed unpromising and was thought to be no more than protection for the ventricles. The three ventricles were each assigned localized functions in the traditional manner. Leonardo's preferred arrangement identified the first as the "receptor of impressions," which took in data from all the senses. In the second ventricle was the *senso comune* (the "collective sense"), where information from all the senses was correlated, in company with the key faculties of imagination, intellect, and voluntary and involuntary motion. At the end of the system, the third ventricle acted as a flask to store memories. The soul, which was served by all the faculties, resided at the center of this neurological kingdom.

The horizontal section of brain at bottom right, in which a sectioned head is hinged open, shows the convergence of sight and hearing. Sight, as the "noblest sense," operates though the geometrical instrument of the eye, acting as the "window of the soul" via a short optic channel. The round "crystalline humor" at the center of the eye is again traditional, and there was no sense at this time of the lens as a focusing device. Leonardo later injected the ventricles with wax and demonstrated their actual shapes (see pages 168–69).

To help us visualize the eight protective layers (including the hair) that surround the brain, he ingeniously provided a sketch of a sectioned onion.

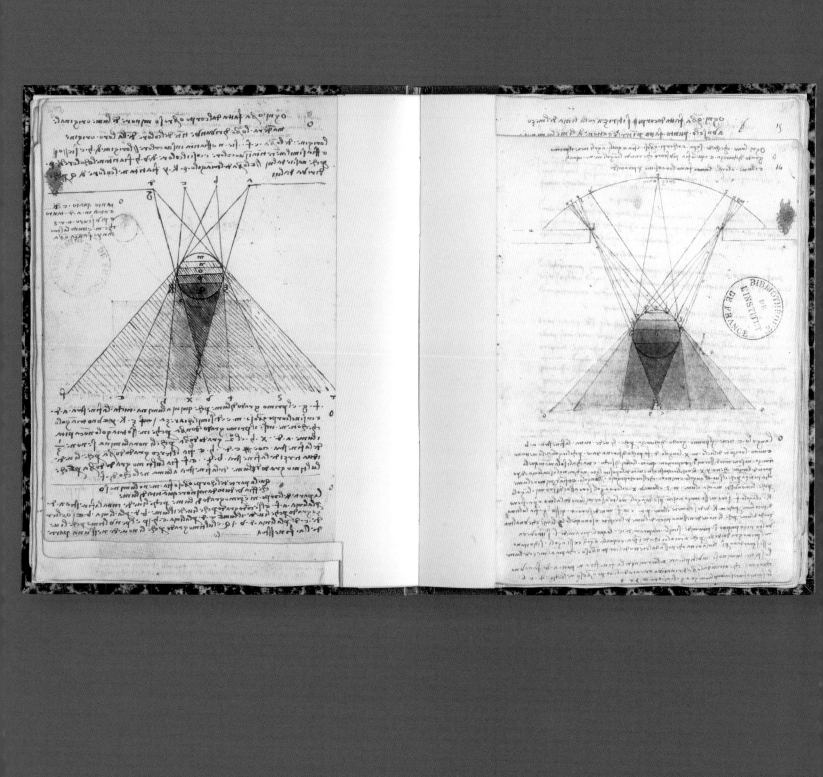

41. Studies of Light and Shade on Spheres

c. 1490, Paris, Bibliothèque de l'Institut de France,
MS Ashburnham II 13v

Florentine painters had pioneered the use of linear perspective to construct geometrical spaces, and they had developed systematic ways of describing light, shade, and cast shadows. Leonardo was the first to subject shadow to optical analysis.

In the illustrated example, he studies a sphere illuminated from a window. For the sake of his analysis, he takes four equidistant points across the aperture. The upper sector, designated *m*, will be brightest since it receives the impact of light from *a*, *b*, *c*, and *d*. Band *n* will "be seen" (as Leonardo put it) fully from *b* and *c* but incompletely from *a* and *d*. And so on, until *q* at the base of the sphere will receive no direct light. The shadows cast behind the sphere are graded in a corresponding manner, with a conical umbra and three degrees of penumbra. Leonardo knew, of course, that the actual effects were continuously graded, not banded, but he was demonstrating that proportional laws govern the intensity of illumination on different parts of an object, together with its "primary shadows" and its "secondary shadows."

Shadows, he wrote, are "in the nature of universal things, which are more powerful at their origins and grow weaker towards the end." In a notable act of lateral thinking, he compared the conical shadow to an "oak tree that is more powerful at the point of its emergence from the ground; that is to say, where it is thickest."

The overarching rule is Leonardo's pyramidal law, which determines that a dynamic motion diminishes in proportion to the distance from its origin. Thus, if a thrown ball will travel 10 yards (9 meters), when it has traveled 5 yards (4.5 meters) its speed will have diminished by half. Perspective works like this. Something that is 5 yards away will look twice as big as the same thing 10 yards away. Gravity also acts pyramidally, albeit in reverse, in that a falling body will gain proportional increments of speed.

42. Studies of the Angular Impacts of Light on a Man's Profile and Three Illuminated Spheres

c. 1490, Windsor, Royal Library, 12604r

Leonardo is here proposing a rule for the intensity of light on an irregular body illuminated from a point source of light. A complex form like the human head presents a variety of planes to the impinging light. As always, Leonardo sought to apply mathematics to phenomena in the natural world.

He considered that light acts as a material force, striking or "percussing" any form that it strikes—much like a thrown ball or a sword striking a direct or glancing blow on a surface. The percussion will be most powerful when the light impacts perpendicularly, as at g (located at the depression on the man's forehead). The points f and h (above and below g) will also exhibit something close to maximum illumination. It looks as if e (above f) will subtend at about a 45-degree angle to the surface, and the illumination on the surface there will therefore be about half that at f. As the angle diminishes, the impact of the light reduces proportionately.

He formulated the rule that "where the angles made by the line of incidence are most equal [i.e., 90 degrees] there will be greater light, and where they are most unequal [i.e. oblique] it will be darkest." Leonardo was in effect proposing a system of ray tracing, akin to that used in computer rendering of light on surfaces. The difference is that modern ray tracing uses a cosine law named after Johann Heinrich Lambert, the eighteenth-century Swiss-German mathematician. Leonardo's intuition that the solution was geometrical was justified. This is not to say that he expected any painter to conduct actual calculations in painting a head, but that the grading of light on a face should be informed by an awareness of the rule, given a specific light source.

The smaller diagram to the left shows that if three spheres are illuminated from a square window, the angle of their shadows traced back to the window will converge on the point n at the center of the window.

DVODECEDRON ABSCI
SVS SOLIDVS

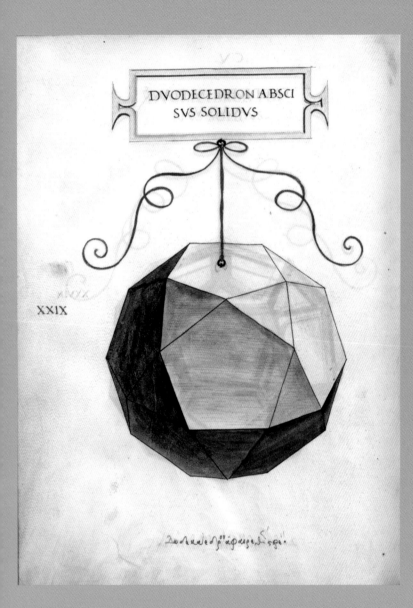

DVODECEDRON ABSCI
SVS VACVVS

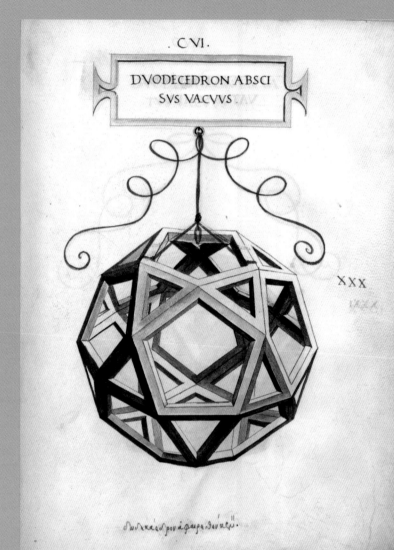

XXIX

XXX

43. A Truncated and Fenestrated Dodecahedron (Icosidodecahedron) from Luca Pacioli, *De divina proportione*
1496, Milan, Biblioteca Ambrosiana

Among the luminaries brought to the Milanese court was the mathematician Luca Pacioli, who in 1494 had published his important encyclopedia, *Summa de arithmetica, geometria, proportioni et proportionalita* (*Compendium of Arithmetic, Geometry, Proportions, and Proportionality*). Within two years he had joined the court and established a close rapport with Leonardo, who benefited from Luca's knowledge of mathematical texts, particularly Euclid's *Elements*. In 1498, Leonardo illustrated his friend's treatise, *De divina proportione* (*On Divine Proportion*), printed in 1509, which centered on the five regular or "Platonic" solids.

We need some mathematics to understand Leonardo's illustrations. The five regular bodies are the only ones whose faces are composed from identical polygons: 4 triangles for the tetrahedron, 6 squares for the cube, 8 triangles for the octahedron, 12 pentagons for the dodecahedron, and 20 triangles for the icosahedron. They were exalted by Plato as the fundamental building blocks of the universe. For Leonardo they were the highest exemplars of the mathematical perfection that underlies the design of nature.

Pacioli's treatise related the construction of the solids to the divine or mean proportion, later known as the "golden section" (which results from a line's being divided unequally in such a way that the ratio of the longer part to the shorter part is the same as that of the whole to the longer part). Pacioli explored what happens when the solids are truncated (cut symmetrically at their corners), transforming them into semiregular bodies. Additionally, he stellated both types, constructing symmetrical, pointed figures on their faces.

The solids had been represented before, but Leonardo devised a more "concrete" way of visualizing them. They are portrayed on vellum in pen, ink, and wash as material objects, hanging in space and modeled systematically in light and shade. Each is also portrayed in its "fenestrated" form so that we can view its full spatial array.

The illustrated example shows a solid and a hollow dodecahedron (icosidodecahedron) that have been truncated to create semiregular bodies, composed of pentagons and equilateral triangles. The illustrations in *De divina proportione* were very influential, not least on the great German astronomer Johannes Kepler (1571–1630).

1	2	3	4	5	6	7	8	9	10
2	4	6	8	10	12	14	16	18	20
3	6	9	12	15	18	21	24	27	30
4	8	12	16	20	24	28	32	36	40
5	10	15	20	25	30	35	40	45	50
6	12	18	24	30	36	42	48	54	60
7	14	21	28	35	42	49	56	63	70
8	16	24	32	40	48	56	64	72	80
9	18	27	36	45	54	63	72	81	90
10	20	30	40	50	60	70	80	90	100

44. Number Square, with Figures in Motion and Other Studies

C. 1501, LONDON, BRITISH LIBRARY, CODEX ARUNDEL, 153R

Leonardo stated that geometry deals with "continuous quantities"—lines and surfaces that could be artificially divided but run continuously. On the other hand, arithmetic deals with "discontinuous quantities"—separate numbers that progress step by discrete step. On the whole he preferred the former, since they related to space and form in nature. He particularly valued geometrical proportions that could not be reduced to numbers, such as $\sqrt{2}$, which is the diagonal of a square with sides one unit long.

Arithmetical proportions were crucial to Leonardo in one respect. They served as the foundations of harmony in music in the system established by the sixth-century BCE Greek philosopher Pythagoras. As a performer on the *lira da braccio* (a Renaissance string instrument), Leonardo would have been well versed in the basics of music, and he would have been able to draw upon the wisdom of his colleague Franchino Gaffurio (1451–1522) in Milan, who was the foremost theorist of music in Italy.

Leonardo's collaboration with Luca Pacioli after 1496 extended his understanding of mathematical proportions. He recorded that he had purchased Luca's *Summa de arithmetica, geometria, proportioni et proportionalita* (see page 81), which treated the mathematics of proportions in some detail.

Leonardo twice transcribed a 10 × 10 number square from Pacioli's book, clearly attracted by its unalterable sets of sequences and multiples. In the page shown here from the Codex Arundel, he has with minute care transcribed the 100 numbers in left-to-right script and begun to note the names of the multiples: "double / triple / quadruple / quintuple." He then broke off, probably because it was becoming too crowded. In the number square in Codex Madrid II (1503–5) he started his listing down the left side of the square, but again stopped at "quintuple."

Just below the square here he wrote in tiny script a variation of his recurrent refrain of frustration: "tell me if ever anything was done." This appears across his manuscripts in a number of variant and abbreviated forms, often triggered by the mysteries of math and its endless sets of conundrums.

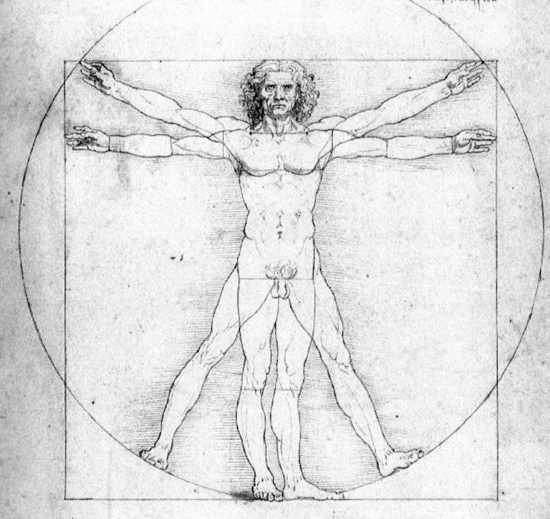

45. "Vitruvian Man"

c. 1497, Venice, Gallerie dell'Accademia

In a note at the top of "*Vitruvian Man*"—the world's most famous drawing—Leonardo tells us that the work is based on a statement by the first-century Roman architect Marcus Vitruvius Pollio. In his treatise *De architectura*, Vitrurius wrote that "if a man lies on his back with hands and feet outspread, and the center of a circle is placed on his navel, his figure and toes will be touched by the circumference. Also . . . a square can be discovered as described by the figure. For if we measure from the sole of the foot to the top of the head, and apply the measure to the outstretched hands, the breadth will be found equal to the height."

Earlier illustrators assumed that the circle and square should both be centered on the navel. The only convincing way to make the formula work is to assume that the square is centered on the man's genitals. Leonardo additionally wrote, "If you open your legs so much as to decrease your height by $1/14$ and spread and raise your arms so that your middle finger is on a level with the top of your head, you must know that the navel will be the center of a circle of which the outspread limbs touch the circumference; and the space between the legs will form an equilateral triangle." Leonardo's positioning of the fingers and toes is the only arrangement that works with the main circle.

The overall schema is *geometrical*, but the internal proportions are *numerical*. For example, "the face from the chin to the top of the forehead and the roots of the hair is a tenth part [of the body]; also the palm of the hand from the wrist to the top of the middle finger is as much; the head from the chin to the crown, an eighth part." The many compass marks show that the internal music of the body is composed from measured intervals, not the pentagons or other geometrical figures that are often imposed on the image.

"Leonardo's positioning of the fingers and toes is the only arrangement that works with the main circle. . . . The many compass marks show that the internal music of the body is composed from measured intervals."

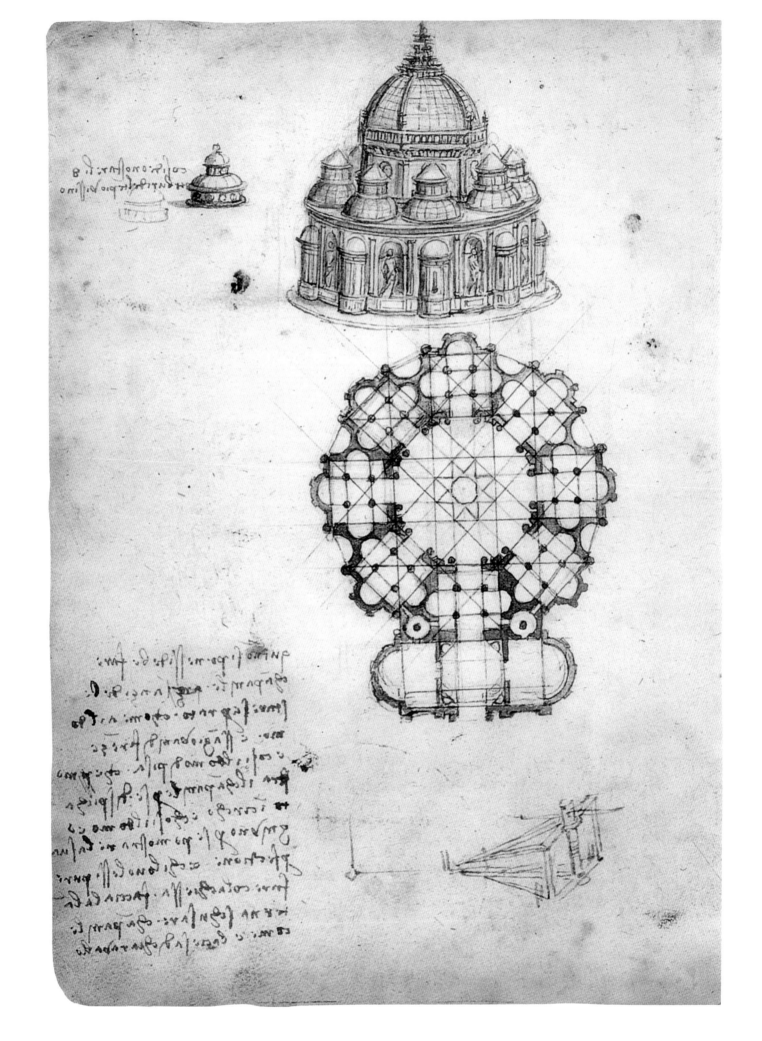

46. Centralized Temple, Design for a Small Dome, and a Lifting Machine (?)

c. 1488, Bibliothèque de l'Institut de France, MS Ashburnham I 5v

Using a series of simple geometrical units, Leonardo worked inexhaustible variations on centralized "temples" (as he called them). The centralized form was beloved of Renaissance theorists and designers, but it was less well regarded by the commissioners of actual buildings, since it was not readily adapted to the functional demands of church rituals. The impression is that Leonardo's "temples" would have been the size of baptisteries rather than cathedrals.

His careful demonstration of the multiple symmetries of the plan is combined with a perspectival view of the exterior as a solid form in space. This was a novel way of presenting the plastic form of architecture. In other drawings, he sectioned the "temples," much as he did the human skull. When he wrote to the authorities of Milan Cathedral to present his model for a domed crossing tower, he specifically drew an analogy between a building and the human body.

The compact, modular design consists of a central octagon surrounded by eight cruciform spaces, each like a miniature temple in its own right. The geometrical units cluster symmetrically on the exterior, interrupted only by the necessary atrium at the entrance. At the top left Leonardo illustrated an alternative for the small domes, adding oculus windows to admit more light. The ribbed central dome is notably like that built earlier at Florence Cathedral by Filippo Brunelleschi.

In the note to the lower left, Leonardo expressed his hope of avoiding an attached bell tower, which would violate his cherished symmetry: "Here a campanile neither can nor should be made. Rather they should stand separately. . . . If you nevertheless want it to be with the church, make the lantern serve as the campanile."

Although Leonardo himself did not construct such a church, his manner of visualizing its form in space and his modular way of combining geometrical shapes had a massive impact, particularly on Donato Bramante, his colleague in Milan, who was later to embark on the construction of St. Peter's in the Vatican.

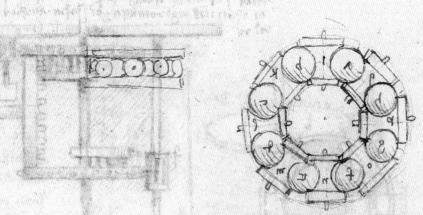

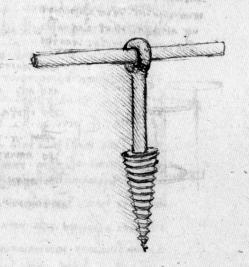

47. Design for a Roller Bearing, Pinions Turned by a Wheel, and a Conical Screw with a Shaft and Rod

c. 1499, Madrid, Biblioteca Nacional de España, Codex Madrid, I 20v

Leonardo was well versed in the extensive achievements of his fellow engineers and their predecessors. In Florence he could draw on the tradition of Filippo Brunelleschi, the builder of the dome of Florence Cathedral. Leonardo expanded on the study of engineering in a number of ways, not least in his depiction of the "elements of machines" as discrete components that could function in a wide variety of devices. Other engineers designed and drew complete machines as functioning entities. There is a series of such "elements" in the first of the Madrid Codices.

Friction and wear were major problems in load-bearing machines, particularly those constructed in wood and lacking effective lubricants. The design on the top right of the opposite page is for a new kind of bearing that uses balls. A series of balls could be placed in a ring to facilitate rotary motion, but the rear of one rolling ball would rotate in the opposite direction to the front of the one that follows. Leonardo devised concave reels as separators for the balls. Through each reel runs an axle attached to rotating wheels on the outside and inside of the ring.

He explained in the accompanying note that he was using "wooden balls in place of rollers to move a weight. . . . The wheels with their axles . . . keep the wheels in order, so that they perform their rotating function and cannot escape." The three moving elements—the wheels with their axles, the concave reels, and the round balls—act entirely in concert with the minimum of friction. Like most great designs, it looks obvious once it is conceived.

The drawing on the left examines the related problem of the direction of rotation of four pinions driven by a large-toothed wheel. In the note on the right of the page, Leonardo argued that "the pinions that are found engaging one of the semicircles of the wheel that moves them will turn in a contrary direction to that which occurs with the pinions turned by the other semicircle." On either side of the vertical axis of the device he wrote "semicircle." At the bottom right he illustrated a compact conical screw of unknown size, resembling a gimlet or auger that is rotated by a horizontal bar.

RIGHT Contemporary wooden model of Leonardo's *Design for a Roller Bearing.*

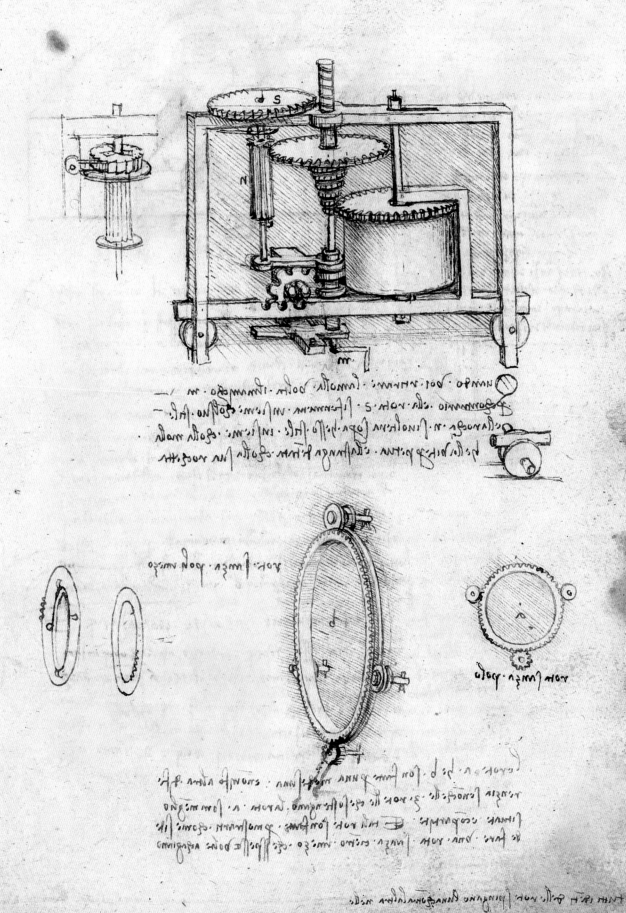

14

48. Gearing for a Clockwork Mechanism and Wheels without Axles

c. 1499, Madrid, Biblioteca Nacional de España, Codex Madrid, I 14r

In the age before the pendulum, it was difficult to measure small increments of time in a regular manner. None of the sources of power to drive a clock—including hanging weights and springs—delivered power entirely consistently over time.

Leonardo was much attracted to the potential of barrel springs, since they offered compact sources of power. The problem was that a wound-up spring delivered a lot of power at the beginning, and progressively less as it wound down. Various devices had been invented to counteract the problem. Leonardo's favored solutions were pyramidal and spiral gears. These were designed according to his pyramidal theory of the diminution of power, which applied to all dynamic systems in which motion gradually slowed to a complete halt (see page 77). Thus he looked to gears that compensated mathematically, in effect negating the pyramidal decline. Other engineers were not using mathematics in the context of the theory of dynamics.

In this wonderfully precise pen drawing of a mechanism for translating the power of a barrel spring into a steady rotational motion, the teeth of the gear wheel at the top of the barrel engage with progressively wider whorls in a pyramidal gear to compensate proportionally for the winding down of power. To accommodate the changing lateral position of the shaft, a worm gear at its base turns a vertical gear wheel that transports the platform supporting the shaft away from the spring. The wheel at the top of the pyramidal gear turns a vertical shaft and a large upper wheel with what is intended to be a steady degree of power.

The other studies at the bottom of the page show wheels in the form of rings without central axles. They are supported by their small pinion wheels, either three or four in number. Leonardo wrote that he did not see "any difference between them, other than that the three pinions that support the wheel *a* [on the far right] are better located and separated." He noted that it is often necessary to use a wheel that has no axle.

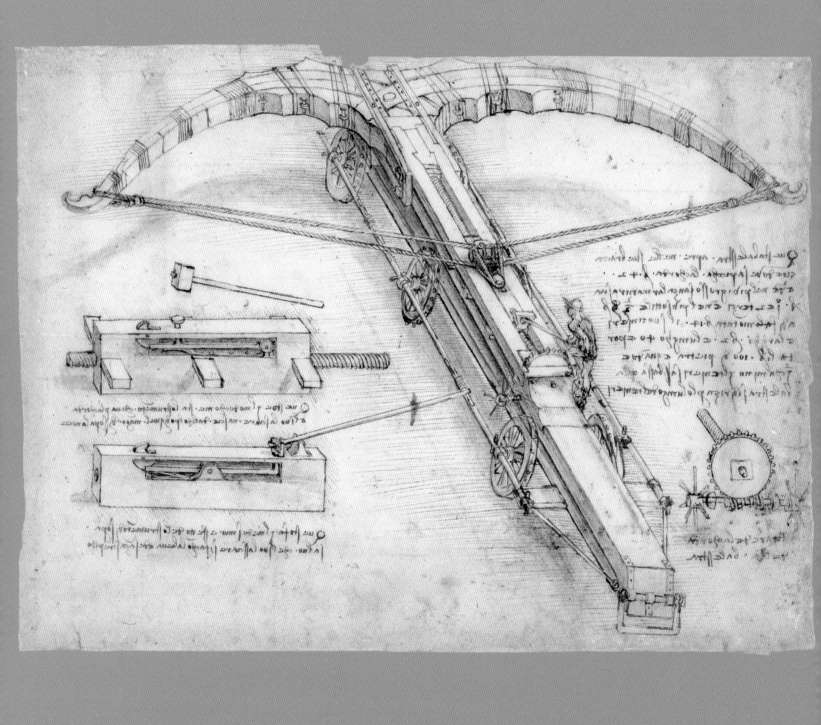

49. Designs for a Giant Crossbow

c. 1488, Milan, Biblioteca Ambrosiana, Codice atlantico, 149br

Many Renaissance military engineers advertised their abilities in illustrated treatises that promised superiority. Leonardo's letter of introduction to Ludovico Sforza, boasting of his mastery of a wide range of military inventions (see page 33), was well positioned to attract the attention of a patron whose father had risen to power as commander and whose territories were under regular threat.

Among Leonardo's armaments that went beyond those in "common usage" were monstrous versions of known devices. The giant crossbow is one of the most striking, particularly because it is drawn in such a way as to facilitate its construction. It is portrayed in nonconvergent perspective so that the more distant parts of the construction are not diminished in size. On the drawing, Leonardo wrote that it had a wingspan of almost 100 feet (30.5 meters), and that it could hurl 100 pounds (45.4 kilograms) of stone.

The arms of the bow are made from laminated wooden strips so that they might bend without cracking. The mighty shaft is borne on six canted wheels with linked axles. The train that tightens the ropes is pulled backward by a pair of windlasses, as detailed in the drawing at the lower right. The drawings on the left extract the "element" of the trigger block. Leonardo explains that the upper mechanism releases the rope when the hammer strikes the nut, while the lower one uses a lever.

Characteristically, he considered the mathematics of crossbows. We might think that the power with which the projectile is thrown would be proportional to the distance that the rope of the bow is withdrawn. However, the configuration of the arms changes as the rope is pulled back, complicating the calculation. Leonardo decided that the power is inversely proportional to the interior angle of the rope at its point of withdrawal.

The giant crossbow seems to promise the destruction of castle walls. When the ponderous weapon was reconstructed for a television program in 2006, its impact proved to be more visual than vicious.

"Among Leonardo's armaments that went beyond those in 'common usage' were monstrous versions of known devices. The giant crossbow is one of the most striking, particularly because it is drawn in such a way as to facilitate its construction."

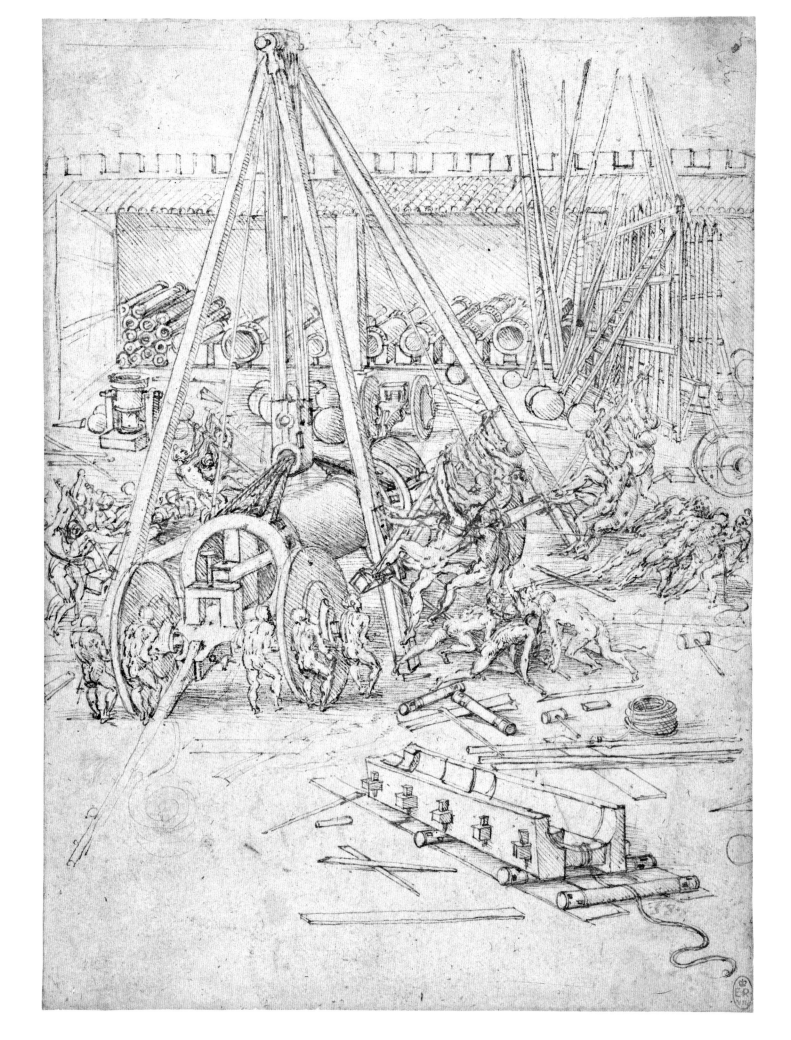

50. Men Struggling to Move a Huge Cannon
c. 1485, Windsor, Royal Library, 12647

Leonardo was fascinated by the technology of war machines but he was repelled by war, which he called "beastly madness." In one of his riddles, he played on the hideous destructive power of major weapons: "Emerging from the ground with terrible noise it will stun all those standing nearby and with its breath it will kill men and ruin castles and cities." The answer to the riddle is a cannon cast in a pit.

In the work here, Lilliputian men within an armory dedicate all their manic efforts to serving their massive metal master. Some are straining at the axles of wheels far larger than themselves. Other squads of subjugated men haul on the levers of windlasses to wind ropes over pulleys attached to the pyramidal frame in order to raise the huge body of the bombard onto the carriage.

Stored in the background are cannons of various sizes, while on the far left, approximately one-third of the way down the page, we can see a single mortar. The massive barrel of the cannon closely resembles one of the two sections of the Dardanelles Gun, cast in Turkey in 1464. Each section of the Turkish bombard was screwed onto the other using levers inserted in the rings of rectangular apertures. Leonardo was much interested in Turkey, and made a design for a Bosporus bridge. Knowledge of the most advanced technologies traveled fast. The overall length of the Dardanelles cannon was 17 feet (5.2 meters). Leonardo's monster looks to be even larger than the Turkish supersize bombard.

The drawing is full of closely observed technology, including in the foreground a half-mold on rollers for the casting of a smaller cannon. The hordes of little "pen-men" resemble those he was intending to use in his planned *Treatise on Painting* (see page viii) to illustrate human motions of pushing and pulling. Yet these rationally observed details are placed in the service of the visionary fantasy that falls outside the known types of drawing produced by Renaissance artists. For whom was the drawing intended? It seems to be the personal exorcising of a military nightmare—perhaps a nightmare with a Turkish dimension.

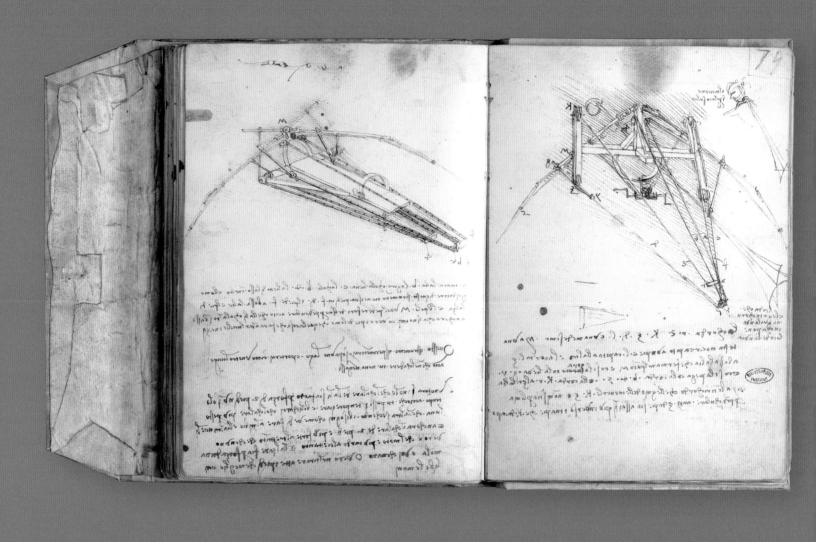

51. Designs for a Flying Machine

C. 1488, Paris, Bibliothèque de l'Institut de France, MS B 74V & 75R

Realizing the age-old dream of human flight would have been Leonardo's supreme achievement. He well understood that his great "bird" (*uccello*) would "fill the universe with stupor, bringing eternal glory to the place of its birth." The flying machine would also represent the greatest challenge to the engineer as a "second nature" in the world: in other words, inventing a mechanism that emulates nature in its perfect operation, without redundancy and without insufficiency.

His approach was to learn from nature, seeking the rationale behind natural design to invent a "bird" that would work on its own terms rather than literally imitating a natural organism. Above all, it should be a mathematical machine: "a bird is an instrument working according to mathematical law. It lies within the power of man to make this instrument in all its motions. . . . Accordingly we may say that such an instrument fabricated by man lacks nothing but the soul of man."

A series of designs from the late 1480s shows Leonardo thinking intensively about how to overcome the problem of the power-to-weight ratio using only human musculature. He realized that just attaching wings to our arms would get us nowhere.

The designs on the two facing pages shown here from MS B involve the basic "skeleton" and its motive power. They both demonstrate the amplification of arm-power by the legs of an aviator (not shown in the drawing), whose feet would pump a pair of stirrups. In the drawing on the left page, the aviator's hands would either be free or lever directly on the mechanism, whereas on the right-page drawing his arms would rotate hand pedals.

The right-page design also tackles the problem of how to steer the whole contraption, "as is done by the kite and other birds." Leonardo envisaged a four-vaned tail at the end of a long shaft attached uncomfortably to a band around the aviator's head (on the upper right of the page). He advised that "this instrument will be tested over a lake, and you will carry a long goatskin as a girdle so that if falling in you will not be drowned."

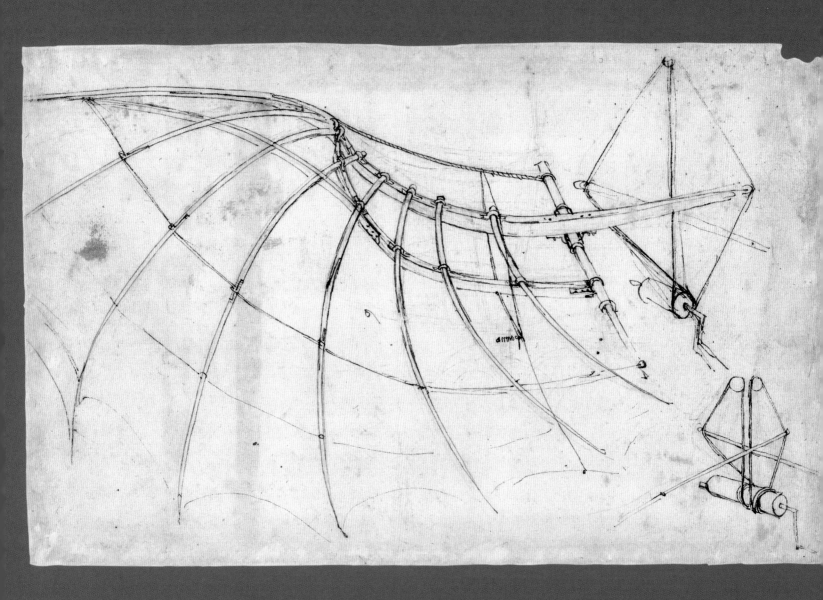

52. Design for the Wing of the Flying Machine

C. 1485, MILAN, BIBLIOTECA AMBROSIANA, CODICE ATLANTICO, 858R

Leonardo devoted a great deal of thought to the most effective design for the wings of his flying machine. He learned from the anatomical structures of the wings of birds and bats—particularly the latter, because they consist of a skeletal framework covered by an impermeable membrane. He identified a site to construct his "bird" on the roof of the Corte Vecchia, a Sforza palace in Milan (no longer extant), not far from the cathedral. He designed test wings to discover how much lift they might generate. It seems unlikely that he succeeded in constructing a complete "bird."

Alongside machines that were driven by flapping wings, Leonardo looked to other options to sustain the aviator in the air. We know that he would have encountered insuperable problems in generating the necessary lift through flapping. At various times, he considered constructing a craft akin to a modern hang glider.

The wing illustrated here is a relatively simple design in which a skeleton of flexible wood and rope is overlaid by cloth (*panno*) that passes over the wing and is attached underneath at half the width of the wing. The main axes of the wings are attached to ropes that run over pulleys and around a cylinder turned by a handle. This mechanism would not deliver powered flight but would serve to adjust the angles of the wings.

This wing design was used in a hang glider constructed in 2002 by the British firm SkySport Engineering, which specializes in the restoration of historic aircraft. Only materials available to Leonardo were used. On the hills near the sea in Sussex, the Leonardesque contraption rose into the air, piloted by Judy Leden, world hang glider champion. The lift provided by the creaking wings was prodigious, to such a degree that the glider had to be tethered by ropes to prevent its intrepid aviator from disappearing over the sea. The aim was not to demonstrate that Leonardo invented human flight, but to show that his ideas about wing design were soundly based.

ABOVE RIGHT A hang glider constructed in 2002 by the British firm SkySport Engineering based on Leonard's designs; it is shown here in the exhibition *Leonardo da Vinci: Experience, Experiment and Design*, held at the V&A museum in London in 2006.

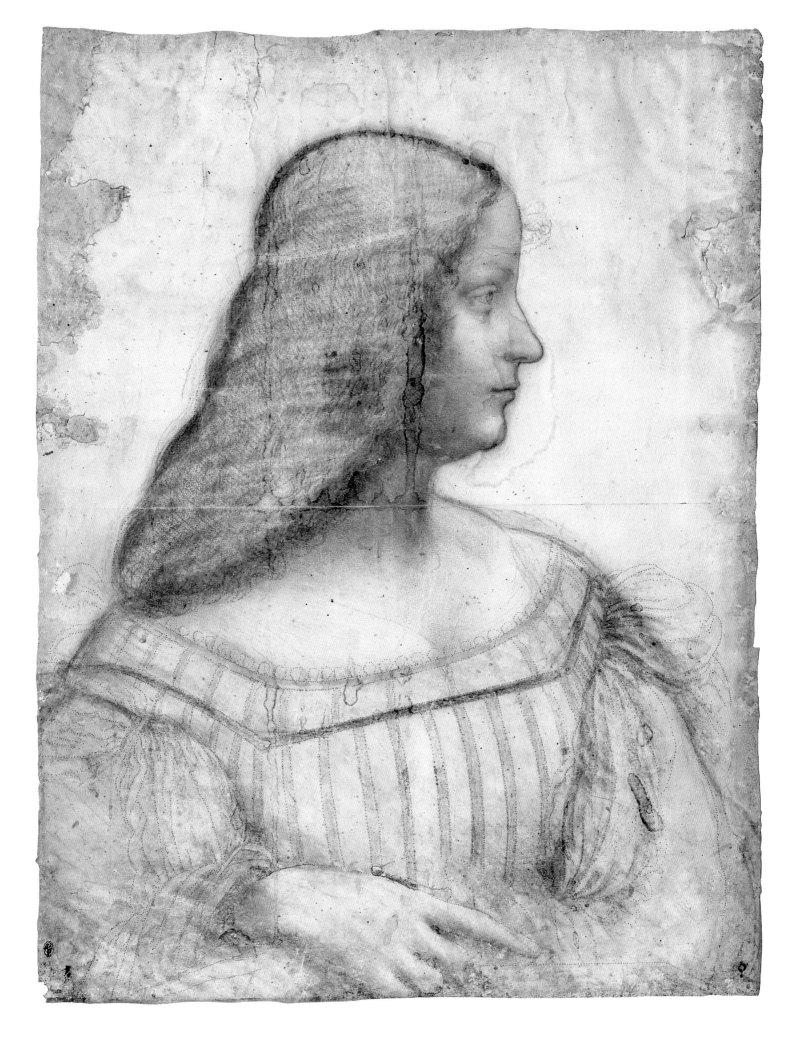

53. Cartoon for the Portrait of Isabella d'Este
1500, Paris, Louvre

When his patron in Milan, Ludovico Sforza, was overthrown by the invading French troops of Louis XII in 1499, Leonardo decided not to remain, although offered work by the new rulers. He sent money to Florence in anticipation of his return. He first went to Venice, where he advised on hydraulic engineering, and then to Mantua, where Isabella d'Este, sister of Ludovico's wife, gave him a ready welcome. An avid patron, Isabella had already asked Cecilia Gallerani to lend her the Leonardo portrait with the ermine (see pages 48–49) so she could compare it with portraits by Giovanni Bellini.

The main artistic fruit of Leonardo's brief stay in Mantua is his cartoon for a portrait of Isabella, drawn in charcoal with black and colored chalks. It retained the profile format as was obligatory for aristocratic women in the North Italian courts, but the artist has attempted to give an enhanced sense of the marchioness's presence by setting her body at an angle. Although the drawing has been damaged and trimmed, we can still delight in the delicate subtlety of Leonardo's hand as he caresses the contours of Isabella's face, and evokes the abundant softness of her hair in its diaphanous veil and the floating ribbons of her drapery.

The main outlines were very finely pricked so that the design could be transferred. There is a drawing in the Ashmolean Museum in Oxford, done by a member of Leonardo's workshop, that has been made by transfer from this one. Isabella's pose has been adjusted in the copy by lowering her right forearm to grant it more space. The copy also shows that her hands were resting on a parapet and that she was pointing to a book. In March 1500, Isabella's agent in Venice mentioned that he had seen a portrait of her there executed by Leonardo; it seems that the prime version remained in Mantua and that the portrait admired by the agent in Venice was the copy.

Over the course of the next six years, Isabella wrote on a number of occasions to various intermediaries in Florence to obtain either a portrait painting of her or any other painting by Leonardo. She was not successful.

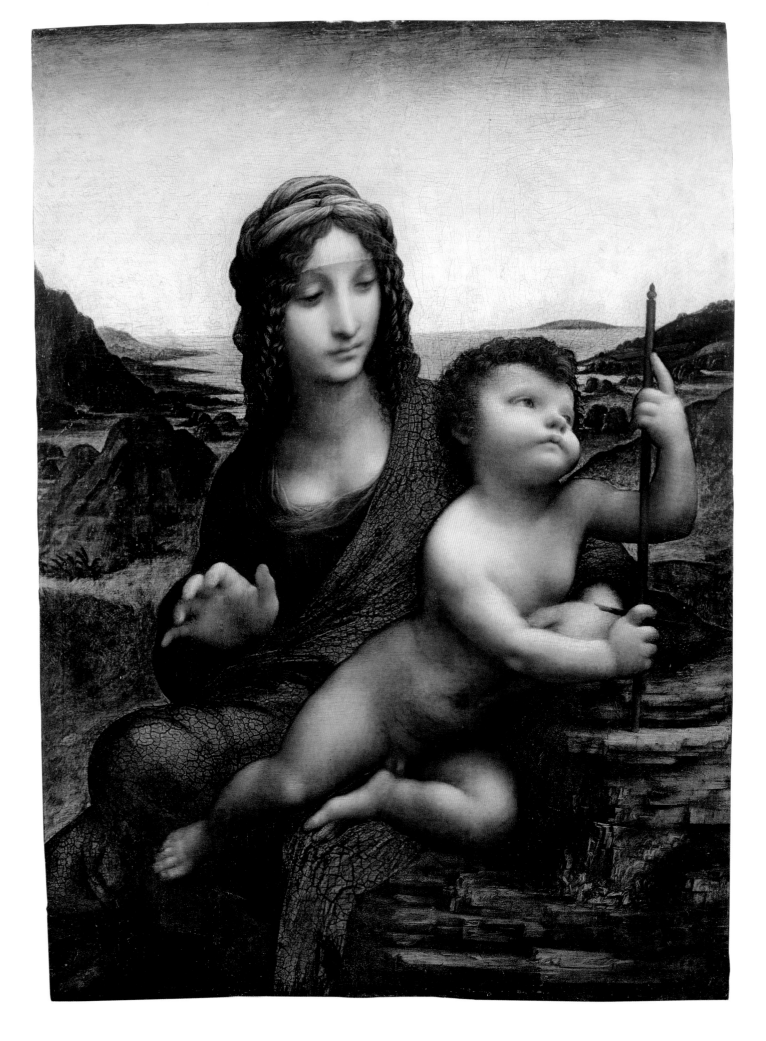

54. Madonna of the Yarnwinder
C. 1501–8, COLLECTION OF THE DUKE OF BUCCLEUCH, DRUMLANRIG CASTLE, DUMFRIES AND GALLOWAY, SCOTLAND

55. Madonna of the Yarnwinder (the "Lansdowne Madonna")
C. 1501–8, PRIVATE COLLECTION

One of the correspondents of Isabella d'Este when she was striving to extract a painting from Leonardo (see page 101) was the head of the Mantuan Carmelites in Florence, Fra Pietro da Novellara. Twice in April 1501 he updated Isabella on what Leonardo was doing. On the second occasion, he informed her that "his mathematical experiments have . . . greatly distracted him from painting." However, Leonardo had promised to undertake her portrait, once "he has finished a little picture he is doing for . . . Robertet, a favorite of the King of France."

Fra Pietro described the "little picture" as "a Madonna seated as if she were about to spin yarn. The child has . . . grasped the yarnwinder and gazes attentively at the four spokes that are in the form of a cross. As if desirous of the cross he smiles and holds it firmly and is unwilling to yield it to his mother." This is a very perceptive account of what was a new kind of Madonna composition, which contains an implicit narrative. The yarnwinder, signifying Christ's sacrificial cross, is actively and prophetically embraced by the young child.

Florimond Robertet, who served as secretary to three French kings, had met Leonardo when the French invaded Milan in 1499. He had to wait for his *Madonna* until 1507, when it was reported by the Florentine ambassador that "a little picture by his hand has recently been brought here [Blois] and is held to be an excellent thing." This stimulated King Louis's ambition to obtain a painting by Leonardo.

The *Madonna of the Yarnwinder* is one of the best documented of Leonardo's paintings. The complication is that we know of two very high-quality variants of the composition: one in the collection of the Duke of Buccleuch, opposite; and one that is also known as the *"Landsdowne Madonna,"* shown on page 105. They are both in private collections. Can we identify which one was sent to Blois?

A series of scientific examinations has revealed very remarkably that the two paintings underwent parallel developments in Leonardo's workshop. Infrared reflectography, which has the potential to reveal underdrawings on the white priming layer of a panel or canvas, disclosed an elaborate series of changes.

In both, the child's pose has been adjusted and the shaft of the yarnwinder realigned. The fingers of the Virgin's hands have been comparably changed. The most surprising of the shared modifications is in the middle ground to her left. In the underdrawings it is possible to see a figure group under an arch, in which we can identify two women, a child, and a stooping man. This motif appears in at least three other versions by Leonardo's followers and is recognizable as Joseph making a baby walker for his son, watched by Mary and a female companion. The followers have picked up the motif that Leonardo eliminated, probably quite late in the completion of Robertet's painting.

That Leonardo produced two paintings of this small-scale devotional subject is confirmed by the presence of a "Madonna with the Child in her Arms" in a list of paintings by Leonardo in the hands of his assistant Salaì (formally Gian Giacomo Caprotti da Oreno, 1480–c. 1524) in 1525, six years after the master's death. Can we tell which painting went to Blois and which remained in Leonardo's hands? There is no way at present of arriving at a definite answer.

The two paintings differ in a number of respects. The landscape in the Buccleuch version on page 102 diverges from Leonardo's customary backgrounds, but the foreground rocks are beautifully characterized. The background in the "*Lansdowne Madonna*," opposite, is more convincingly Leonardesque, but the rock structures below the yarnwinder lack geological conviction. The painting of the figures in both paintings is of the highest quality. Any stylistic judgments must be tempered by the conservation history of the two paintings. The Buccleuch *Madonna* remains on its original panel and is in good condition, albeit with yellowed varnish. The "*Landsdowne Madonna*" has been transferred from panel to canvas and then remounted on inert board. Inevitably there has been some paint loss, if not extensive, and the painting has been cleaned. Allowing for these divergences in condition, both small *Madonnas* can be credited largely to Leonardo himself.

OPPOSITE *Madonna of the Yarnwinder* (the "*Lansdowne Madonna*"), c. 1501–8.

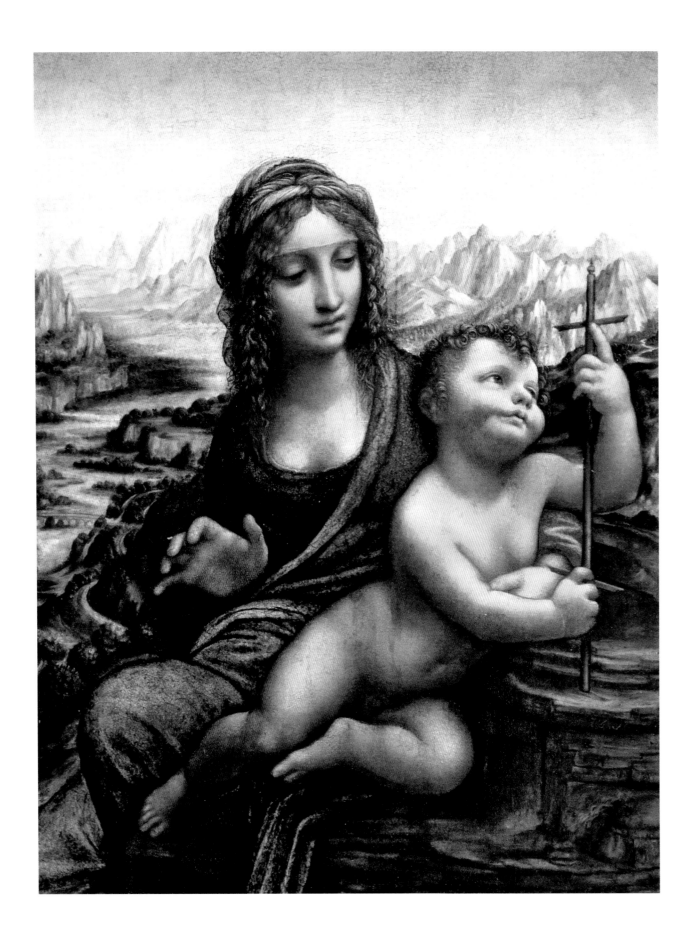

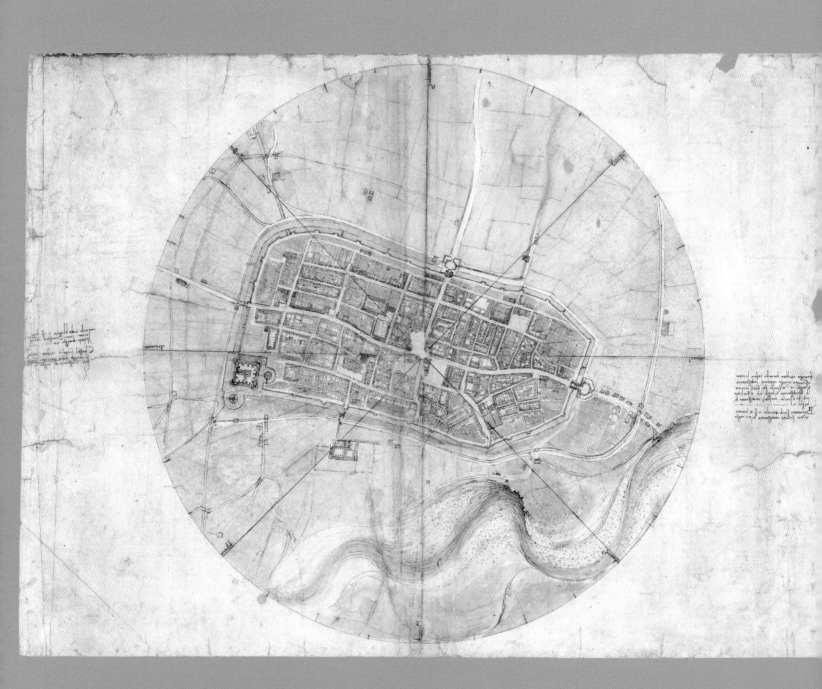

56. Map of Imola

1502, Windsor, Royal Library, 12284

After Leonardo's return to Florence in April 1500, he probably resided at the monastery of Santissima Annunziata, where the Servite monks had commissioned him to paint their high altar. There seems to have been little or no progress on the commission. Fra Pietro da Novellara reported to Isabella that the painter had completed a cartoon of the *Virgin, Child, St. Anne, and a Lamb* (see page 156) and was engaged on the little *Madonna* for Robertet (see page 103). A little over a year later Leonardo was named as "architect and general engineer" to Cesare Borgia (1475–1507), whose troops were rampaging in central Italy to subjugate the traditional Papal States on behalf of Cesare's Spanish father, Pope Alexander VI. Leonardo traveled in Cesare's service for eight or nine months.

The most spectacular example of the skills he deployed during this time is the *Map of Imola*, executed with wonderful precision in pen and ink and watercolor.

From a central vantage point, Leonardo has taken radial bearings of the walled town of Imola and its immediate surroundings, using eight prime orientations (N, NE, E, SE, S, SW, W, and NW), subdivided further into eight intermediate degrees. He correlated these with measurements on the ground, paced out by men commandeered for the purpose. He also seems to have used detailed information about the buildings from an existing map. The result offered Borgia an aerial view of the fortified city that would allow him to plan the disposition of his forces and to manage his own security within the city. On the left and right, Leonardo noted the orientation and distance of other cities, which was vital information for armies on the move.

The map exploits the highest levels of accuracy. Yet it is not an inert record. The city assumes the character of a living organism, tingling with implicit life. The river Santerno surges past in a series of stony meanders, excavating ragged chunks of bank on the outside of the bend nearest the city. Leonardo could not portray any portion of the "body of the earth" in a lifeless manner.

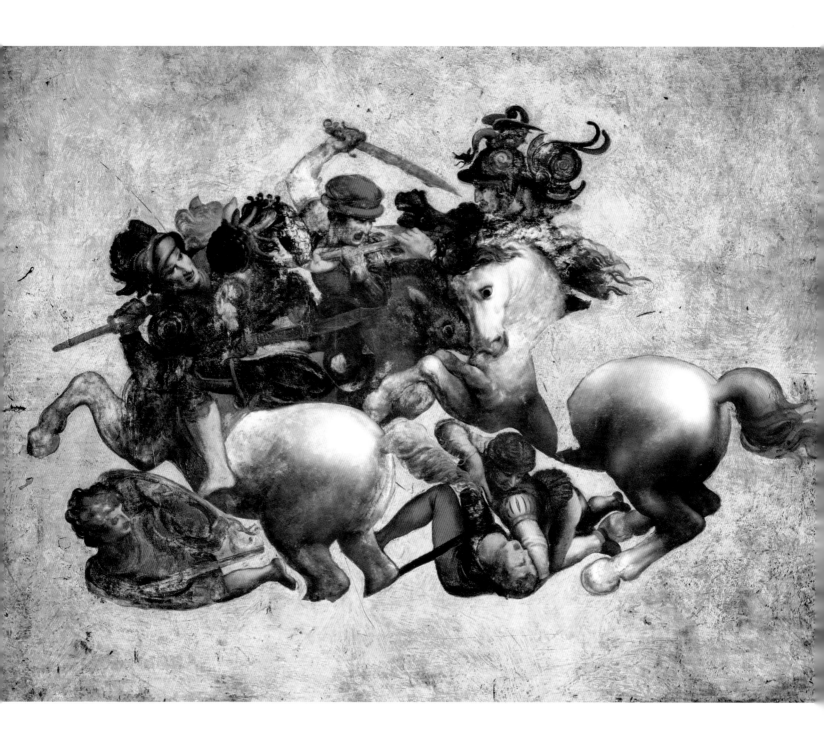

57. Copy of the Battle of Anghiari (the "Tavola Doria"),

Unknown Artist

C. 1559 (ORIGINAL 1503–7), FLORENCE, UFFIZI

58. Studies for the Battle of Anghiari

C. 1503, VENICE, GALLERIE DELL'ACCADEMIA

59. Studies of the Heads of Warriors

C. 1504, BUDAPEST, MUSEUM OF FINE ARTS

On his return to Florence after serving Cesare Borgia, Leonardo was involved in a number of schemes of military and hydraulic engineering. In 1503, we have the first notice that he had been commissioned to portray the Battle of Anghiari in the Sala del Gran Consiglio, the large new council hall of the Florentine Republic. On October 24, he moved into the monastery of Santa Maria Novella, where there was a hall large enough to accommodate his huge cartoon.

The *Battle of Anghiari* was part of a patriotic scheme for the decoration of the council hall. A companion piece of the Battle of Cascina of 1364 was to be commissioned from Leonardo's rival, Michelangelo. Leonardo's subject was the Florentine victory over the Milanese at Anghiari in Tuscany, in 1440. The key moment was the capture of the Milanese standard. The best of the copies of Leonardo's unfinished mural is the large panel painting once owned by the Doria family.

Four horsemen are locked together in a violent tangle, desperately contesting control of the Milanese standard. The old warrior in the center, screaming with rage, threatens to bring his scimitar down on the hands of the two Florentines who advance from the right. The other Milanese soldier contorts himself to brace the shaft of the standard across his back. Beneath the hooves of the horses, who are as savagely combative as their masters, one fallen foot soldier cowers under his shield, while another stabs a recumbent enemy in the throat.

The protagonists wear cuirasses and helmets that are extravagantly decorative. Leonardo's fantasies on organic themes—a ram's head, exotic shells, and seething dragons—transport the battle into the realm of legend rather than one of documentary accuracy.

Various copies of the mural record the central portion of the composition planned by Leonardo, which he had begun to paint on the wall. This was in keeping with an interim agreement on May 4, 1504, in which Leonardo was pressed to either complete the whole cartoon or begin painting that portion of the mural for which the cartoon had been finished. We can calculate that this painted section would have been 14 or 15 feet (4.3 or 4.6 meters) wide, and that the whole field to be painted was as long as 60 feet (18.3 meters) across.

A drawing in pen and black chalk in Venice (opposite, near left) shows how Leonardo's brainstorm drawing style allowed him to intertwine this knot of combatants. We can discern the central warrior with his aggressively raised arm, and the fluttering standard with its bent shaft. The incoming Florentines are as yet little defined, while a horse has collapsed where the fighting foot soldiers were to appear. Below, Leonardo has portrayed naked men whose bodies are contorted in savage action, presumably as studies for those who fight on foot. This is one of a series of impulsive drawings of men and horses in frantic action.

On June 6, 1505, a fierce storm interrupted his work on the wall and the cartoon was damaged. The records of supplies and contemporary witnesses indicate that Leonardo's technique was at least as experimental as that of *The Last Supper*. He adopted oil as the binding medium for his pigments rather than working with the traditional technique of fresco. The medium would grant him the range of colors that he could enjoy when painting on a panel, and it would permit him to work at his own pace.

We know from Leonardo's accounts in a piece in one of his notebooks titled "How to Paint a Battle" that he was striving for extraordinary visual effects that lay outside the scope of fresco. Some excerpts will convey a flavor of what he aspired to achieve:

> You must make the foreground figures covered in dust—in their hair, on their brows, and on other level surfaces suitable for the dust to settle. . . . And if you should show one who has fallen, indicate the spot where he has slithered in the dust turned into blood-stained mire. . . . Make the conquered and beaten pale, with their brows knit high and let the skin above be heavily furrowed with pain. Let the sides of the nose be wrinkled in an arch starting at the nostrils and finishing where the eyes begin. [Show] . . . the lips arched to reveal the upper teeth and the teeth parted, as if to wail in lamentation. . .

> Show dead men, some half and others completely covered in dust. [Show] the dust, as it mixes with the spilt blood turning into red mud . . . and others in their death throes, grinding their teeth, rolling their eyes or clutching their crippled legs and bodies with their fists. . . . Show an angry figure holding someone up by the hair—wrenching that person's head against the ground, with one knee on the person's ribcage. . . . The angry figure will have his hair standing on end, his eyebrows lowered and drawn together, and teeth clenched, with the two lateral corners of his mouth arched downward.

If we doubt whether even Leonardo could have achieved all this, his drawings for the heads of key combatants show that he could achieve facial expressions that are the equal of his written accounts. A study in black and red chalk in Budapest (opposite, top right) depicts the central warrior, identifiable as Niccolò Piccinino, and a snarling Florentine. The face of the Milanese captain is deeply etched with screaming fury.

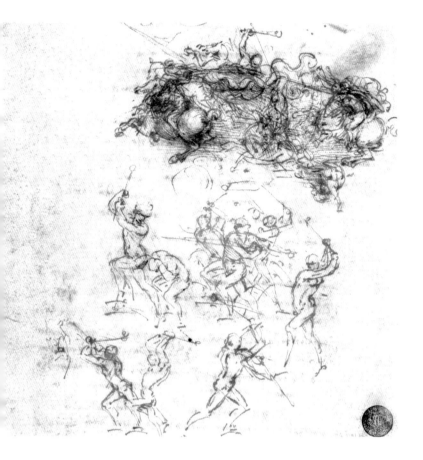

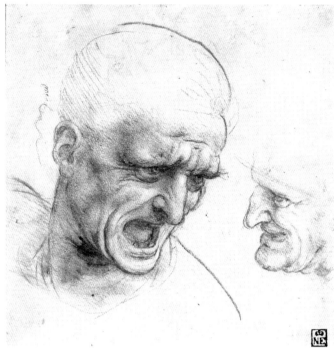

LEFT *Studies for the Battle of Anghiari*, c. 1503.

ABOVE *Studies of the Heads of Warriors*, c. 1504.

In any event, Leonardo's ambitions were not to be realized. The Florentine authorities were under irresistible pressure from the French to surrender Leonardo's services to their regime in Milan. In May 1506, the artist left for what was meant to be a three-month leave of absence. During 1507 and 1508, a tug-of-war between the Florentines and the French resulted in Leonardo's shuttling between the two cities before moving more permanently to Milan. The leader of the Florentine Republic complained that Leonardo had "taken a goodly sum of money and provided a small beginning of the great work which he should have made."

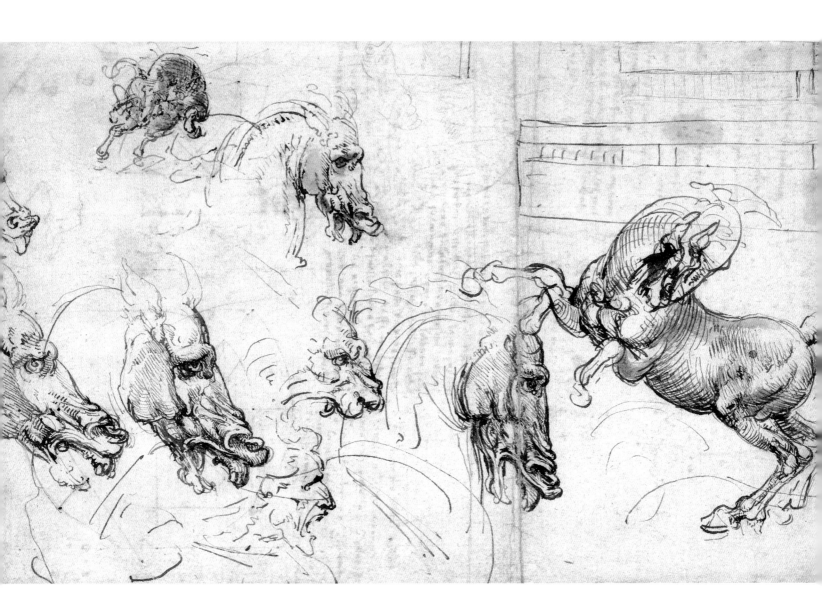

60. Study of Heads of Horses, Lion, and Man

c. 1506, Windsor, Royal Library, 12326r

This spirited page is associated with the *Battle of Anghiari*. Leonardo's horses were to fight with each other as aggressively as the soldiers. He was looking at how a horse can withdraw its muzzle and nostrils to bare its incisors and gums. There is no question that the drawings are based on observations of actual horses.

However, as is typical of Leonardo, the series of studies goes beyond what is strictly needed for the task in hand. Having concentrated on the way that horses bite aggressively, the artist then has a roaring head of a lion and a shrieking man float into view, as a graphic meditation on the universality of expression in man and animals. The dynamically twisting horse in the top left is typical of studies of horses in motion that were triggered by the *Battle* but were not obvious candidates for inclusion in the painting. Leonardo's mind wanders in a thrilling manner, but not always in a way that is conducive to the practical completion of paintings.

The traditional science of physiognomy was known to Leonardo (see pages 13 and 71). He owned the *Book of Physiognomy* by Michael Scot, the thirteenth-century Scottish philosopher, which was printed in 1477. Alongside the analysis of human faces, Scot classified the physiognomic characters of animals. Whereas traditional physiognomy dealt with the static facial "signs" of the face—the fixed features that seemed to signal the subject's character, in which Leonardo was certainly interested—his study of the subject focused at least as much, if not more, on the commonality of facial expressions in man and animals across their full range. There had been nothing comparable in either art or science.

The drawings are brilliant examples of Leonardo's penwork after 1500. The varied motions and pressures of his pen have a graphic power that perfectly complements the expressive energy of his subjects. His earlier mode of hatching to create shadow had been to build up rows of parallel lines of varied density. In the rearing horse the rapid ink lines curve descriptively around the forms, as if sculpting their plastic form with a claw chisel.

61. Sequential Images of a Man Striking a Blow and Optical Diagram

c. 1506, Windsor, Royal Library, 19149v

Leonardo's planned *Treatise on Painting* was to contain extensive discussions of the human body in all kinds of motion: "at rest, moving, running, standing upright, leaning, seated, stooping, kneeling, recumbent, hanging, carrying and being carried, pushing, pulling, striking, being struck, weighted down, and lifting." They were all to be illustrated with small, rapid sketches.

The motions all fell into one of three categories: "motion of place, and motion by simple action, and the third is by [both] action and motion of place." The last is compound motion, such as "dancing, fencing, playing, sowing, plowing, and rowing." But Leonardo thought further about rowing, because the "motion of place" is that of the boat. Every motion occurs across what he calls a "continuous quantity" in that it occurs indivisibly across space, not in separate steps of space and time.

He explained that "the movements of man during the course of a single event are infinitely varied in themselves. In the case of a man delivering a blow to some object . . . such a blow occurs in two directions. . . . Either he is raising the thing that is to descend to create the blow, or he is making the descending motions." Each motion is continuous across space. He added that "one and the same action will show itself as infinitely varied because it may be seen from an infinite number of locations."

Leonardo's sequential images of the hammering man, above which he wrote the title *On Painting*, exhibit a cinematographic quality. In 2006, they were animated for an exhibition at the Victoria and Albert Museum in London. It transpired that Leonardo had infallibly identified the key stages needed for the animation, to which were added intermediate stages to achieve smooth motion.

The other studies, on what is a large sheet folded into four (only the bottom left portion is shown here), deal with images projected through a hole into a darkened chamber (a camera obscura or pinhole camera), the interaction of colored lights, and the path of light rays in the eye, which can be dated to c. 1507.

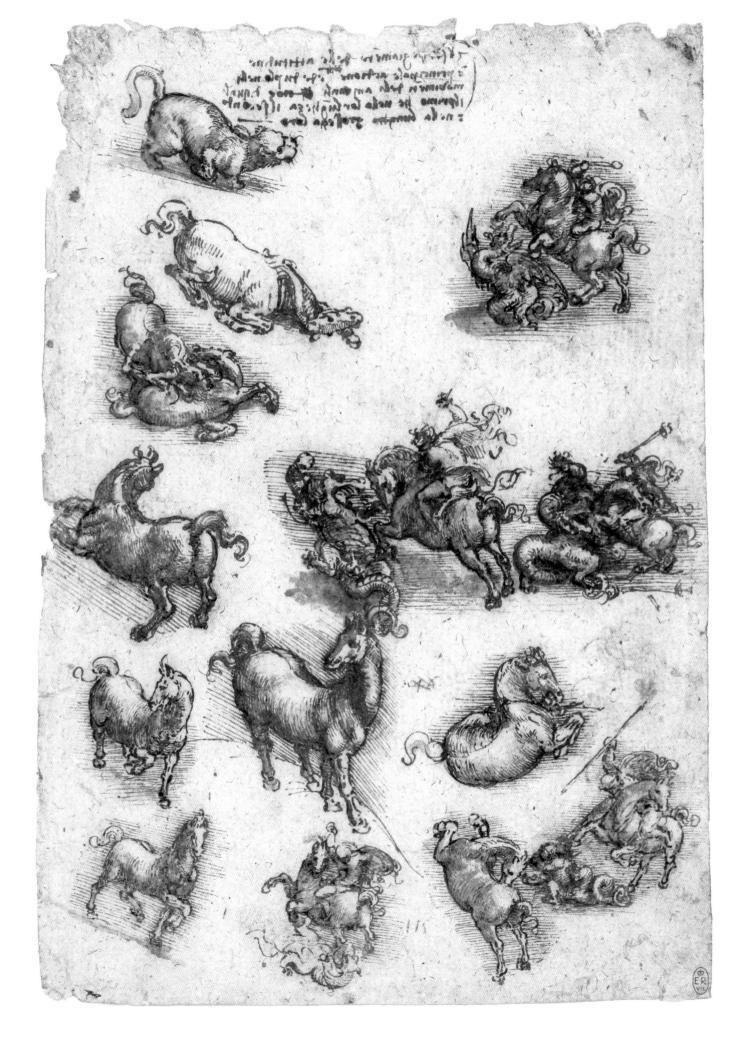

62. Studies of Horses in Motion,
St. George and the Dragon, and a Cat (?)

C. 1516, WINDSOR, ROYAL LIBRARY, 12331

This sheet of fourteen studies is related in a general sense to the *Battle of Anghiari* (see pages 108–11). We can see two horses fighting savagely and two rearing in a manner that recalls Leonardo's plans for the mural. However, the drawings do not serve a preparatory function, and they probably date from well after the *Battle*. The sheet as a whole has assumed a life of its own, as testimony to Leonardo's unbridled inventiveness.

It seems likely that the first drawing on the page was the central image of St. George on a rearing horse in deadly combat with a leonine dragon thrashing its spiraling tail. It is astonishing how Leonardo can compress so much spatial energy into a sketch under 3 inches (7.6 centimeters) tall. The speed of his pen and the alacrity with which he applies the brown wash to shade the forms has never been surpassed.

The subsequent order of the studies is difficult to determine, but it is clear that the artist switched back and forth between the Anghiari-style horses and the St. Georges. Whatever Leonardo's intention when he first laid pen to paper, the note at the top makes it clear that the drawings serve as an illustration of the torsions of animals in motion: "The serpent-like movement is the principal action in animal and it is double, the first occurring along its length and the second across its width."

Looking at the five St. Georges, it is easy to see how Leonardo's frantic inventiveness was a conspicuous factor in his completing so few works. He devises one compelling image of the dramatic action. But he can see more . . . and more. How is he to choose? The central drawing is the most lucid and traditional, while the one squeezed in next to it is truly original, with a massive dragon, and a terrified horse. Even if one of the drawings had been chosen, he would likely have continued manipulating the composition in his cartoon and on the panel during the course of painting.

"Looking at the five St. Georges, it is easy to see how Leonardo's frantic inventiveness was a conspicuous factor in his completing so few works."

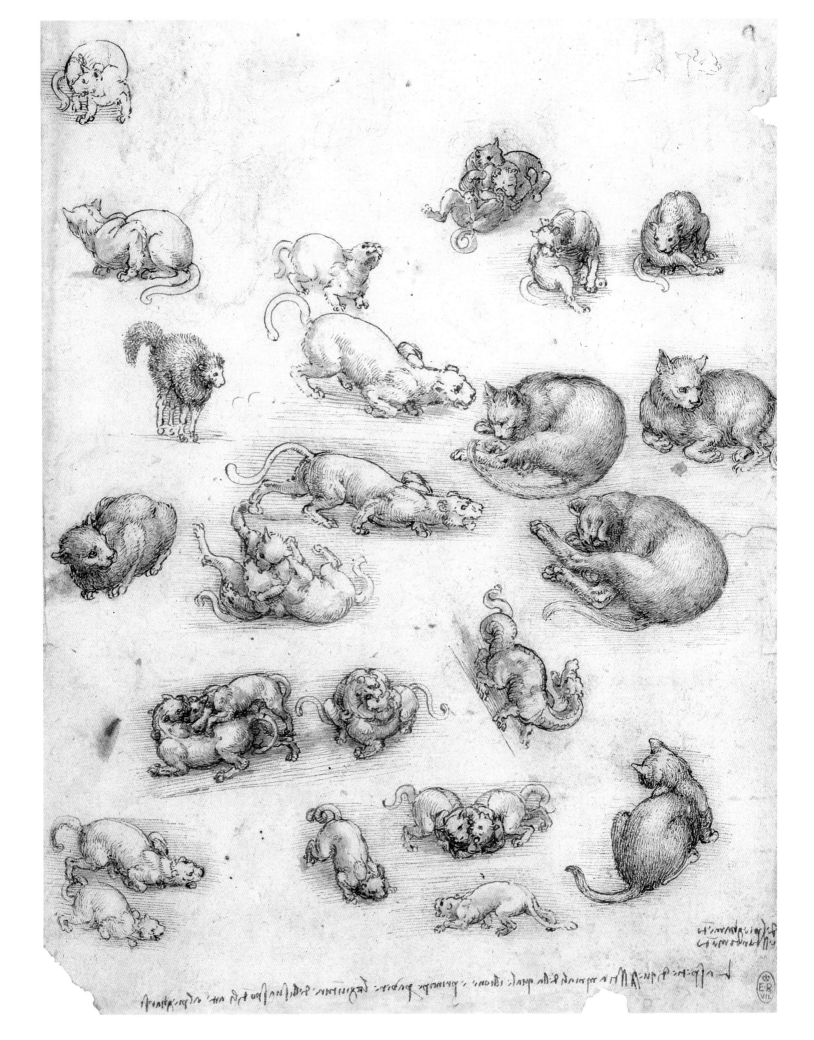

63. Studies of Cats and Other Animals
c. 1516, Windsor, Royal Library, 12363

Like the sheet of horses and St. Georges, this page of twenty-three lively little sketches is related to the plan Leonardo conceived of writing "a separate treatise describing the motions of animals with four feet, among which is man, who in his infancy similarly crawls on all fours." Leonardo was exceptional in recognizing the commonality of movement between humans and quadrupeds. The treatise would not just be descriptive but would be founded on the anatomy of the various creatures. At the bottom of this page, he praises "this animal species, of which the lion is the prince, because of its spinal column, which is flexible."

The two studies to the right of the center of the page were probably the first to appear. (As a left-hander, Leonardo tended to begin writing or drawing on pages to the right of center.) They are beautiful and utterly convincing drawings, from life, of a comfortably domesticated cat, as are those at the right edge of the page and the bottom-right corner.

Thereafter, Leonardo's imagination comes into play. In five of the sketches, a pair of cats is ferociously wrestling. Their actions seem part remembered and part invented. The latter is obviously true of the fuzzy creature that arches its back and tail in the upper left. A rat or mouse puts in an unexpected appearance. A curly-tailed dragon suddenly arrives at an angle to all the other creatures, a refugee from the St. Georges.

It is not always easy to tell when observation and fantasy are involved. The aggressive felines beside the sleeping cats appear to be lionesses, crawling forward with their chests close to the ground. Lions were kept in cages behind the government palace in Florence, and the drawings may well be based on observation. Others of the crawling creatures are not definitively either cats or lionesses.

In any event, there is a strong sense that Leonardo was having fun.

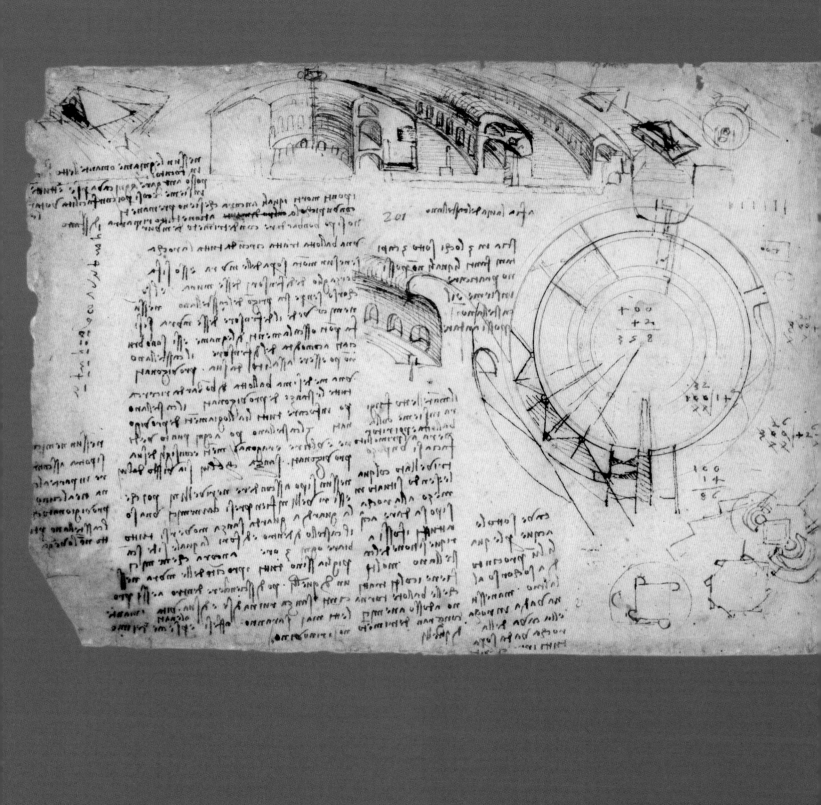

64. Scheme for a Circular Fortification

C. 1504, MILAN, BIBLIOTECA AMBROSIANA, CODICE ATLANTICO, 132R

On June 30, 1504, the Florentine authorities interrupted Leonardo's work on the *Battle of Anghiari* (see pages 108–11) so that he could travel to the coastal town of Piombino to advise its ruler, Jacopo IV Appiani, on how its fortifications might be improved. The port of Piombino provided vital access to the sea at a time when Florence was at war with Pisa. On November 1, Leonardo noted that he made "a demonstration" for the "lord in Piombino." Among other things, he recommended the removal of the crests of some hills to improve the defenders' lines of fire, estimating the costs involved.

His work at Piombino triggered some radical rethinking about new kinds of fortifications that would best resist attack by increasingly effective cannon, bombards, and mortars. His most novel idea was for a squat, circular fortress with concentric rings of walls. To better deflect incoming projectiles, everything is curved: the bastions, the faces of the massive masonry rings, the embrasures of the windows, and the sidewalls of the gun ports. The idea is that shots hitting the curved contours would be deflected: "every blow diminishes by half" rather than striking flat walls with maximum force.

The page illustrated here is one of a series in which Leonardo presented the circular plan with the rings in a three-dimensional section to demonstrate the routes of internal circulation for the commander and the three "captains," and the narrow gun ports through which the defenders could fire in relative safety. He explained that "no enemy can see the person who defends this wall." He advised that a well should be made at the center of the fortification so that the "moats can be filled whenever the commander so determines." He noted that a single stationary guard, changed every three hours, could be positioned so as to view the circular castle within and without. He was totally rethinking the logistics of defense.

65. Four Mortars Firing over a Castellated Wall
c. 1505, Windsor, Royal Library, 12275

This astonishing image, drawn mainly in very fine pen with delicate brown washes, transforms a savage bombardment into a formalized demonstration of the dynamics of projectiles. A related drawing also contains a *Battle of Anghiari* horse, confirming the work's date as c. 1505.

Four mortars are positioned in pits outside a castellated wall of a notably old-fashioned kind. The entrance, flanked by bastions that support cannons, has been blocked by a sloping wall of masonry. Behind the wall is a courtyard with lower and blunter fortifications punctuated by arched gun ports through which cannon are pointed. The mortars rain an improbable and devastating cascade of missiles into the courtyard. It is difficult to reconcile the demonstration with any practical setup. No mortars could fire such volleys of missiles. How would the attackers install the mortars so close to enemy walls? Or does the setup show a way of destroying an enemy army when it has already captured the fortress? Either way, it assumes the guise of a military fantasy.

The trajectory of the missiles has been described with meticulous mathematical care. The most powerful projectiles follow a semicircular path, while the intermediate ones pursue paths that are of varied steepness. Each curve is symmetrical around its highest point. It is unclear how this orderly effect could be achieved from the mouths of standard mortars. Unless a better explanation becomes available, we can only assume that this is the kind of "demonstration" that is designed to tickle a patron's militaristic fancy rather than a practical design.

Tracking the path of projectiles as drawn lines is part convention and part observation. Leonardo observed that "a stone thrown through the air leaves in the eye that sees it an impression of the movement, and drops of water do the same as they descend from the clouds." He would not have used the phenomenon of the persistence of vision in his paintings, but could do so in his drawings when it suited his purposes.

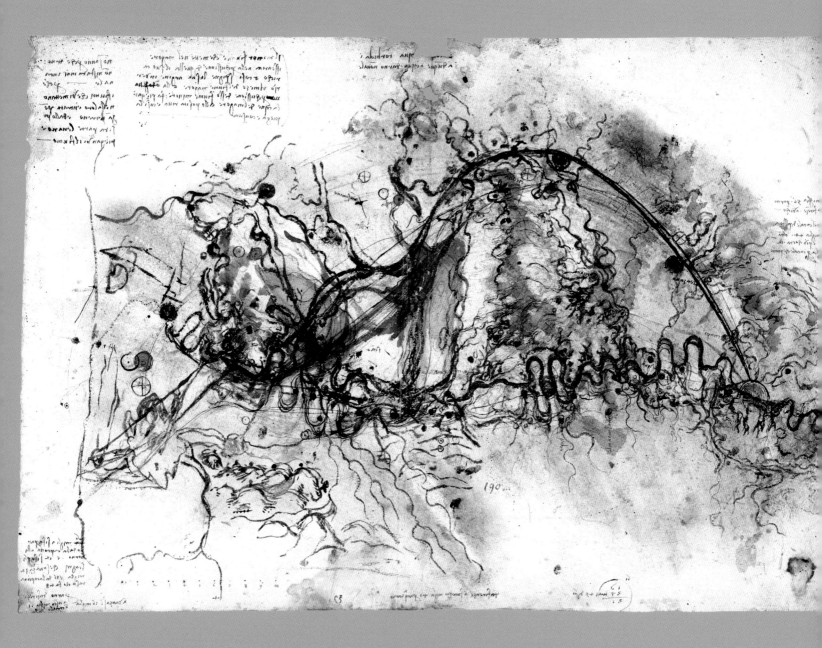

66. Scheme for an Arno Canal

C. 1503–5, WINDSOR, ROYAL LIBRARY, 192279

In 1503, Leonardo devised a scheme to divert the Arno past the maritime city of Pisa, which had been freed from Florentine rule. Work was put in hand, but by October 1504 it was clear that the Arno was not going to be diverted, and the project was abandoned as a fiasco.

As part of his engagement with the Arno, Leonardo turned his attention to a civil project to bypass the unnavigable reaches of the Arno west of Florence, where it runs through rocky and mountainous terrain. He devised a great arching canal that would pass northwestward through Prato and Pistoia before turning in a southerly direction into a navigable section of the Arno near Pisa.

Here we can see Florence near the right margin and two dark circles that indicate Prato and Pistoia. The coast runs close to the left margin. No map had ever been drawn with such expressive life. The "body of the earth" is "vivified" by its "veins of water." Although the penwork and the colored washes look very free, there is scale along the bottom left, and the main features are pricked through for transfer.

As Leonardo considered the topography of the Arno valley, he observed features that were to revolutionize his understanding of the history of the earth. He noted that where rivers cut through mountains, stratified deposits could be seen, including successive layers of shells. Since there was more than one layer, the biblical deluge could not have been responsible.

He concluded that "in ancient times" the Arno was "dammed up . . . in such a way that before entering the sea . . . the river formed two lakes. The first was where the city of Florence now flourishes along with Prato and Pistoia." The second lake was in the upper Arno, north of Arezzo. In the Codex Leicester Leonardo extended this vision to embrace the whole of the known world, speculating that as the Straits of Gibraltar widened, the Mediterranean would become an extension of the Nile!

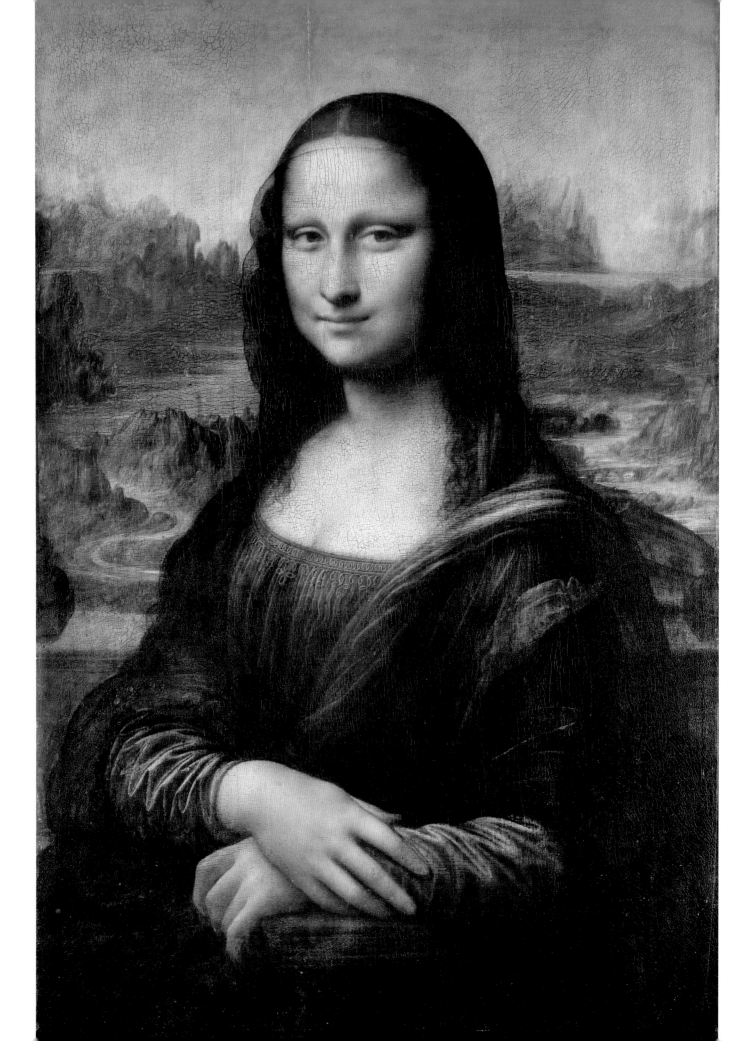

67. Portrait of Lisa del Giocondo (the "Mona Lisa")

c. 1503–15, Paris, Louvre

68. Portrait of Lisa del Giocondo

2010, digitally restored by Pascal Cotte

The routine origins of this portrait stand in the sharpest contrast to its status as the world's most famous visual image.

From the marginal note added by Agostino Vespucci in October 1503 to his copy of Cicero's *Letters to Friends*, we learn that Leonardo had embarked upon a portrait of Lisa del Giocondo. Vespucci was an acquaintance of Leonardo's. Lisa came from the Gherardini family, Tuscan landed gentry, whose prosperity had declined. Her husband, Francesco del Giocondo, was a rich silk merchant who extended his activities into trading and moneylending. By 1503, Lisa was twenty-four years old and had given birth to five children. Francesco was acquainted with Ser Piero da Vinci, the artist's father, who had acted in a legal capacity for the silk merchant.

Because of its early impact on Florentine painters, we can identify the picture in the Louvre with that recorded by Agostino. The portrait was almost certainly not finished when Leonardo left Florence in 1507. It was seen in Leonardo's hands in France in 1517 when it was described by a local chronicler as "a certain Florentine woman portrayed from life at the behest of the late Magnificent Giuliano de' Medici." This reference has been used to argue that Lisa is not the sitter. However, it is likely that Giuliano (1479–1516), Leonardo's patron in Rome from 1513 to 1516, admired the unfinished image as a masterly painting and encouraged Leonardo to complete it. In any event, it appears as "*la Ioconda*" on the 1525 list of paintings in the hands of Salaì in Milan six years after his master's death. By 1550, it was in the collection of Francis I at Fontainebleau.

The portrait evolved into a "universal picture" in which Leonardo invested his highest intellectual, imaginative, and technical skills. We can see from technical examinations—particularly from changes in the sitter's costume—that it evolved from a portrait of a bourgeois Florentine wife to an image of a more philosophical kind. There are two main dimensions to this evolution: poetic and scientific.

The literary dimension resides in Leonardo's fervent desire for his art to surpass poetry. In a *paragone* (comparison of the arts) that he wrote, Leonardo argued that sight, which operated though the prime human sense, conveyed images with a vividness and emotional power that poetry could not match.

"The portrait evolved into a 'universal picture'

in which Leonardo invested his highest

intellectual, imaginative, and technical skills."

In the *Mona Lisa*, he implicitly challenged the poets' evocation of the "beloved lady," a central genre in Renaissance poetry. Dante (c. 1265–1321), whose poetry Leonardo knew well, spoke of the overwhelming power of the lady's eyes and smiling lips. This became a standard trope in subsequent love poetry and featured in the poems that were written about Leonardo's portraits of ladies. The image of Lisa as a smiling woman who looks at us but somehow remains enigmatic and out of reach translates the poet's formulas into a living, visual presence. This presence is readily apparent in a digitally restored version, opposite, by optical engineer Pascal Cotte, which used algorithms to restore something of the original colors and allows us to gain a better sense of the space within the painting.

The scientific dimensions directly involve the optical phenomena to which Leonardo paid such attention, including the gradations of light and shade on solid bodies (see pages 76 and 79). More unexpected is the geological content. The landscape behind the sitter speaks of the past history of the body of the earth and tells us of events to come. We see the two high lakes of which Leonardo spoke in his analysis of the Arno Valley (see page 125). The upper lake will eventually burst through, and the dry riverbed to the left will be charged with seething waters. The artist was not literally portraying the prehistoric or future Arno, but was shaping Lisa's landscape on the basis of what he had learned about change in the "body of the earth," to stand alongside the implicit transformations in the body of the woman as a "lesser world" or microcosm.

OPPOSITE *Portrait of Lisa del Giocondo*, 2010, digitally restored by Pascal Cotte.

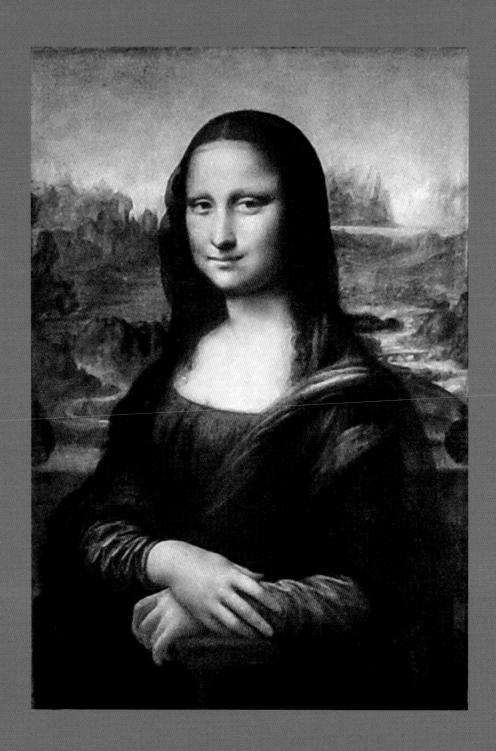

69. Studies of the Optics of the Human Eye, with an Experimental Model of the Eye

c. 1507, Bibliothèque de Institut de France, E 3v

In his earliest studies of vision, Leonardo thought that sight was a simple business. A pyramid of light rays emanating from an object enters the eye to register its relative size and its distance. As he became more aware of medieval optical theory and gained more direct access to the sophisticated ideas of the Arabic philosopher Ibn al-Haytham (Alhazen, c. 965–c. 1040), Leonardo came to realize that the act of seeing was a complex process.

On this page from his manuscript *On the Eye*, we see the rays passing through the pupil, where they are inverted as in a camera obscura (a pinhole camera). The spherical crystalline humor reinverts the image, passing it to the optic nerve at the rear of the eye. (There was no sense at this time that the "crystalline humor" was stretched by muscles into a lens shape in order to focus images on the retina.)

In the manuscript, Leonardo worked through possible variations on the path of the rays. In this drawing here, toward the center of the page, he experimented with a system in which the second inversion occurs behind the crystalline humor. The smaller resulting pyramid then coincides neatly with the optic nerve.

He realized that simply drawing the possible paths of rays would not settle the matter. In the drawing at the top right, he devised an innovatory experiment to see what actually happens inside the eye. A large model of the eye was constructed with a pupil at its base and a sphere suspended in water in a glass bowl. The experimenter looked into the model eye through the rim of the glass bowl, with his own eye in the position of the optic nerve.

Leonardo was now aware that a receptive surface at the back of the eye will receive rays from various points on an object. The rays that pass through most directly will register the shape and position of an object most clearly, but not definitively—thus even close edges would appear blurred to some extent; the contours, nonlinear. Leonardo wrote that "the eye does not know the edge of any body." This optical uncertainty is very apparent in his paintings from the *Mona Lisa* onward.

70. Study of the Vessels of the Arm, with a Demonstration of the Vessels of an Old and Young Person

c, 1508–10, Windsor, Royal Library, 19027r

This page of vascular studies is one of many that derived from Leonardo's dissection of a man who had died in the Hospital of Santa Maria Nuova in the winter of 1507–8. The man, who claimed to be a hundred years old, faded away in front of Leonardo, who "made an anatomy to see the cause of a death so sweet." He concentrated on the man's vascular system, because it seemed his body was no longer adequately nourished by his blood vessels and that his organs and skin had become "desiccated."

The larger drawing shows the main superficial vessels of the arm, mapped out as if Leonardo were looking at a river system. He was a staunch advocate of the ancient idea of the microcosm, in which the human body mirrored on a small scale the features of the earth and the wider system of the cosmos. He claimed that the bones are like the mountains, the soil is the flesh, and the vessels are the rivers, which he called the *vene d'acque* (veins of water). Leonardo gave the standard doctrine of the microcosm a new visual cogency and was able to use it as a research tool.

He decided that the old man's vessels had become tortuous "in the manner of a snake," and had silted up as a consequence. Leonardo knew from his hydraulic engineering studies that straight channels transmitted water with the greatest degree of efficiency, while meandering rivers left deposits as they curved back and forth. In the smaller drawings he illustrates vessels that are "young" and those that are "old." The former pursue straight courses such that the blood can course through at full pace, whereas the latter would pass blood only in a sluggish manner. He noted that the vessel surrounding the heart of the centenarian was notably affected by silt, and diagnosed the cause of death as "weakness through failure of blood and of the artery which feeds the heart and lower members."

71. Demonstration of the Vessels of the Thorax, and the Heart as the "Seed" of the Vascular System

C. 1508–10, WINDSOR, ROYAL LIBRARY, 19028R

Leonardo's vision that the functioning of the human body was as at one with the operation of all natural systems reached its fruitful climax at the time of his dissection of the "centenarian."

The heart serves as the "lake of blood" from which "the vessels originate, which make ramifications throughout the human body, similarly the Oceanic sea fills the body of the earth with infinite veins of water." The rule of the microcosm extends to all living things. Analogies are everywhere. The way a tree branches exhibits a fundamental affinity with the branching of blood vessels.

So powerful is an argument based on analogy that Leonardo used one to solve a long-running physiological dispute about whether the heart or the liver is the source of the vascular system. Aristotle argued for the primacy of the heart, having studied embryo chicks, but Galen, the second-century Greek physician and philosopher, later maintained that the liver produced the blood, which was then distributed by the heart.

On this page, Leonardo began with the highly organized demonstration of the main vessels of the torso and upper abdomen, with just an outline to denote the position of the heart. He paid particular attention to the ramifications of the hepatic vessels, sensing that they are like roots. He then argued (in the note below the drawing) that "if you should say that the vessels arise in . . . the liver . . . just as the roots of the plants arise from the earth, the reply to this analogy is that plants do not have their origin in their roots. . . . This is seen through experience in the germination of a peach that originates from its stone."

The diagrammatic images in the upper left show the heart (*core*) with the main vessels, and a fruit stone (*nocciolo*). It is readily evident that "the tree of the vessels . . . has its roots in the manure, that is to say the mesenteric veins [that feed and drain the intestines] go on to deposit the blood they have acquired in the liver." Thus, "the heart is the nut that generates the tree of the vessels."

Polmone

Figato

206

72. Demonstrations of the Trachea and the Branching of the Bronchi in the Lungs and the Organs of the Upper Abdomen

c. 1508–10, Windsor, Royal Library, 19054v

This is one of the most beautiful and cogent of Leonardo's synthesized demonstrations of the systems of the body. It combines organic form with his characteristic search for the mathematics of structure and function. It is one of a series of studies that concentrates on the irrigation channels that conduct fluids around the body.

The note beside the lateral view on the right shows four conduits and the spine: "*a* trachea, whence the voice passes/ *b* esophagus, whence the food passes/ *c* apoplectic vessels [the pair of carotid arteries] whence passes the vital spirits/ *d* dorsal spine where the ribs arise/ *e* vertebrae, where the muscles arise that terminate in the neck and raise the face to the sky."

Leonardo's focus in the highly developed demonstration on the left is on the way that the trachea bifurcates regularly. He thought about how the complex spatial array might be displayed most comprehensively and lucidly: "first make this lung complete, seen from four aspects in its complete perfection; then you will make it so it is seen fenestrated, solely with the ramifications of the trachea from four other aspects." As in his illustrations of the Platonic solids (see page 80), "fenestrated" means rendered in a skeletal mode in space without any intervening material.

We know from his analysis of branching in trees that the total cross-sectional area of the branches at any level in the system should remain constant. Thus the cross section of each of the two conduits at the first stage of branching should be a half of the main one, the next would be a quarter, and so on, proportionately. If this rule of equality is broken, the flow will be disrupted. Leonardo knew that this rule applied to all systems that transport fluids in the human body and in nature more generally. In modern terms, he was showing that the volume of a fluid passed at constant velocity is proportional to the cross-sectional area of the channel.

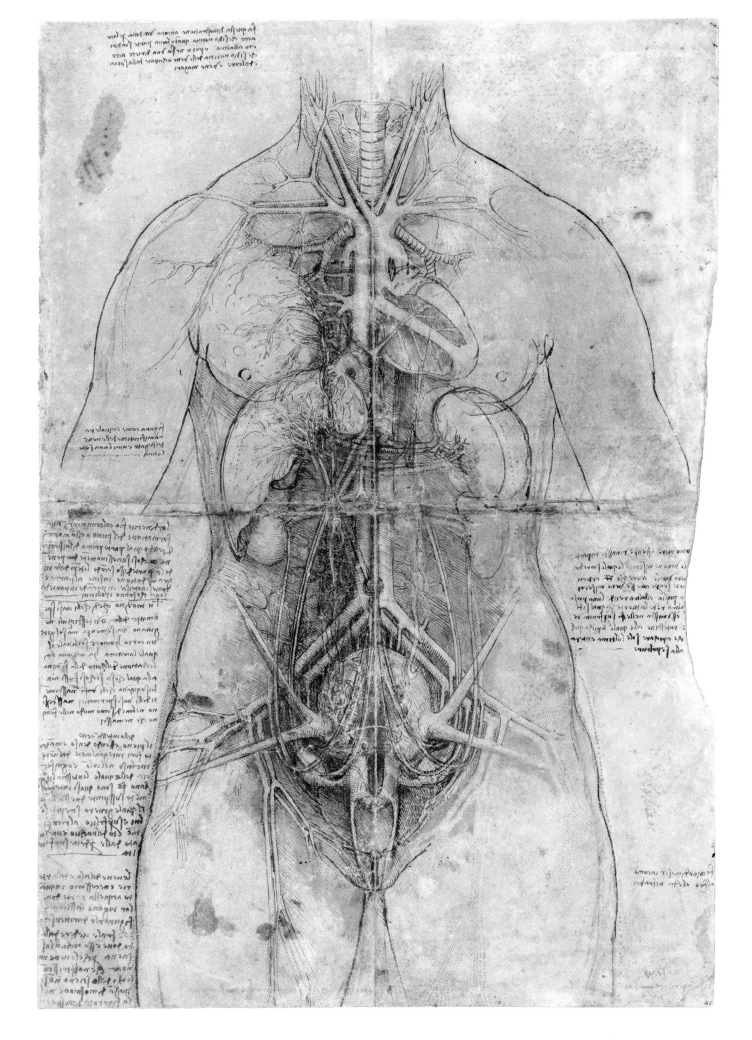

73. Demonstration of the Irrigation Systems of a Female Body

C. 1508–10, WINDSOR, ROYAL LIBRARY, 12281R

The culmination of Leonardo's campaign to chart the irrigation of the human body is this very large study of plural systems within the outlines of a woman's body. He valiantly attempted to unite the vascular, respiratory, urinary, and reproductive systems, using his innovatory techniques of representation.

The arteries and veins branch systematically into progressively smaller tributaries, as do the bronchial tubes. The heart appears to consist of two chambers, an interpretation that Leonardo was to abandon shortly after making this drawing. The spherical womb is a traditional feature, with its lateral "horns." Throughout, the artist was combining morphological knowledge gained from dissections with his conception of how the components function in the context of traditional physiology. His ultimate aspiration in anatomy was to "remake" the human body as a functional machine rather than to provide "descriptive anatomy" in the manner of Henry Gray's famous textbook in the nineteenth century.

He deployed a remarkable range of graphic techniques in the one drawing, using ink and black chalk. Some forms are shown as solid, some are in shadow, some are sectioned, and others are rendered as if transparent. His ambition was to create an ultimate composite of the bodily systems. Undaunted, he reminded himself on the left of the drawing to "make this demonstration also as seen from the side . . . and then make one from behind."

The main outlines are pricked for transfer to another sheet, presumably so he could clarify those parts where the overlaid features had become confusing. We may imagine that he had made or was intending to make three comparable demonstrations of the male body, as well as of the woman from the side and back.

The note on the left contains an obscure meditation on life and death: "Man dies and is always reborn in part by the mesenteric vessels, which are the root of vital nourishment. . . . One takes up life and the other gives out death. . . . This process is the ultimate one that only occurs in underground, that is to say in graves."

74. Studies of a Wig for Leda

c. 1506–15, Windsor, Royal Library, 12516

Leonardo's *Leda and the Swan*—his only painting of a mythological subject—was regarded as one of his greatest paintings and was very influential. There is no record of it after 1775. It is now known through a series of copies and variants, of which that at Wilton House (below right) is probably the best. It shows Leda, the Queen of Sparta, in close company with the swan who seduced her (Jupiter in one of his many rapacious disguises). The four progeny of their union surge boisterously from two giant eggs. The setting is moist and succulent. It was very much an essay on the fecundity of nature.

Other ancient and Renaissance representations of this subject depict the act of intercourse. Leonardo's depiction was conceived not as a narrative but as a sensual portrayal of the naked Leda with her attributes—the swan and the babies.

A series of very spirited drawings survives, including early ones in which Leda kneels in a twisting pose based on a Roman Venus. The studies on this sheet (opposite) in pen and ink with black chalk are for Leda's very elaborate wig. They feature the insistently curved pen strokes that Leonardo increasingly adopted after 1500.

The intricate plaits and whorls of the wig itself work tightly engineered variations on the vortex motion of water. Leonardo noted that "the motion of the surface of water . . . resembles the behavior of hair" (see full quote on page 183). He made play between the artificial vortices of the wigmaker's art and the licentious freedom of Leda's own hair, which cascades from the lateral edges of the wig and spouts forth from the center of the whorls.

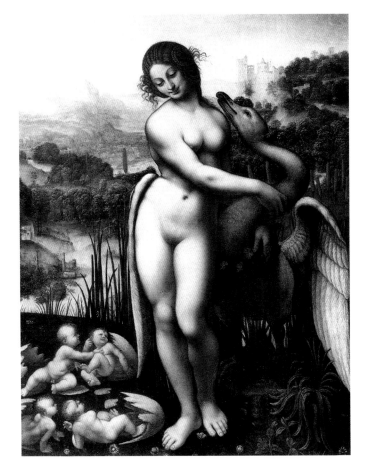

Typically for Leonardo, he was not content to invent something that would work only in the picture—he also had to understand the total structure of the wig. Thus we see two variants of the back, the lower of which displays a developed knot design. Beside a study of the wig on another sheet he wrote, "this can be taken off and put on without damaging it."

RIGHT *Leda and the Swan*, after Leonardo, unknown artist, c. 1525.

141

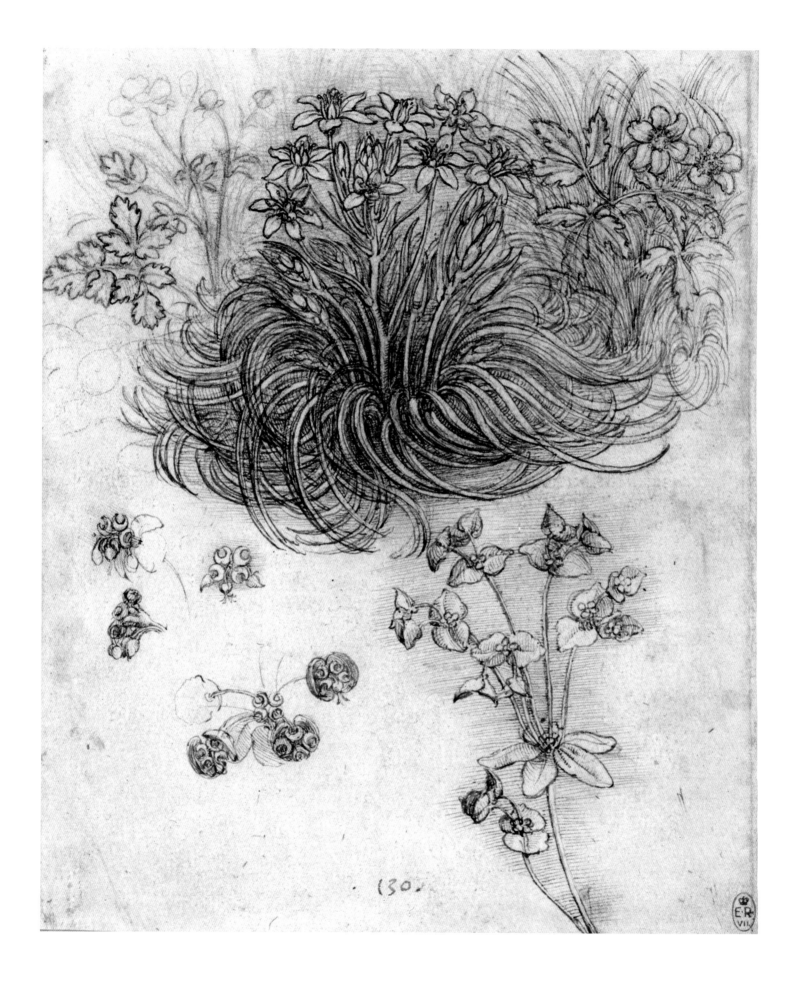

75. Studies of the Star-of-Bethlehem (*Ornithogalum umbellatum*), Crowfoot (*Ranunculus aquatilis*), Wood Anemone (*Anemone nemorosa*), and Sun Spurge (*Euphorbia helioscopia*)

c. 1506–8, WINDSOR, ROYAL LIBRARY, 12424

Along with his many other projects for treatises on aspects of nature, Leonardo was considering a "discourse on herbs." Both the star and the sun spurge were medicinal herbs (both are now considered unsafe to consume). To this end, he began recording the appearances of various plants and their flowers as a guide to their identification, and as a hymn to nature's inventive beauty. However, as in all his studies of nature, he sought to draw out the structural rationales of the whole and parts.

The main plant on this page, the star-of-Bethlehem, is drawn with wonderful rhythmic vitality. The stems of the star-like flower sprout above thin leaves that surge from the center of the plant like water in vortex motion. The basic disposition of the plant is accurate, but the leaves have been organized by Leonardo in a way that is very improbable in a natural specimen. He constructed an ideal specimen that speaks in a very definite way of spiral growth. It is what he called a "demonstration."

The close presence of the plants to the left and right seem to suggest that he was looking at flowers in a meadow, but it is equally likely that he was creating a composition from picked flowers with accompanying leaves.

He was particularly fascinated by the unusual structure of the inflorescences and branches of the succulent sun spurge on the bottom right. While looking at plants, he always had in mind structural features that might let him devise a classification. On a drawing of a rush and sedge he attempted to define the "types" of rushes, and noted that one had a round stem while another was triangular in cross section.

The portrayal of the plants on this sheet is fully in keeping with the vegetation he was planning for his *Leda and the Swan* (see page 141). On the fertile ground, plants, including bulrushes, were to be growing in lush abundance. These component parts of living nature belonged to the same system of "vivification" in the "body of the earth."

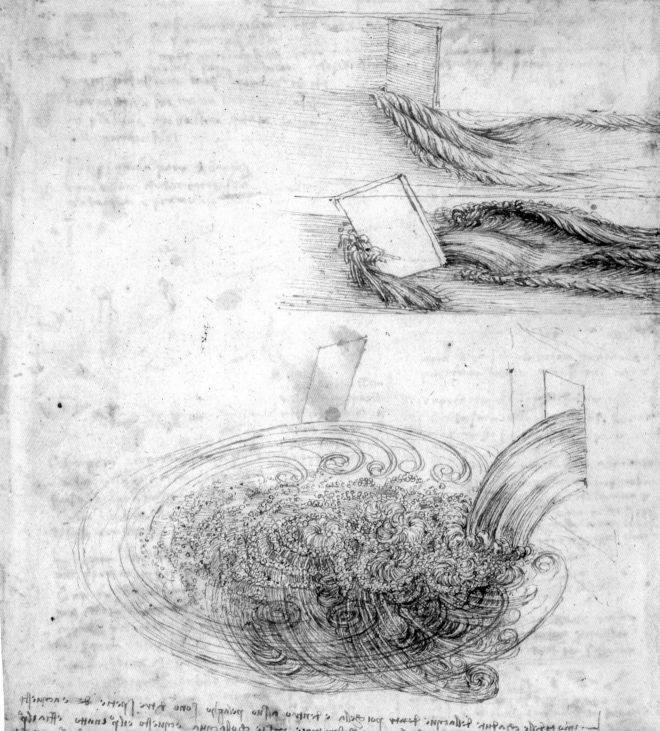

76. Studies of Turbulent Flow Past Tilted Obstacles and Water Falling into a Pool

c. 1508–9, Windsor, Royal Library, 12660v

This astonishing drawing stands at the climax of Leonardo's intense studies of water in motion, including those in the Codex Leicester (see pages 146–47). The setup in the main study resembles that of the experimental tank with glass sides that is twice illustrated in the Codex. The skeins of vortices streaming out behind the rectangular obstacles in the two upper drawings irresistibly resemble flowing hair. Leonardo noted more than once this analogy between water and hair (see pages 141 and 183), adding that "the motions of wind resemble those of water."

The main study may be regarded as a composite "anatomy" of turbulence, compiled in much the same manner as the great synthesis of the anatomy of a woman on page 138. It brings together various hydrodynamic components: the motion of water "in itself" inexorably completing its whirling action according to the amount of impetus embedded in each current; the rebounds of water striking water at the point of the water's entry into the pool, where the surface is forced downward; rebounds from the bottom of the pool; and the rise of submerged bubbles that surge upward in rosette formation, exploding noisily at the surface.

Leonardo himself aspired to classify the effects: "the motions . . . are of three kinds, to which a fourth may be added, which is that of the air being submerged in the water." He somewhat lost track of his classification during the course of his heroic efforts to cope with the variables involved. For instance, "this water then emerges in the shape of large bubbles, acquiring weight in the air and on this account falls back through the surface of the water, penetrating as far as the bottom, and it percusses and consumes the bottom."

The lowest note, squeezed in on the bottom right, tells that Leonardo has observed from "a boat" that "water within water more completely obeys the revolutions of its impacts than the water that borders on the air, and this arises because water within water has no weight, but it has weight within air."

"The skeins of vortices streaming out behind the rectangular obstacles in the two upper drawings irresistibly resemble flowing hair. Leonardo noted more than once this analogy between water and hair."

77. Studies of Water and Obstacles, with a List of Books for Leonardo's Treatise on Water

c. 1508, Collection of Bill Gates, Codex Leicester, 15v

The Codex Leicester, once owned by the earls of Leicester, consists of seventy-two pages of dense writing, generally with marginal illustrations. It is largely devoted to all aspects of the science and management of water in motion, on which Leonardo had long been planning a comprehensive treatise.

On this page, which contains thirty-eight "propositions" about water, each marked with a big capital letter, he lists the "books" that he plans to include in the treatise. He begins with the nature and physics of water, "Of the waters in themselves." He then looks at the sea, the "veins" (water channels within the earth), and the rivers. He moves progressively toward more detailed matters: "the natures of the beds," "the objects" (transported within the waters), "the gravels," "the surfaces of waters" (waves etc.), and "things moving [floating] on the surfaces." Practical concerns come next: "the repairs of rivers," "the conduits," "the canals," "the instruments tuned by waters" (for example, mills), and "making water to rise." He finishes with "things consumed by waters." This was not the first or the last of his plans for the treatise.

In the drawings here, he considers various kind of fixed obstacles that might be used to control the flow of water: "stationary obstacles in the rivers are the cause of the preservation of the islands, sandbanks and their depths, because they always form a firm shield against the oncoming waters."

The uppermost drawing demonstrates that "if the obstacle is sloping where it faces the oncoming waters . . . it will not excavate soil from its front, but on the side and back it will." The water courses over the wedge-shaped obstacle, turbulently excavating the bed behind it. Here, as elsewhere, Leonardo is concerned about working with the power of water so that it can be persuaded to achieve his ends, rather than fighting it. At the bottom of the page he wrote, "the science of these objects is of great usefulness because it teaches how to bend the rivers and avoid the ruins of the places struck by them."

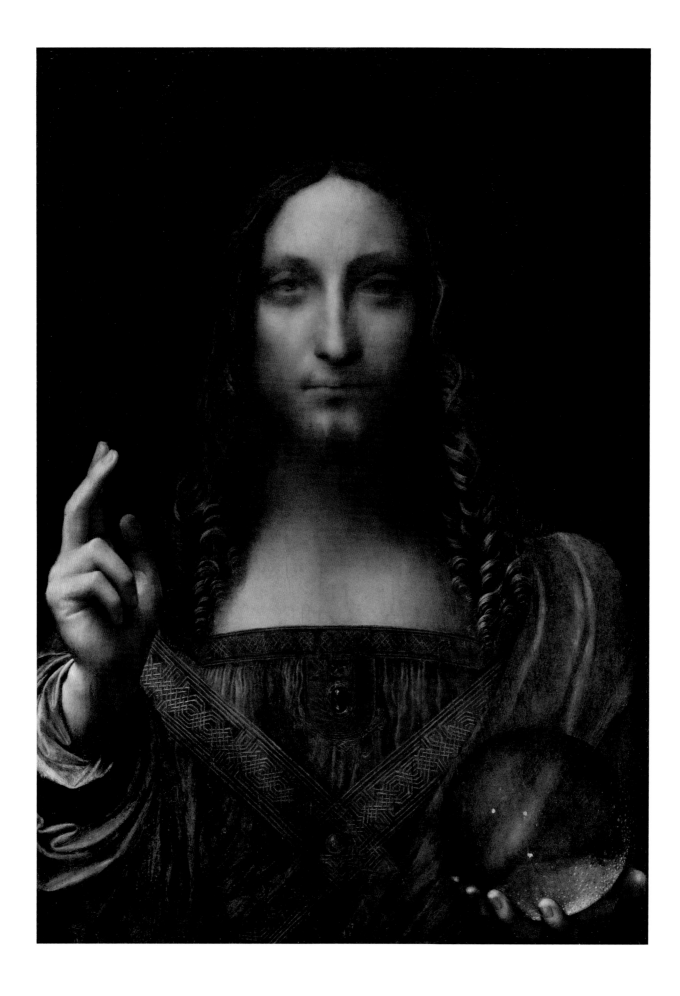

78. Salvator Mundi
c. 1504–10, Abu Dhabi, Louvre

79. Study for the Drapery on the Chest of the Salvator Mundi and for a Sleeve
c. 1504, Windsor, Royal Library, 12525

80. Study for the Sleeve of the Salvator Mundi
c. 1504, Windsor, Royal Library, 12524

The world's most expensive work of art, sold at Christie's in New York on November 15, 2017, for $450 million, is the first autograph Leonardo painting to appear since the early twentieth century. It was bought in 2005 for less than $1,175 at an auction in Louisiana by two dealers, Robert Simon and Alexander Parish. It was sent for sale by the Kuntz family of New Orleans, and had earlier featured in the impressive Francis Cook collection in England, heavily overpainted and unrecognizable as a Leonardo. Robert Simon oversaw its conservation and bore witness to the gradual emergence of the damaged original. In its newly restored form, it first appeared in public in the major show *Leonardo da Vinci: Painter at the Court of Milan* at the National Gallery in London during the winter of 2011–12. It was then purchased by the Swiss art entrepreneur Yves Bouvier, who owns major storage facilities for valuable works of art. He was acting for the Russian collector Dmitry Rybolovlev, who subsequently consigned it for sale at Christie's. It has been quite widely accepted as by Leonardo or substantially by him.

There is no documentation for the commissioning of the picture, but a "Christ in the manner of God the Father" appears in the 1525 list of paintings owned by Salaì. It inspired a number of copies and versions, and was engraved by the Bohemian etcher Wenceslaus Hollar in 1650. There are also two drawings for the drapery at Windsor.

The subject of the "Savior of the World" is traditional. The basic elements are Christ's iconic frontal pose and gaze, his blessing hand, and the orb of the earth that he holds. The emotional tone is set by the Gospel of St. John (14:6): "I am the way, the truth, and the life." In St. Matthew (11:29), Christ invites us to "Take my yoke upon you, and learn of me; for I am meek and lowly in heart: and ye shall find rest unto your souls." The bands on Christ's chest, adapted from the crossed stoles of priests, signal the yoke we are invited to bear.

Within this set framework, Leonardo has rethought the iconography and introduced a new kind of communicative power. The most striking innovation in the content involves the sphere, which no longer represents the earth. It is made from rock crystal, a semiprecious mineral that was prized for prestigious objects, like reliquaries. Inside the sphere, we can see the inclusions that are characteristic of rock crystal. These are small gaps that arise as the molten mineral cools. Leonardo describes with delicate precision how the inclusions catch the light. He has transformed the terrestrial globe into the crystalline sphere of the heavens, and Christ therefore becomes "Savior of the Cosmos."

Leonardo shows Christ's features in "soft focus," using fine glazes of color. Christ's blessing hand and the fingers of his left hand are depicted more sharply, and seem to move closer to us, creating depth within what is otherwise a very shallow space. This is in keeping with Leonardo's researches into the eye, in which he emphasizes how uncertain we are about the precise edges of forms, while recognizing that there is an optimum distance at which objects are seen more clearly (see page 131).

This optical uncertainty renders Christ's features elusive, in spite of their assertive frontality. This indefiniteness suggests that Christ, even though he has assumed human guise, belongs to an ineffable realm distinct from ours. In this the work shares much with the *St. John the Baptist* on page 188.

Although the paint surface has suffered as the result of the cracking of the walnut panel and some crude earlier restorations, there are passages that bear witness to Leonardo's unrivaled skills. The shiny curls of Christ's hair, particularly on his left, exhibit the vortices that Leonardo described as shared with water in motion (see page 183). The rivulets of drapery that flow down his chest recall those in the *Mona Lisa*. The play of light on Christ's fingertips in front of the orb is beautifully described. His blessing hand is realized with understated anatomical conviction—something that the copyists always miss. The angular interlace on Christ's crossed yolks, on the upper band of his tunic, and on the central plaque with its translucent jewel, are incisively drawn and lit in the best-preserved areas. The geometry of the interlace recalls Islamic patterns Leonardo would have seen in Venice in 1500.

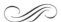

THE FOLDS OF THE DRAPERY ON CHRIST'S CHEST are studied in a very subtle drawing in red chalk on red paper (opposite, right), which anticipates the soft effects in the actual painting. Leonardo was working out the way that one of the crossed bands would affect the patterns of folds. The second study on the page, heightened in white, may present an early idea for the sleeve of Christ's raised arm.

The other drawing (opposite, left), in the same refined medium, is definitely for Christ's right sleeve, and the outer folds are quite closely followed in the painting. However, in the drawing, the upper part of the sleeve is gathered into a band around his wrist. The configuration was adopted

in one of the closer copies of the *Salvator*, whose location is now unknown. What this indicates is that the painting underwent a prolonged genesis, and motifs that were not to appear in the final work seeped into the awareness of a painter in Leonardo's immediate circle. This leaking of abandoned motifs also happened with *Madonna of the Yarwinder* (see pages 102–5).

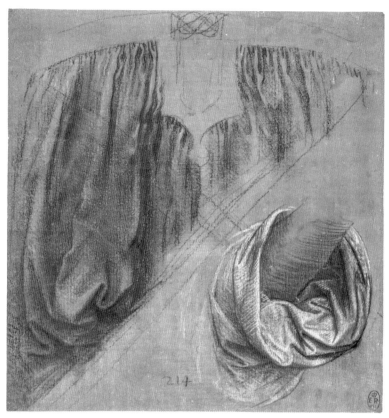

LEFT *Study for the Sleeve of the Salvator Mundi,* c. 1504.

ABOVE *Study for the Drapery on the Chest of the Salvator Mundi and for a Sleeve,* c. 1504.

81. Virgin of the Rocks

C. 1495–1508, London, National Gallery

The panel of the Virgin, Child, St. John, and the Angel Uriel in the Louvre (see page 40)—intended for the center of the large altarpiece for the Confraternity of the Immaculate Conception in Milan—was never installed. It seems likely that it was commandeered by Ludovico Sforza in 1494.

When Leonardo left Milan in 1499, the Confraternity still had not received a painting of the Madonna as specified in the contract of 1483 (see page 41). In 1506, when Leonardo was still absent from Milan, arbitrators were appointed to resolve the tangled dispute. A year later, a long document summarized the complex sequence of events, noting that the painting was still to be completed. In 1507–8, after Leonardo had returned to Milan, the replacement painting was finally installed in the altarpiece. This painting was purchased for the Marquis of Lansdowne in 1785 and subsequently entered the National Gallery in London.

Technical examinations of the London picture have revealed an underdrawing that portrays the kneeling Virgin on a much larger scale and in a style similar to that of the disciples in *The Last Supper*. It seems that the replacement picture was begun in a revised form in the mid-1490s, but was later completed in a way that makes it closely resemble the first version. The main compositional change is that the angel's pointing hand has been removed.

How far did Leonardo himself paint what is essentially a copy? Many of the most important features of the painting testify to Leonardo's handiwork, not least the angel's diaphanous draperies, scintillating curls, and refined facial features, the subtle modeling of which display his distinctive handprint technique. The plants and vegetation are characterized by the more synthetic quality of his nature studies after 1500. However, the more generalized qualities of the rocks, which are less geologically differentiated, may indicate that Ambrogio played a role in the execution of the painting. The angel's hand and Jesus's back remain unfinished, apparently unnoticed by the Confraternity.

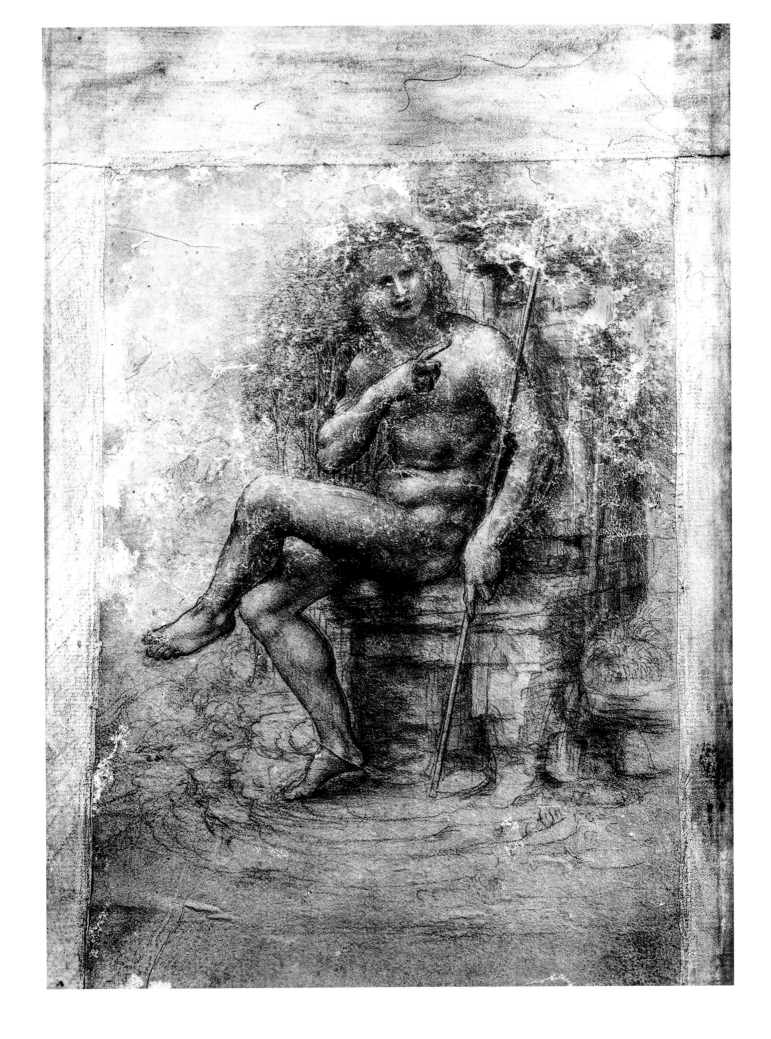

82. Study for a Seated St. John the Baptist

C. 1508–13, FORMERLY MUSEO DI SACRO MONTE, VARESE (LOST)

This very battered drawing was stolen from the Museo di Sacro Monte in 1974.

To show St. John naked or nearly naked in a landscape is exceptional at this time. The direct communication of the saint is consistent with Leonardo's exploration of how painted figures can be set in dialogue with the spectator in such a way that we become participants in completing an implicit story. The saint stares at us as intensively as Christ in the *Salvator Mundi* (see page 148) or the Louvre *St. John* (see page 188). He points to the cross on his staff as an unmistakable allusion to Christ's sacrifice.

Allowing for its condition and for its being known only through old black-and-white photographs, the drawing (which was in red chalk on red paper) seems to be by Leonardo himself. The pose is skillfully articulated in space, and the saint's anatomy is modeled in the nonemphatic manner that Leonardo recommended for youthful figures. The stratified rocky seat and the rapidly drawn, curving strata at the saint's feet are typical of Leonardo. The mountainscape in the distance and the trees are like those in the Louvre *St. Anne* (see page 160).

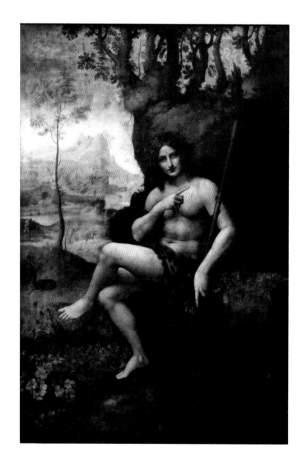

The saint's relatively high degree of finish suggests that this drawing was intended as a model for a devotional picture of the kind generated in the workshop. Two paintings of St. John, "large" and "small," appear in the Salaì list of 1525. A painting, right, corresponding to the drawing, survives in the Louvre—albeit much altered. It was recorded in the French royal collection at Fontainebleau in 1625, but was overpainted as a *Bacchus* in the late seventeenth century. It may have been felt that the image was too sensual in tone for a saint. St. John's cross has been transformed into Bacchus's thyrsus (a wand of giant fennel topped by a pine cone). He also has ivy in his hair and a leopard skin. The painting in its present state suggests that it was a studio picture based on the now-lost drawing.

ABOVE RIGHT *St. John the Baptist, known as Bacchus*, Italian School, workshop of Leonardo da Vinci?, sixteenth–seventeenth century.

155

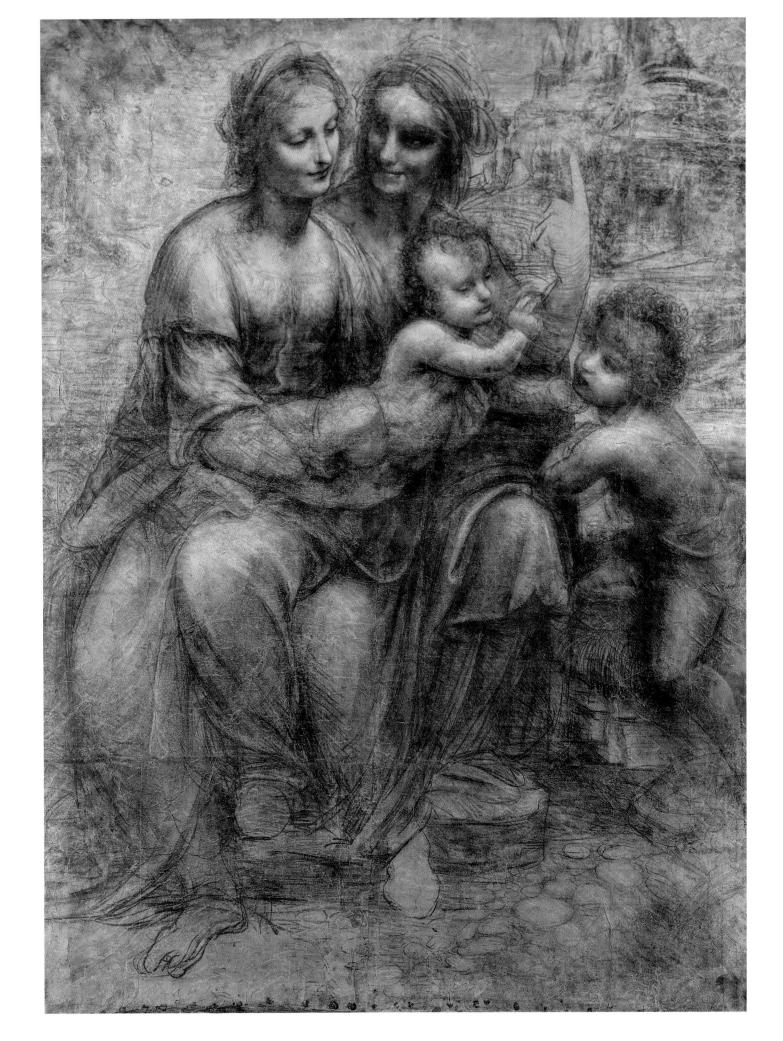

83. Cartoon for the Virgin, Child, St. Anne, and St. John the Baptist
c. 1507–8, London, National Gallery

84. Drawing for the Cartoon of the Virgin, Child, St. Anne, and St. John the Baptist
c. 1507, London, British Museum

Leonardo was much occupied with paintings of the Virgin, Child, and St. Anne after his return to Florence. In 1501, Fra Pietro da Novellara described the painting to Isabella d'Este, saying that Leonardo was

> portraying a Christ Child of about a year old who is almost slipping out of his Mother's arms to take hold of a lamb, which he then appears to embrace. His Mother, half rising from the lap of St. Anne, takes hold of the Child to separate him from the lamb (a sacrificial animal) signifying the Passion. St. Anne, rising slightly from her seated position, appears to want to restrain her daughter from separating the Child from the lamb. She is perhaps intended to represent the Church, which would not have the Passion of Christ impeded. These figures are all life-size but can fit into a small cartoon because they are all either seated or bending over and each one is positioned a little in front of each other and to the left-hand side.

As with the *Madonna of the Yarnwinder* (see page 103), Fra Pietro was exceptionally responsive to the new kind of narrative Madonna invented by Leonardo.

In his "Life of Leonardo da Vinci" (1550 and 1568) entry in *Lives of the Artists*, Giorgio Vasari describes how Leonardo produced a cartoon after returning to Florence in 1501 that included the infant St. John as well as the lamb, which the painter exhibited in an unprecedented manner for two days, to much acclaim. It is unclear if Vasari was describing a different cartoon from that seen by Fra Pietro or if he was conflating two separate compositions, one of which was the cartoon that was to lead into the Louvre painting on page 160.

Such cartoons very rarely survive, and this one has suffered much wear and tear, including a shotgun-blast assault in the National Gallery by an ex-soldier in 1987. It does not correspond precisely to the versions described by either Fra Pietro or Vasari, in that it includes St. John but no lamb. The implicit narrative in this case involves Jesus blessing and comforting St. John while supported by the smiling Virgin, as St. Anne knowingly points heavenward to remind her daughter that everything is divinely ordained. It is possible that St. Anne is actually St. Elizabeth, the mother of St. John.

This kind of highly modeled, full-scale drawing was pioneered by Leonardo. In his hands, it transcends its functional nature and becomes a work of formal beauty and emotional engagement in its own right. The characteristically unfinished passages also reduce its functionality. The three-dimensional monumentality of the densely integrated figure group is typical of his second Florentine period.

A REMARKABLE DRAWING IN THE BRITISH MUSEUM (opposite) shows Leonardo working out the complex group in a frenzy of invention. Within a drawn frame that has a measured scale across its base, he brainstormed so intensively in black chalk and two colors of ink that it is difficult to see what is emerging in the more tangled areas. He then took up a sharp instrument and pressed the preferred elements of the design onto the reverse of the sheet (not shown here). Below the larger group on the front side of the sheet, he sketched the figures on a small scale in black chalk and pen, and extracted component parts of the composition for improvised study.

The little sketches of hydraulic engineering also drawn on the sheet include a waterwheel and a braced structure that could resist water. The incomplete note on the bottom left reads, "make locks where the water . . ." The sketches in the left corner are similar to those in the Codex Leicester, in which Leonardo was much concerned with the management of water (see pages 146–47), confirming the date of c. 1507–8. In the note to the right he reminds himself to ask "Paolo of Talvecchia to see the stains in the German stones." This probably refers to the kind of pebbles with colored veins that appear in the foreground of the Louvre *St. Anne* on page 160, and were likely intended for the painting he was planning in the cartoon (on page 156).

OPPOSITE *Drawing for the cartoon of the Virgin, Child, St. Anne, and St. John the Baptist*, c. 1507.

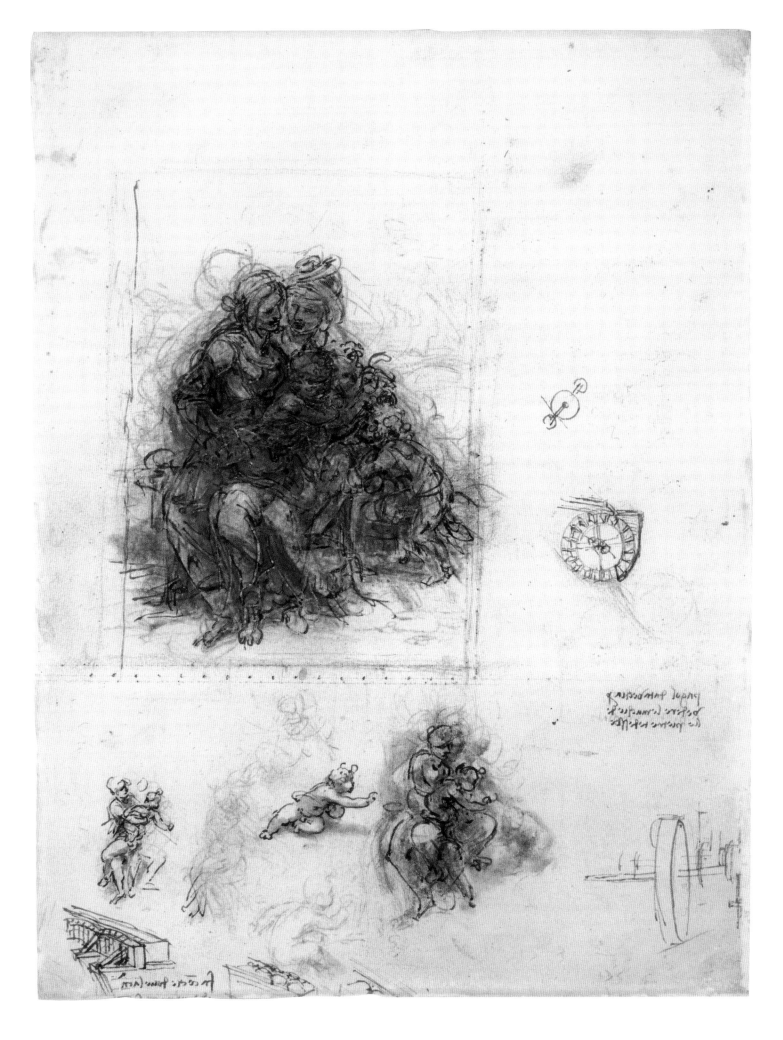

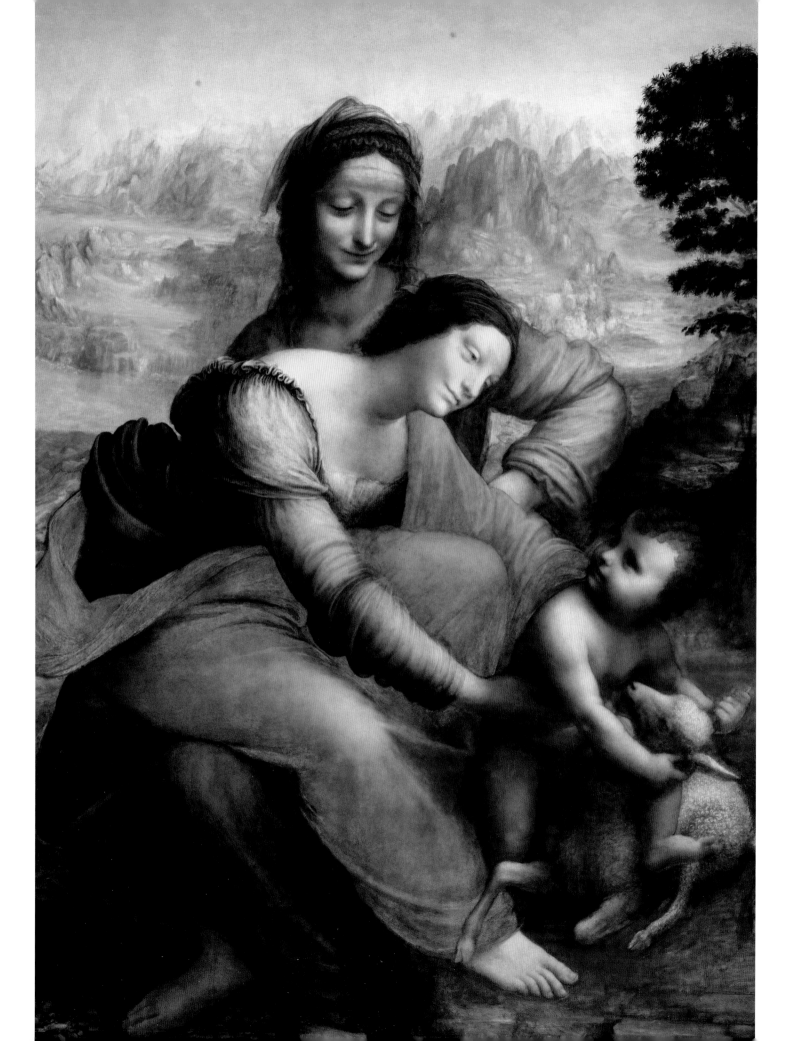

85. Virgin, Child, St. Anne, and a Lamb

C. 1508–16, PARIS, LOUVRE

86. Study for Head of St. Anne

C. 1508–10, WINDSOR, ROYAL LIBRARY, 12533

87. Study for the Drapery of the Virgin

C. 1508–10, PARIS, LOUVRE

The culmination of the various projects for a *Virgin, Child, and St. Anne* is the painting in the Louvre. It almost certainly stands at the end of the series of drawings and cartoons on the subject, and was probably the only finished painting. We have the cartoon described by Fra Pietro da Novellara in 1501, the one that features in Vasari's biography of Leonardo, and the surviving cartoon in London depicted on page 156. No cartoon or compositional study is known for the Louvre painting, although the version described by Fra Pietro was obviously similar in concept.

The Louvre painting's origins may lie in two Madonnas that Leonardo promised to bring from Florence to Milan when he entered the service of Louis XII in 1507–8. Leonardo wrote to Charles II d'Amboise, governor of Milan, that he intended "to bring . . . two pictures of . . . Our Lady of two different sizes, which have in my own time been brought to completion for our own most Christian King, or for whomsoever Your Lordship pleases." A year earlier, Charles had told the Florentine government that Leonardo was obliged to make a painted "panel" for the king. Louis's wife was Anne of Brittany, and a painting featuring St. Anne would have been very appropriate.

A "Madonna and Child set in the lap of St. Anne" was seen in Leonardo's residence near Amboise in 1517 by Antonio de Beatis, who was one of the secretaries to the visiting cardinal of Aragon. What is probably the same painting features in the Salaì list in 1525 as a "painting of St. Anne." It seems that King Louis XII never received his picture. A painting of the subject was later recorded in Francis I's chapel not long after Leonardo's death. It appears that one of the cartoons also entered the French royal collection.

There is no direct evidence to determine when the painting was begun and when it was finished. There is a consensus that it is the last of his major paintings, and we might reasonably assume that it was only finished when Leonardo was in France after 1516.

The painting is the most formally and emotionally fluent of the various St. Anne compositions, based on a series of interwoven curves and a diagonal chain of tender glances. The tone of the imagery is perfectly captured by the contemporary poet Girolamo Casio, who was a friend of Boltraffio, Leonardo's leading pupil:

On the St. Anne Leonardo Vinci is painting, who holds in her arms Mary the Virgin,

who does not want her Son to mount the lamb.

Ecce Agnus Dei [behold the lamb of God], said John,

Who entered and departed the womb of Mary

Only to guide with his holy life

Our feet to the celestial sacrifice.

Of the immaculate Lamb he would seize and cries

To make himself a sacrifice for the world.

His mother restrains him for she does not wish

To see her son's destruction and her own.

St. Anne, as one who knew

That Jesus was clad in our human veil

To cancel the sin of Adam and Eve,

Instructs her daughter with pious zeal,

Drawing her back from light thought,

That his immolation is ordained by Heaven.

The paint is applied with magical lightness in thin glazes that endow the forms (especially after the recent cleaning) with an extraordinary radiance. Leonardo retained more color in the shadows here than in his earlier Madonnas. The details are highly refined: the wriggling curls of the lamb's soft coat; the beautifully observed rocks and colored pebbles below St. Anne's feet; the elusive features of St. Anne, who enigmatically knows the secrets. . . . The plaits and veils of St. Anne's headdress are studied with melting delicacy in a black chalk drawing at Windsor, opposite, top left. Her features in the drawing are as much inferred as described, inviting our emotional engagement.

The painting's landscape, which signals the body of the earth as in the *Mona Lisa*, floats evanescently in the background, the mountains bleached by bright mists and caressed by mobile waters. We know that Leonardo paid much attention to aerial perspective and the blueness that resulted from moisture borne in the air. The tall tree, even though its greenness has decayed to brown, testifies to how he analyzed the appearance of leaves, clusters of leaves, and branches at different distances from the viewer. For Leonardo, no part of any picture could be treated casually. Every visual effect had to be reconstructed on the basis of his study of how nature looks and how it works.

He stressed that the painter must observe how different cloths behave when draped over limbs and under the pressure of folding. Heavier cloths fall into longer and rounder curves, as in the skirts of St. Anne and the Virgin. Thin cloths such as silks and muslins fold more sharply into smaller and more angular folds. The upper layer of diaphanous material over the Virgin's arms compresses into a series of concentric ripples with defined crests.

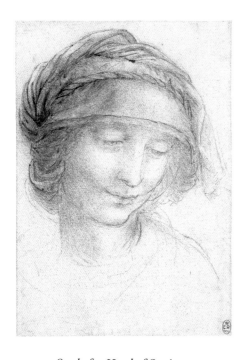

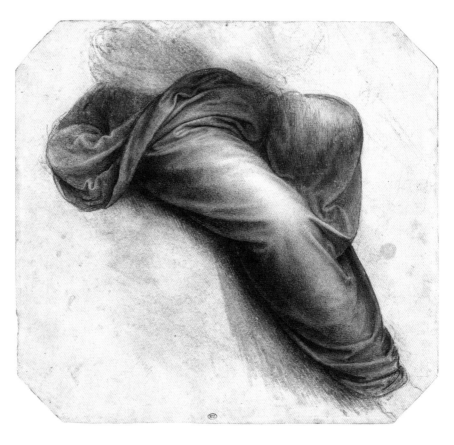

ABOVE *Study for Head of St. Anne,*
c. 1508–10.

RIGHT *Study for the Drapery of the Virgin,*
c. 1508–10.

The effects of the drapery over the Virgin's legs have been compromised over time by the deterioration and bleaching of the blue lapis lazuli, one of the most expensive but the least predictable of pigments. A drawing in the Louvre, above right, allows us to envisage the drapery's original appearance. The mixed medium—black chalk, washes of black and brown ink applied with a brush, and white heightening—defies our ability to tell precisely how it was applied. The effect is almost stippled. The result has an elemental force, like folded strata in the body of the earth.

THE CONVICTION OF THE PARTS AND THE WHOLE of the painting so disarms us that we forget the inherent implausibility of the subject and setting. The weightlessness of Leonardo's touch and the rhythmic buoyancy of his composition set aside questions about how the mobile weight of Mary's body could be comfortably sustained on her mother's lap. Leonardo is a supreme magician of the science of art.

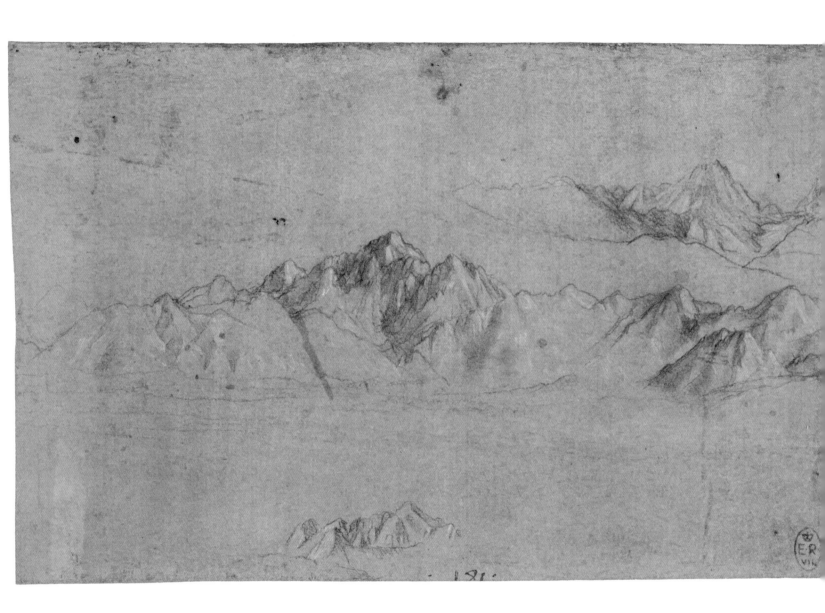

88. Study of Two Distant Mountain Ranges

This is one of a series of atmospheric studies of distant mountains in red chalk on red prepared paper. One can be dated definitely to December 1511, since it shows fires started in the Italian Alps by Swiss soldiers who were fighting against the French at the behest of Pope Julius II as part of the Holy League. We know that Leonardo made at least one journey to explore "the chain of the Alps," and climbed to a high vantage point to test how visibility was affected by altitude.

The improbable medium of red-on-red was chosen to reduce the tonal contrast between the drawing and the ground, in order to convey the loss of distinctness of even huge mountains viewed in the distance. Leonardo knew, of course, that mountains look increasingly blue as they are seen farther away—and he formulated rules for their increasing blueness—but here he was dealing with the loss of definition of the mountains' contours, as well as light and shade, rather than color. He noted that forms with dark shadows are more visible at a distance than those under full light.

In addition to using linear perspective, he noted, the painter can create an illusion of depth using "another perspective, which we call aerial, because through variations in the air we are made aware of the different distances. . . . And if you wish in painting to make one thing appear more distant than another you should represent the air as rather dense."

Those paintings from the *Mona Lisa* onward that contain landscapes exploit very similar panoramas of mountains, and he clearly sensed that they possessed an elemental beauty that spoke eloquently of the "body of the earth" and the passage of time. The veiled beauty of distant mountains, as in the late *St. Anne* on page 160, stands in sharp contrast to the violence of their creation during huge uplifts and collapses in the earth's crust—as Leonardo well knew. The majesty of mountains in his hands was both lyrical and terrible.

"The improbable medium of red-on-red was chosen to reduce the tonal contrast between the drawing and the ground, in order to convey the loss of distinctness of even huge mountains viewed in the distance."

89. Studies of the Light of the Sun on the Moon and Earth

c. 1508, Collection of Bill Gates, Codex Leicester, 2r

The main concern of the Codex Leicester is water in the body of the earth and the huge transformations that this body had undergone over time. The earliest folios deal with the relationship of light from the sun on the earth and with the moon, which seems to be a separate topic, but Leonardo was arguing that the seas of the earth play a vital role in reflected light on the moon.

Each page is densely written, with subsidiary illustrations, as in this second folio that illustrates the optical cause of the *lumen cinereum*, the "ashen light" in the shaded part of the moon. The main diagram shows the sun on the right illuminating the moon at an angle such that only a crescent of moonlight is visible from the earth. Nonetheless, he observed that the dark portion of the moon exhibits a glimmer of light. He explained this as resulting from "earth-light" reflected off the seas and impinging on the moon.

The small but meticulous drawing in the lower right shows this glimmer, and he further explained that the "ashen light" looks darker where it borders on the luminous crescent and lighter where it abuts the "blackness of the void." We can confirm this for ourselves, by following Leonardo's instructions: "If you want to see how the shady part of the moon is brighter than the background against which it is seen, cover the eye with the hand . . . , covering the [bright crescent of the moon]." This account of the subjective role of the eye in a scientific observation is very remarkable.

In this and related pages in the codex, he radically argued that the moon is essentially like the earth, and is not a perfect heavenly body: "The moon is clothed with its own elements, that is water, air, and fire and thus it sustains itself . . . in that space, as does our earth with its elements." Thus, the moon has seas, lands, and mountains of its own.

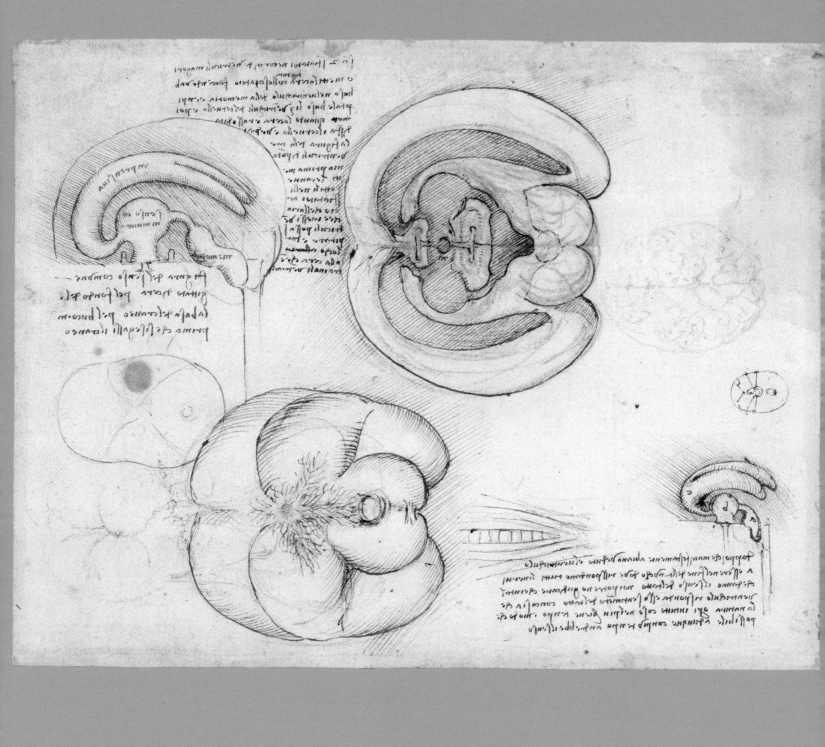

90. Ventricles of the Brain Injected with Wax

C. 1507–10, Windsor, Royal Library, 19127R

Leonardo had earlier accepted the traditional format for the ventricles as three more or less spherical containers joined along a horizontal axis (see page 75). Here he injected the ventricles with wax to see their actual shape.

His notes instruct the investigator to "make two vent-holes in the horns of the great ventricles, and to insert molten wax with a syringe, making a hole in the ventricle of the memory. . . . Then when the wax has set, remove the [substance of] the brain and you will see the shape of the ventricles. But first put narrow tubes into the vents so that the air which is in these ventricles can escape." This method is taken from the technique for making solid casts in bronze, which he would have first seen in Verrocchio's workshop.

In the very slight sketch on the right of the page, it seems as if sight is alone in passing to what Leonardo termed the *imprensiva* ("receptor of impressions"), while the other senses pass to what he now called the fourth ventricle. As in previous studies, he was striving to endow sight with a privileged location as the superior sense.

Below the schematized image at the lower right, he wrote, "the ventricle *a* is at the end of the spine where all the nerves that give the sense of touch come together. We can tell that the sense of touch operates in this ventricle, seeing that Nature works in all things in the shortest possible time and manner."

The sectioned brain on the top left and the view from below in the center of the page were seemingly made from a human specimen, whereas the *rete mirabile* (the fine network of blood vessels) on the bottom of the page is based on vertebrate anatomy, perhaps that of an ox. Leonardo was synthesizing his observations.

His radical reshaping of the ventricles does not affect his conception of how they function. In the see-through diagram in the upper left, the anterior ventricle is labeled *imprensiva*, the central one acts as the *senso comune* (confluence of the senses), and the compartment at the end contains *memoria* (memory).

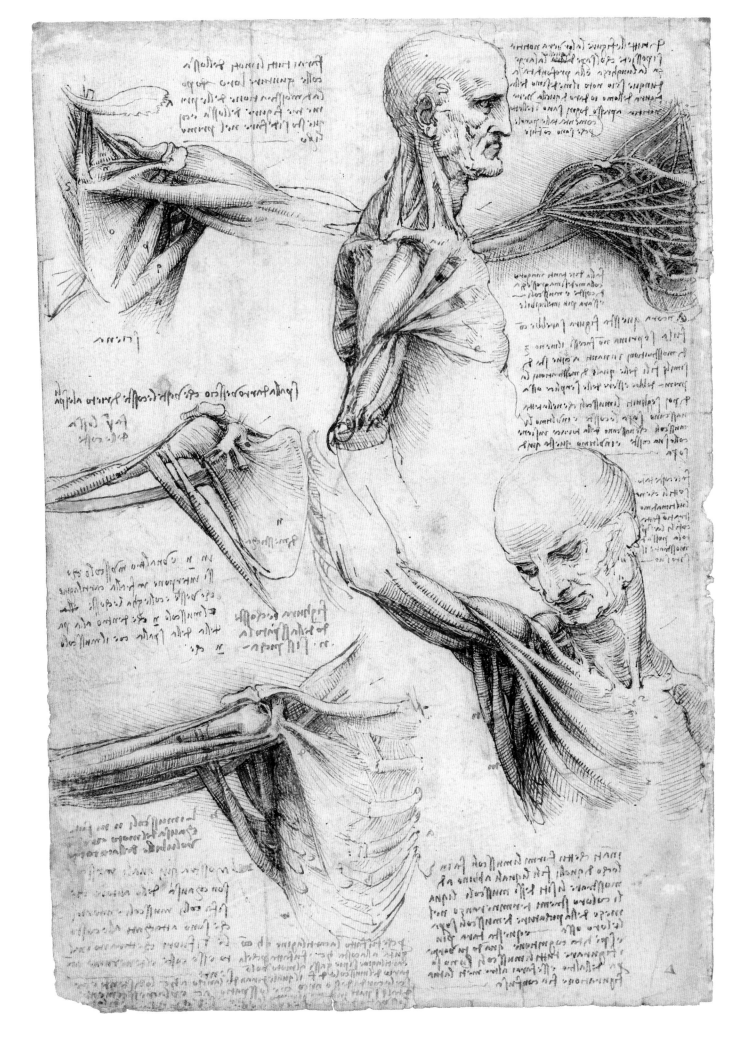

91. Bones and Muscles of the Shoulder and Neck, with a Wire Diagram

c. 1510, Windsor, Royal Library, 19003r

"In this winter of 1510," Leonardo optimistically wrote toward the end of that year, "I hope to expedite all this anatomy." Around this time he conducted his most brilliant researches into the machinery of the human body. He sought for a functional explanation of every anatomical feature as bearing witness to the perfection of natural design: "Although human ingenuity makes various inventions corresponding by means of various machines to the same end [as nature], it will never discover any inventions more beautiful, more appropriate or direct than nature, because in her inventions nothing is lacking and nothing is superfluous."

The first drawing on the sheet, the man seen in profile, displays the *pectoralis major*, the large breast muscle, separated in an exaggerated manner into separate bundles or fascicles, allowing a glimpse of the structures below. In the study of the man with a raised arm, the muscle becomes a series of bands to signify the main directions in which the muscle acts. This tendency to create "windows" in the upper layers reaches its climax in the diagram at the upper right in which all the muscles are reduced to wires. This technique shows the lines along which the contracting muscles pull on the levers of the bones. In a drawing of a leg (not shown) done around the same time as the opposite drawing, Leonardo explicitly states that he wants to construct a model from bones and metal wires.

The three drawings on the left of the sheet carry a strong sense of the dissected forms, as deeper structures are progressively disclosed. The drawing at the top, in which the trapezius has been severed at its point of insertion and hinged away, demonstrates a new technique in anatomical illustration. Leonardo exploited such separated or "exploded" forms in both his engineering and anatomical demonstrations. In his drawing of the vertebral column (not shown), he shows the first three cervical vertebrae separated from each other so that their individual shapes and articulations can be better understood. He argued that drawings that pay such attention to details of form and function will convey "true knowledge" in a way that verbal descriptions could never hope to emulate.

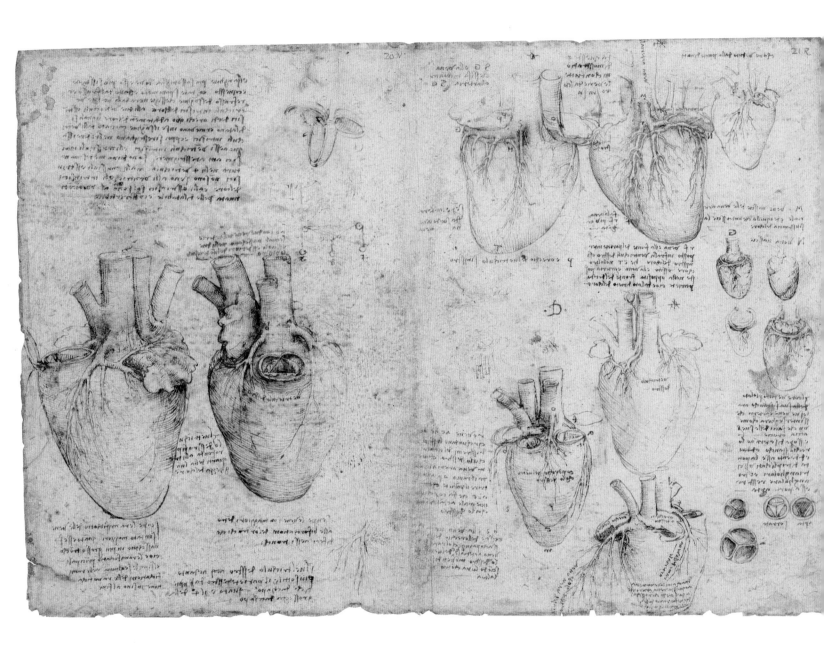

92. Studies of an Ox Heart, Its Major Vessels, and Its Aortic Valves

C. 1513, WINDSOR, ROYAL LIBRARY, 19073–19074V

93. Studies of a Tricuspid Valve, Vortices of Blood, and a Glass Model

C. 1513, WINDSOR, ROYAL LIBRARY, 19117V

After the series of anatomical demonstrations that synthesized what Leonardo had discovered about the vascular system of the "centenarian" (see page 133), he later returned to look in remarkable detail at the anatomy and working of the heart, using an ox heart as his prime source of information. This brilliant double sheet in pen and ink on blue paper, drawn with a great sense of organic grandeur, explores the blood supply to the heart itself and begins to look in detail at the three-cusp valves of the pulmonary vessels.

The two main drawings on the left page, showing auricles as well as ventricles, concentrate on the major vessels that originate from the heart. The pulmonary artery in the left drawing has been severed at its base and hinged back, while the other drawing, in which the heart has been rotated by 90 degrees, clearly displays the three fleshy cups of the valve that guards the entrance to the vessel.

Above those is a small drawing that shows how he intends to section the ventricles, which will be hinged back on either side of the septum. The septum itself was of major interest since it was supposedly penetrated by tiny pores that allowed the blending of the blood from either side of the heart.

The main drawings on the right page examine the blood supply to the exterior of the heart. He looks in some detail at the encircling coronary vessel, which he had diagnosed as having played a role in the "centenarian's" death. In the four diagrammatic sketches to the bottom right, he began to think about the geometry of the valves of the pulmonary artery and aorta. He referred to them as "triplicated triangular doors" and said that "this opened doorway will be triangular."

The pulmonary valves became the subject of one of his most remarkable pieces of scientific research, in which he analyzed organic form according to the principles of geometry. He realized that the valve is not operated by muscular action. He decided that it must be the format of the neck of the aorta and the resulting motion of the blood expelled from the heart that serves to close the valve, before the next thrust of pumped blood forces it open again.

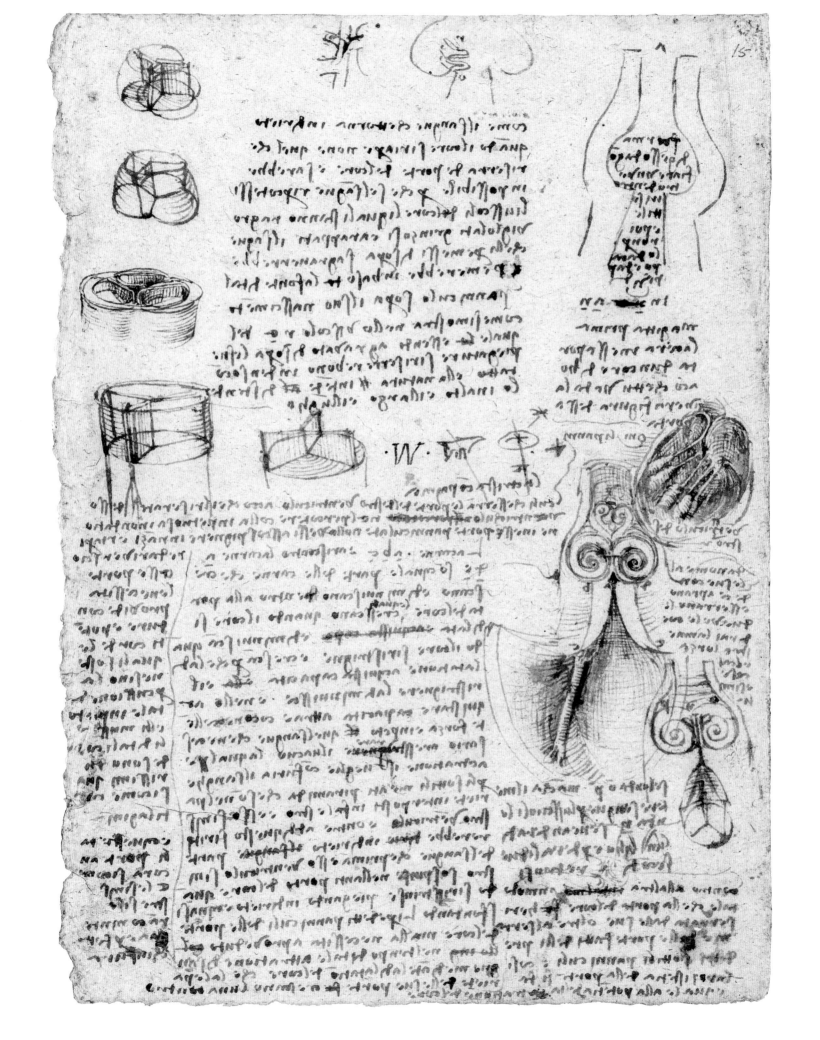

A further drawing at Windsor, opposite, shows the heart opened up and the neck of a pulmonary vessel sectioned to show its flask-like shape. On the basis of what Leonardo knew as a hydraulic engineer and theorist of water in motion, he reasoned that the blood in the progressively constricted vessel would turn back on itself in a vortex motion to close the valve. The primary vortices can be clearly seen, spiraling like ionic capitals in architecture, with small secondary vortices above.

In the diagrams to the upper left he transformed the valve into a piece of stereometric geometry, thinking about how three cusps open more readily than two.

Even more remarkably, he signaled his intention in a drawing and note at the top right to build "a mold of plaster in order to blow thin glass inside . . . but first pour wax into the doorway of the bull's heart so that you can see the true shape of this doorway." Such model building was new in anatomical science.

Leonardo could not of course see what was happening inside the heart but was bringing his knowledge of the motion of fluids to bear on the problem in order to create a visual and physical model. Modern imaging techniques can see what Leonardo couldn't. Morteza Gharib of Caltech built Leonardo's glass model, shown at left, and was then able to use new technologies to realize an image of the flow that confirmed the validity of Leonardo's deductions. Did Leonardo build the model on his own account? Looking at his drawings of flow in the valve, we may well think that he did.

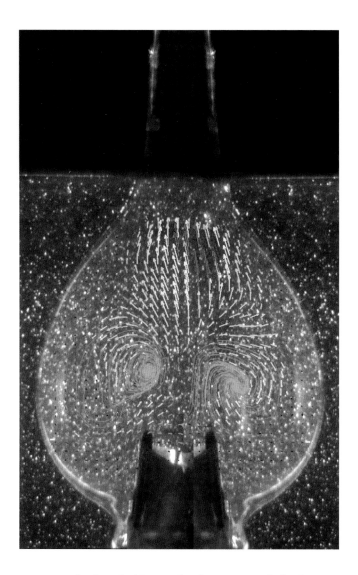

OPPOSITE *Studies of a Tricuspid Valve, Vortices of Blood, and a Glass Model*, c. 1513–16

ABOVE Glass model of bull heart built by Morteza Gharib, professor of aeronautics and bioengineering at Caltech, 2002.

"Leonardo could not of course see what was happening inside the heart but was bringing his knowledge of the motion of fluids to bear on the problem in order to create a visual and physical model."

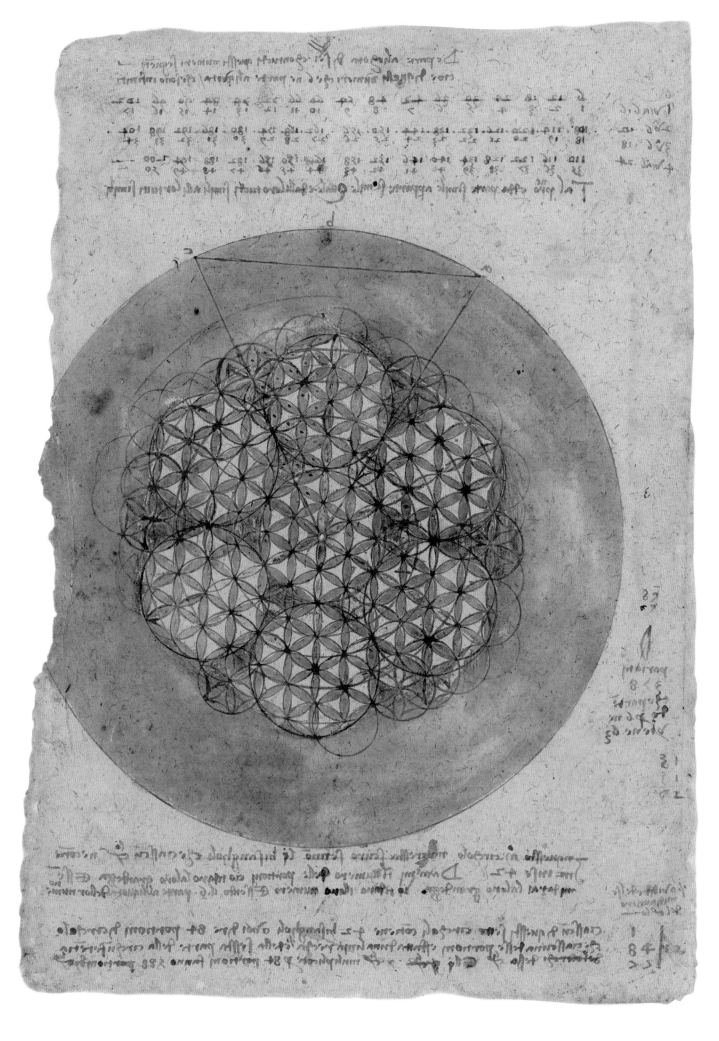

94. Sequences of Aliquot Numbers and Geometrical Studies of Areas

C. 1507–13, Milan, Biblioteca Ambrosiana, Codice atlantico, 307v

Leonardo believed that arithmetic and geometry "embrace all things in the universe." Above all, the design of nature, whether static or dynamic, worked with "proportion . . . which is not only found in number and measure but also in sounds, weight, time, and positions, and every power that exists."

In 1501, he became acquainted with a comprehensive philosophical encyclopedia by scholar Giorgio Valla (1447–1500) that began with substantial chapters on arithmetic, music, and geometry. It was from Valla that Leonardo picked up an intense interest in the relationship between areas enclosed by figures with curved and straight sides. This was related to the ancient and intractable problem of squaring the circle—that is to say being able to define a circle that was absolutely the same in area as a given square. Leonardo tested various solutions, practical and theoretical, and more than once convinced himself that he had found the answer.

Around 1514 he felt confident enough to declare that "as I have shown . . . various ways of squaring the circle. . . . I now begin the book called *De ludo geometrico* [*On Geometrical Recreations*]." This was to contain diverting exercises on the magic of number and form. The illustrated page here is characteristic of the dense patterns of equivalent areas formed by shaded and unshaded portions of intersecting circles.

At the top of the page he listed numbers that contain the aliquot of 6, such that proportional multiples of 6 rule throughout. In the big geometrical construction, he drew a circular figure that contains 6 circles surrounding a central one, each of which contains 6 units, making 42 units as a whole. He additionally constructed an isosceles triangle that divides the circumference of the larger circle into a sixth.

Although such constructions may seem to be no more than abstract "games," Leonardo saw them as indicative of the profound wonders of the mathematics that lie behind natural design. The heart valve (see pages 172–75) is an example of geometrical areas in dynamic action in the organ that regulates our life.

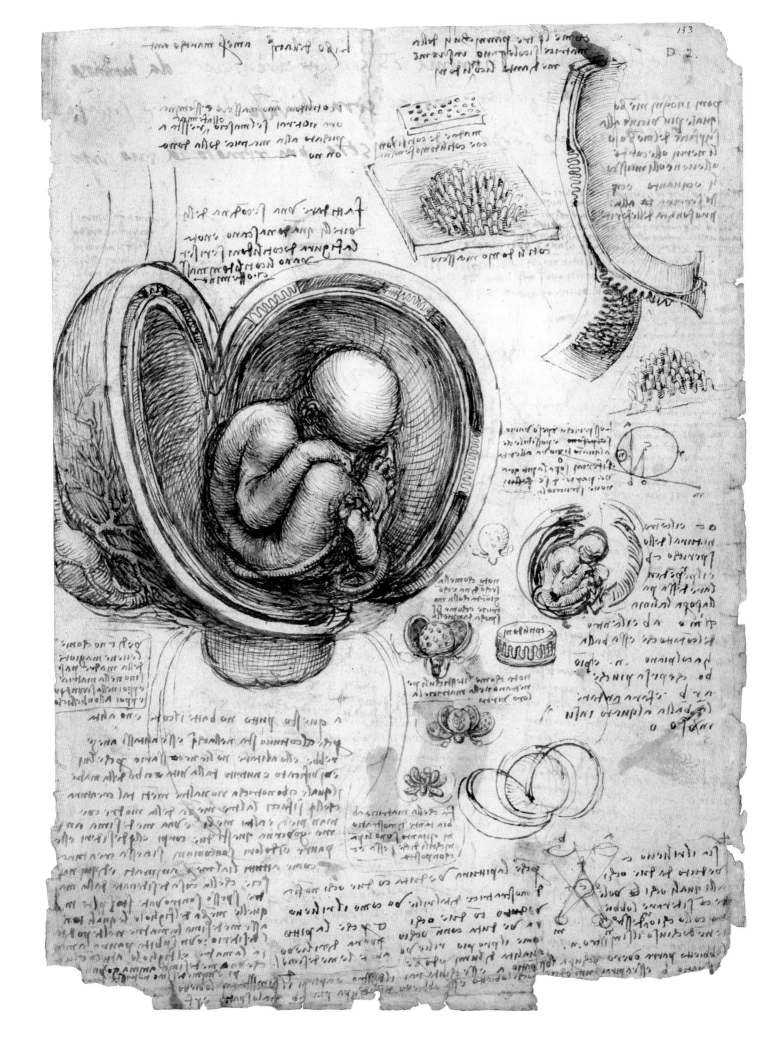

95. Studies of a Fetus in the Womb and of the Placenta

c. 1515, Windsor, Royal Library, 19074v

This moving study of the "great mystery" of the fetus in the womb stands at the formal and emotional climax of a series of drawings of human reproduction. The convincing pose of the fetus, modeled with densely curved pen strokes over red and black chalk, indicates that it was studied from nature. However the womb is more synthetic.

The spherical womb, also apparent in the smaller sketches, reflects Leonardo's desire that the gravid uterus should adopt the most perfect form, as it seems to do when a woman is in the late stages of pregnancy. In the diagrams in which he peels back the surrounding membranes and uterine wall, the fetus is seen to be encircled as if in a round seed-case.

The "cotyledonous" placenta consists of a series of separate pads on the uterine wall and the membrane surrounding the embryo of the kind he had observed in his dissection of a pregnant cow. He explained that as the uterus contracts after birth, the pads draw together and are packed as hexagonal units within a single placenta.

The demonstrations at the top right show how the fingers of each unit of the placenta interdigitate with those of the uterine wall, either as matching protrusions or as insertions into receptive cavities. The diagrammatic technique that he adopted to demonstrate the peeling back of the two membranes is wholly novel.

The other two diagrams on the page might seem to have nothing to do with the main subject. The demonstration at the middle of the right margin shows how a round ball on a slope can be eccentrically counterweighted so as not to roll. In fact, this is relevant to the rotation of the baby in the womb, given that it is not in the head-down position necessary for a standard birth. The optical diagram at the bottom left shows "why a picture seen with one eye will not demonstrate such relief as when shown with both eyes." He was in effect saying that even his very powerful modeling of the fetus cannot equal seeing stereoscopically.

RIGHT Detail of womb opening from *Studies of a Fetus in the Womb and of the Placenta.*

96. A Chain Ferry on the Adda at Vaprio near the Villa Melzi

C. 1511–13, WINDSOR, ROYAL LIBRARY, 12400

During his second period in Milan (1506/7–1513), Leonardo was joined by Francesco Melzi (c. 1493–1570), a young nobleman from Vaprio d'Adda. Unlike the standard workshop apprentices, Francesco was well educated and socially adept. He became Leonardo's close companion and heir to the master's drawings and manuscripts. He is elusive as an artist in his own right, but seems to have copied the master's drawings skillfully. When Leonardo died in 1519, Francesco testified that Leonardo was "like an excellent father to me. . . . Everyone is grieved by the loss of such a man whose like nature no longer has it in her power to produce."

This small drawing in pen and brown ink was made looking down from the Melzi family's villa. We can see a ferryboat consisting of two conjoined hulls, a platform, and a small hut. Moving along the chain or rope, the boat edges across the shallow and turbulent river. A man brandishing a stick appears to be in charge of at least one cow or ox on the ferry. Even at the tiny scale of the drawing, we can see on the right the landing platform of logs and a small, three-arched bridge over a lateral channel that is still visible today. It is rare to be able to look over Leonardo's shoulder at a view that survives, albeit with an ugly road bridge in place of the ferry. The minute vitality of his fine touch is miraculous. It is one of his most spontaneous and nonanalytical drawings.

To the left of the view portrayed with such delicate and energetic fidelity is the Naviglio Martesana canal that runs parallel to the unnavigable river below the villa. The canal was a major engineering achievement, but stopped just north of Vaprio in the face of massive rocks at Tre Corni. Leonardo worked out an unrealized scheme for a very deep lock beside the rock barrier that would permit boats to change levels from the low section of the canal at Vaprio to the much higher level north of Tre Corni.

ABOVE RIGHT A contemporary view of the three-arched stone bridge that appears in Leonardo's sketch.

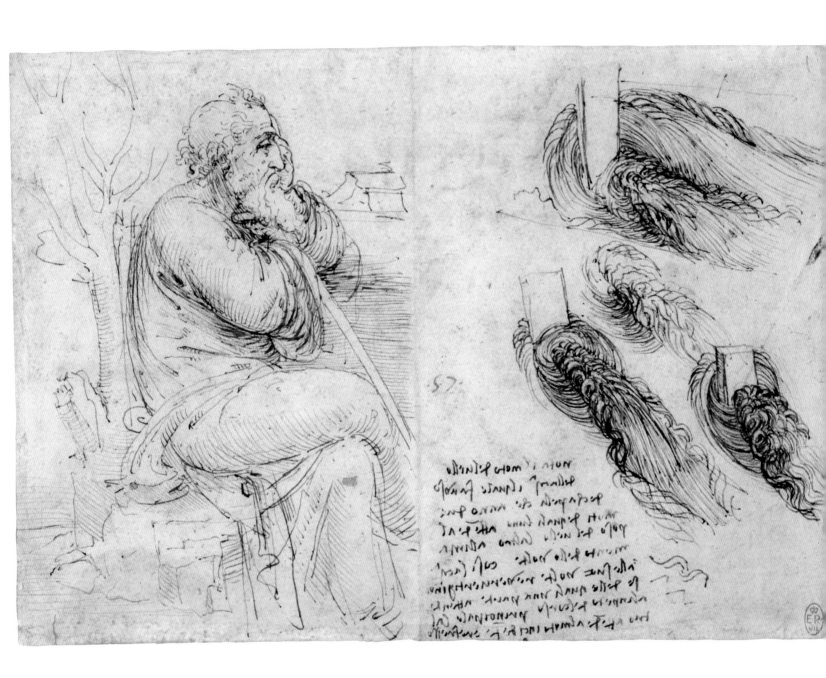

97. An Old Man, with Water Rushing Turbulently Past Rectangular Obstacles at Different Angles

C. 1510, WINDSOR, ROYAL LIBRARY, 12579R

The effect of this sheet—which was folded when Leonardo used it—is misleading. Originally, the old man was not glumly contemplating the enormous complexities of water in turbulent motion. He may well have been intended to be a St. Joseph, who is typically characterized as bewildered by events, not least by the pregnancy of his virgin wife.

Leonardo grappled heroically with the chaotic phenomenon of water in turbulent motion. He was fascinated with the way that water moving in spirals progressively accelerates rather than slowing down like most moving bodies. He decided that this is because the impetus is confined to a constricted space but still has to complete its designated motion.

Looking at the radical effect of an upright stake in a rapidly moving stream of water, he characteristically sensed an analogy: "observe the motion of the surface of water, which resembles the behavior of hair, which has two motions, of which one depends on the weight of the strands, the other on its line of revolving. This water makes revolving eddies, one part of which depends on the principal current, and the other depends on the incident and reflected motions." The power of visual analogy carried him across dynamics and statics.

There is no Leonardo painting that does not feature some aspect of helical form, whether hair, drapery, the growth of plants, or the motion of water itself. The lost *Leda* would have been a symphony of such forms, and vortex hair plays leading roles in the *Ginevra de' Benci*, the *Portrait of a Man with a Sheet of Music*, the *Salvator Mundi*, and *St. John*, while it plays supporting roles in *The Annunciation*, the Munich and Benois Madonnas, the Virgins of the Rocks, the Madonnas of the Yarnwinder, the *Mona Lisa* (in a gentler manner), the *St. Anne* cartoon, and the Louvre *St. Anne* (in the curls of the infants). In this as in other of his concerns, Leonardo moved from an instinctual grasp of form and motion toward an analytical understanding that was ever more mathematical in nature.

"There is no Leonardo painting that does not feature some aspect of helical form, whether hair, drapery, the growth of plants, or the motion of water itself."

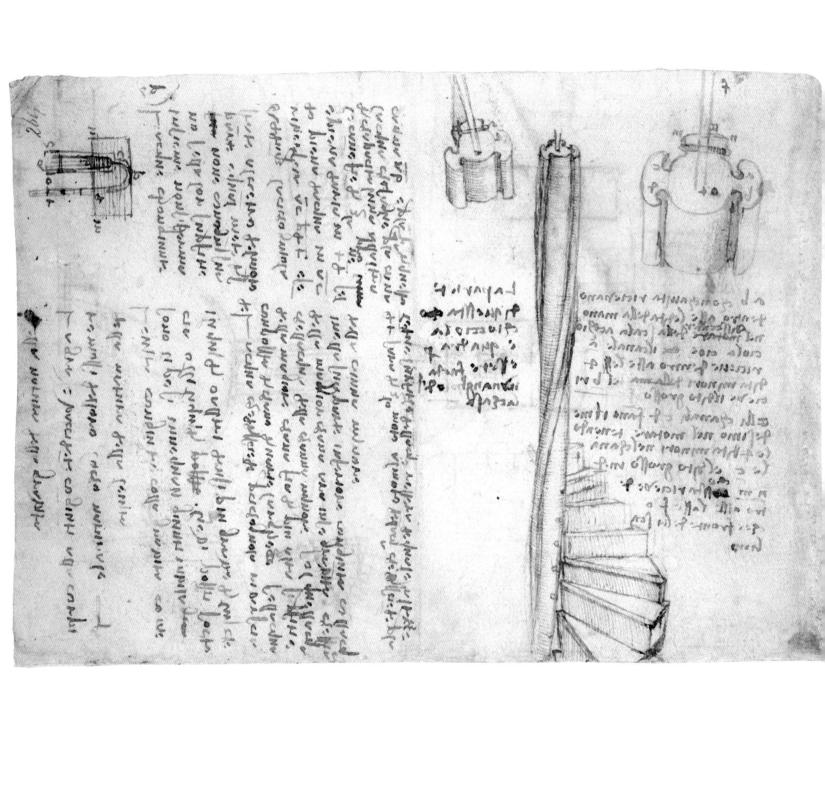

98. Studies for a Spiral Staircase and a Pump

c. 1516, London, British Museum, Codex Arundel, 264r

On moving to the court of Francis I in 1516, Leonardo was housed grandly in the manor house of Cloux (Clos Lucé) and paid a large salary. He was accorded the status of a magus or wise man. It was reported that "King Francis, being enamored to the very highest degree of Leonardo's supreme qualities took such pleasure in hearing him discourse that he would only on a few days in the year deprive himself of Leonardo. . . . The king said that he did not believe that a man had ever been born in the world who knew as much as Leonardo, not only of sculpture, painting, and architecture, but also that he was a very great philosopher."

Leonardo was displayed to visiting dignitaries, and he showed them the paintings that remained with him, including the *Mona Lisa* and the *St. Anne*. He also showed the notebooks that contained his diverse range of designs and researches.

The biggest project that involved Leonardo during the three years before his death in 1509 was for a very grand palace complex at Romorantin (Romorantin-Lanthenay) in the Loire, which would in effect have constituted a kind of a new town. The grand plan embraced gracious courtyards, trim gardens with fountains and a water clock, and a network of canals for irrigation, sanitation, and boating. The palace buildings were to combine the latest Renaissance motifs with the great corner towers of French chateaux. Leonardo's unrealized plans exercised a huge impact on the castles of the Loire.

The page here (turned sideways) is part of a larger double sheet that contains another pump design. The pump on the page shown is upside down. The double sheet involves two prominent aspects of the Romorantin scheme, namely the management of water (for function and fun) and the design of spiral staircases. The "snail staircase," as Leonardo describes it, is presented lucidly to show a double handrail that is cunningly inset into the newel post. The two detailed sections of the central axis show how the grooves allow the user's fingers and thumbs to slide upward and downward while ascending and descending.

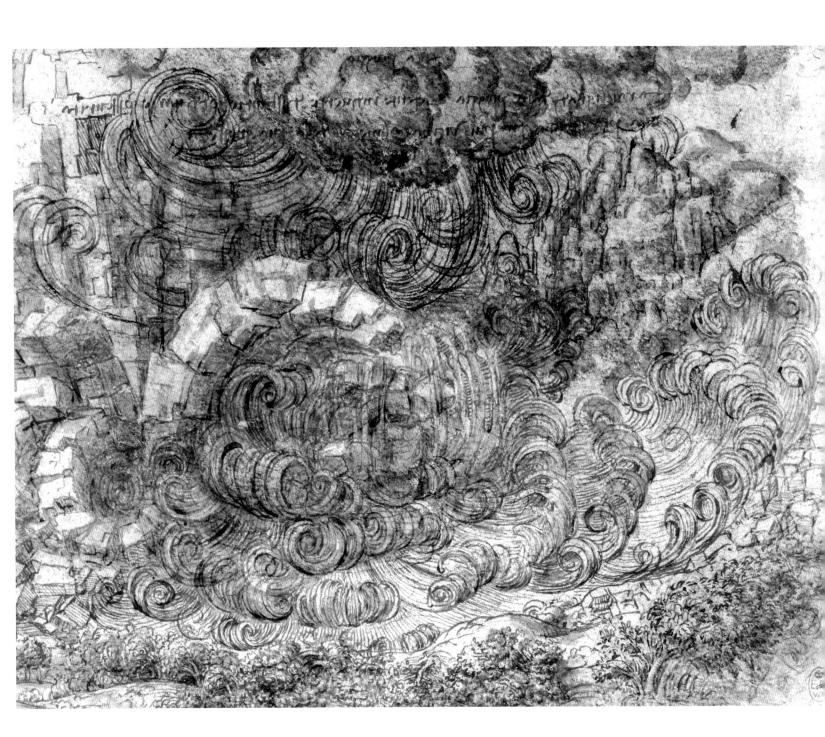

99. A Deluge Wrecking a Mountain, Woods, and a Township

c. 1515–17, Windsor, Royal Library, 12380

This is one of sixteen drawings at Windsor that represent hugely violent "deluges." Most are in somber black chalk, but this one is finished in pen and ink and wash, endowing it with a strangely formalized dynamism.

The deluge drawings somehow combine expressive fury with the scientific content of fluids in vortex motion. They could have served as illustrations for Leonardo's *Treatise on Painting*, which was to include instructions on how to represent "wind, tempest at sea, deluges of water, forests on fire, rain, bolts from heaven, earthquakes, and the collapse of mountains, razing of cities." These were not stock subjects, and he was envisaging genres of art that were yet to be invented.

The note on this drawing is oddly objective: "On rain. Show the degrees of rain falling at distances of varied darkness; and the darker part will be towards the middle of its thickness." His word-painting of deluges contains comparably analytical passages:

> Let the pent-up water go coursing around the vast lake that encloses it with eddying whirlpools, which strike against various objects and rebound into the air as muddied foam. . . . The waves that in concentric circles flee the point of impact are carried by their impetus across the path of the other circular waves moving out of step with them, and after the instant of percussion leap up into the air without breaking formation.

But the human horror of the four elements run amok is also evoked with great power:

> O what fearful noises were heard throughout the dark air as it was pounded by the discharged bolts of thunder and lightning. . . . O how much weeping and wailing. O how many terrified beings hurled themselves from the rocks. . . . O how many mothers wept for the drowned children they held upon their knees, their arms raised towards heaven as they voiced their shrieking curses. . . . Others crouched forward with the breasts touching their knees and in their hugely unbearable grief gnawed bloodily at their clasped hands and devoured their fingers they had locked together.

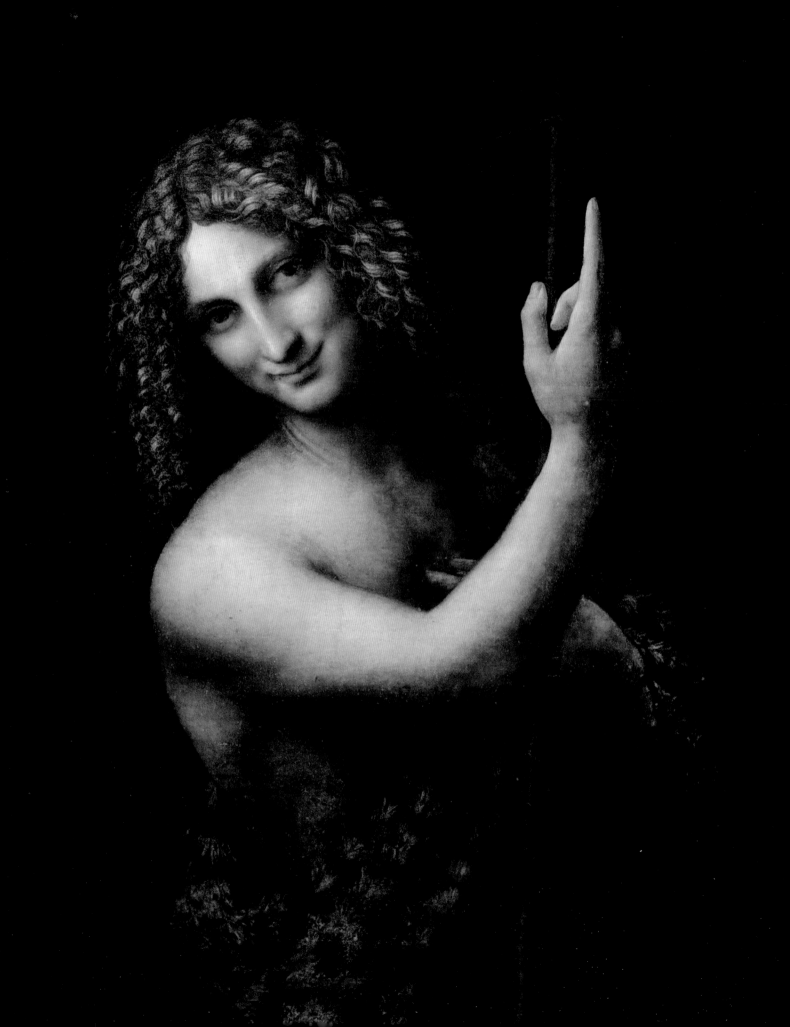

100. St. John the Baptist

C. 1507–14, PARIS, LOUVRE

The *St. John* is probably the "St. John the Baptist as a young man" seen in Amboise by Antonio de Beatis in 1517. It also appears on the Salaì list in 1525.

The image of the pointing saint is the most intense of Leonardo's experiments in the direct communication between the subject and the viewer. It is related to a project of an *Angel of the Annunciation*, known through a student's drawing corrected by the master. The angel in the drawing is announcing directly to us—a daring innovation. St. John is also announcing the coming of Christ: "After me cometh a man which is preferred before me." The saint holds a prophetic reed cross.

Characteristic features of Leonardo's later style are expressed in extreme form. The saint's unavoidable gaze and enigmatic smile are irredeemably ambiguous because none of the forms are rendered with clear edges. The apparent sharpness of the saint's right arm and pointing hand has resulted from restoration to rectify the damage described in an inventory of Charles I's collection. The saint's hair is the most profuse version of the vortex coiffures in which Leonardo delighted. The strongly directional light and dark background achieves the heightened sense of "relief" that he emphasized as a major goal for the painter.

The seductive androgyny of St. John is typical of the portrayal of youthful saints by Leonardo and other artists. This is true above all of St. John the Evangelist—"the disciple whom Jesus loved"—sitting next to Christ at *The Last Supper* (see page 66). Leonardo was aiming for a transcendent beauty that defies categorization by gender. The message of the painting is uncompromisingly spiritual. We are confronted with the mystery of a world we think we can see, but which lies beyond our understanding. St. John knows secrets that are inaccessible to us. Leonardo left "the definition of the soul . . . to the minds of friars, fathers of the people, who by inspiration possess the secrets. I let be the sacred writings, for they are the supreme truth."

LEONARDO'S LIFE

Key Dates and Works

1452

April 15

On Saturday, April 15, around 10:30 pm, Leonardo is born in Vinci out of wedlock. Leonardo's father is Ser Piero di Antonio da Vinci (1427–1504), a notary working in Florence, and his mother is a young orphan, Caterina. The baby is publicly baptized the following day, with six prominent godparents.

1457

February 28

The five-year-old Leonardo is listed in Vinci as a dependent in the tax assessment of his grandfather, Antonio.

First Florentine Period (c. 1464/69–c. 1481/83)

c. 1469

Leonardo moves to Florence at an unknown date and enters the workshop of Andrea Verrocchio.

1472

Leonardo appears in the account book of the Compagnia di San Luca, the painters' confraternity of Florence.

1473

August 5

He inscribes a mountainous landscape drawing: "The Day of S. Maria delle Neve [Holy Mary of the Snows] on the 5 August 1473" (Florence, Uffizi).

c. 1473–74

Around this time he paints *The Annunciation* (Uffizi).

c. 1475

Leonardo paints *The Madonna and Child with a Vase of Flowers* (Munich, Alte Pinakothek).

1476

At some point, probably about 1476, he contributes substantially to Verrocchio's painting of *The Baptism of Christ* (Florence, Uffizi).

April 9 and June 7

Leonardo remains in Verrocchio's workshop. On these dates he is among those twice charged with homosexual activity with a seventeen-year-old apprentice in a goldsmith's workshop. The charges are not followed up.

1478

January 10

Commission for an altarpiece in the Chapel of San Bernardo in the Palazzo della Signoria of Florence. He receives a payment on March 16, but there is no other evidence of work on the commission.

A drawing in the Uffizi is inscribed ". . . ber 1478, I began the two Virgin Marys." One of them may be the "*Benois Madonna*" (St. Petersburg, Hermitage).

Around this time the *Portrait of Ginerva de' Benci* was painted.

1481

In July, Leonardo signs an interim agreement about the *Adoration of the Magi* for the main altar of San Donato a Scopeto on the outskirts of Florence. Between June and September, payments in money and commodities (including wine) are made for work on the altarpiece.

OPPOSITE Detail of *Perspective Study for Adoration of the Kings*, c. 1481–82.

Before and around this time, he begins to explore aspects of technology (civil and military) and science, including anatomy.

The unfinished *St. Jerome* (Rome, Vatican) may date from this time.

First Milanese Period (1481/3–1499)

1481–83

Between September 1481 and April 1483, he leaves Florence for Milan.

1483

April 25

With the brothers Evangelista and Giovanni Ambrogio de [or da] Predis, Leonardo signs the contract to decorate a large altarpiece for the Confraternity of the Immaculate Conception in their chapel at the San Francesco Grande in Milan. The central painting is to portray the Madonna and Child. His contribution is to be the *Virgin of the Rocks* in the Louvre, which may be the "Nativity" sent by Ludovico Sforza as a wedding present to Emperor Maximillian I.

1483–90

At some point Leonardo enters the court of Ludovico Sforza, de facto ruler of Milan. He writes to Ludovico claiming mastery of a wide range of military engineering. Leonardo's intellectual and practical pursuits widen and deepen, not least in the study of anatomy. A series of skull studies is dated 1489, and we have the first of his surviving series of notebooks dealing with a diverse range of artistic, technological, and scientific subjects, including the flying machine.

He paints the *Portrait of a Man with a Sheet of Music*, Milan, Pinacoteca Ambrosiana, probably c. 1483.

1487

Leonardo prepares designs and a wooden model for the domed crossing tower (*tiburio*) of Milan Cathedral. Payments are recorded in 1487 on July 30, August 8, August 18, August 27, September 28, and September 30; in January 1488; and in May 1490. He does not receive the commission.

1489

July 22

The Florentine ambassador to the Sforza court writes to Lorenzo de' Medici in Florence stating that the duke has entrusted Leonardo with the model of the equestrian memorial to Francesco Sforza, the duke's father, but still needs "a master or two capable of doing such work."

1490

July 22

Salaì (Gian Giacomo Caprotti da Oreno), ten years old, arrives in Leonardo's workshop as a trainee. On September 7, Salaì steals a silverpoint drawing stylus from one of Leonardo's assistants, and on April 2, 1489, he steals another from a different assistant.

At approximately this time Leonardo paints the portrait of the duke's mistress, *Cecilia Gallerani* (*Lady with an Ermine*) (Kracòw, Czartoryski Collection).

1491

January 26

Leonardo designs a festival and tournament for the wedding of Ludovico Sforza and Beatrice d'Este.

c. 1491

In an undated letter, Leonardo and Giovanni Ambrogio de Predis complain to Ludovico Sforza about the Confraternity of the Immaculate Conception's low valuation for the *Virgin of the Rocks* and two paintings of angels.

1493

November

Leonardo's full-scale model of the Sforza Horse is displayed under a triumphal arch inside Milan Cathedral for the marriage of Ludovico's niece, Bianca Maria Sforza, to the Emperor Maximilian I.

December 20

Leonardo decides to cast the Sforza Horse on its side and without the tail.

1494

November 17

Ludovico Sforza sends the bronze for the Sforza Horse to his father-in-law, Ercole I d'Este, Duke of Ferrara, to make cannons to combat French invaders.

1495

Leonardo may have gone to Florence, as a consultant for the building of a large council hall, the Sala del Gran Consiglio, for the new Florentine Republic.

Giovanni Donato da Montorfano signs and dates the *Crucifixion* fresco on the south wall of the Refectory of Santa Maria delle Grazie (opposite Leonardo's *Last Supper*). The *Portraits of Ludovico Sforza, Beatrice d'Este, and Their Two Sons* are later inserted in the foreground, probably by Leonardo's studio, but are now badly deteriorated.

1496

June 8 and 14

He works on decorating rooms in the Sforza Castle, but it is suggested by the Duke that Perugino might be approached instead.

Around this time Leonardo creates the *Portrait of Bianca Sforza* ("La Bella Principessa") in ink and colored chalks on vellum (private collection). Bianca, the illegitimate daughter of Ludovico, marries Galeazzo Sanseverino, but she dies within a few months of the wedding.

1497

June 29

The duke expresses his hope that Leonardo will soon finish *The Last Supper*.

1498

February 8

Fra Luca Pacioli completes the manuscript of *De divina proportione*, with illustrations of the regular geometrical solids by Leonardo. Pacioli estimates that the Sforza Horse (without its rider) is to be over 23 feet (7 meters) high.

March 22

A letter addressed to the duke states that Leonardo's work in the refectory of Santa Maria delle Grazie should be brought to completion.

April 20, 21, and 23

Leonardo is at work on the murals in the *Saletta Negra* (Little Back Room) and the *Sala delle Asse* (Room of the Boards, painted with a bower of trees with entwined branches and heraldic motifs in the northwest tower of the Sforza Castle).

April 26 and 29

Isabella d'Este, Marchioness of Mantua, asks Cecilia Gallerani to send Leonardo's portrait so that she might compare it with ones by Bellini.

The portrait now known as "*La Belle Ferronière*," identifiable as Lucrezia Crivelli, the duke's mistress, was painted around this time.

1499

April 26

Ludovico Sforza gives Leonardo a vineyard on the outskirts of Milan.

September 9–10

The French troops of Louis XII storm the city, led by the Milanese mercenary general Gian Giacomo Trivulzio, for whom Leonardo was later to plan an equestrian monument.

October

Louis XII enters Milan.

Leonardo sends money to his account at the Hospital of Santa Maria Nuova in Florence.

He leaves Milan.

Second Florentine Period (1500–1506/7)

1500

February

Leonardo stays in Mantua as the guest of Marchioness Isabella d'Este.

March 13

Isabella d'Este receives a letter from Venice stating that Leonardo had with him his portrait drawing of Isabella.

Leonardo works for the Venetian Republic on defenses against the Turks in the Friuli region.

He witnesses a competition for mills then run by perpetual motion.

April 24

He arrives in Florence, and probably resides in the monastery of Santissima Annunziata, where he draws and exhibits a cartoon of the *Virgin and Child with St. Anne.*

1501

March 28

Isabella d'Este asks Fra Pietro da Novellara (head of the Carmelites in Florence) about Leonardo's activities. On April 3, Fra Pietro replies that Leonardo is at work on a cartoon for a *Virgin, Child, St. Anne, and a Lamb.*

April 14

Fra Pietro tells Isabella that Leonardo is working on the *Madonna of the Yarnwinder* for Florimond Robertet, secretary to King Louis XII. The Madonna is known in two largely autograph versions in private collections.

Fra Pietro also reports that Leonardo is much involved with mathematics.

1502

May–August 18

Cesare Borgia, commander of the papal army, names Leonardo as architect and engineer in the Marche and Romagna. From July to September, Leonardo travels to the cities of Urbino, Cesena, Cesenatico, Pesaro, and Rimini for Cesare.

1503

February

He returns to Florence.

March 9 and June 23

The notary for the Confraternity of the Immaculate Conception in Milan summarizes the legal situation in the dispute over the *Virgin of the Rocks.*

July 24

Leonardo and others demonstrate competing schemes for the canalization of the Arno. During July, he is paid by the Signoria of Florence for his work on the project to divert the Arno near Pisa.

He is reinscribed in the account book of the painters' confraternity, the Compagnia di San Luca.

October

Florentine clerk Agostino Vespucci records that Leonardo has begun the portrait of Francesco del Giocondo's wife, *Mona Lisa,* and a *St. Anne,* and has been commissioned to paint [the *Battle of Anghiari*] in the Sala del Gran Consiglio.

October 24

Leonardo receives keys to the large Sala del Papa and other rooms in Santa Maria Novella, Florence, which will serve as his workshop and residence while working on his cartoon for the *Battle of Anghiari.*

1504

January 25

He attends a meeting to determine the placement of Michelangelo's *David.*

February–October

Leonardo receives a salary for work on the *Cartoon for the Battle of Anghiari.* On February 28, he receives payments for his ingenious scaffolding from which he could draft the huge cartoon, and for a very large quantity of paper.

May 4

The Signoria of the Florentine republic, led by Niccolò Machiavelli, produce an interim agreement that summarizes the state of Leonardo's work on the *Battle of Anghiari* and what he is to do.

June 30, August 30, and December 30

Further payments are recorded for Leonardo's work on the *Battle of Anghiari.*

OPPOSITE Detail of *Virgin of the Rocks,* c. 1495–1508.

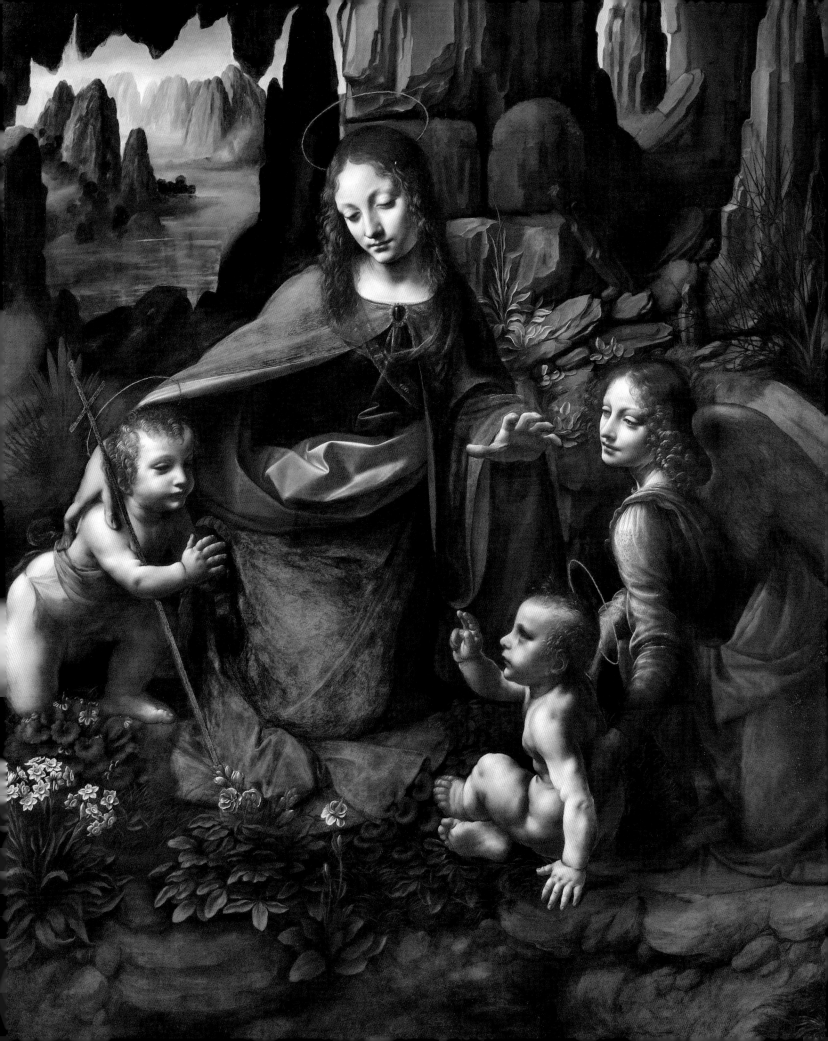

Allowed to interrupt his work, he goes to Piombino as a military engineer at the request of Jacopo IV Appiani, Lord of Piombino and an ally of Florence.

July 9, evening

Leonardo records that his father, Ser Piero di Antonio da Vinci, has died in Florence.

August

Leonardo's uncle, Francesco, bequeaths him property, which occasions a long-running legal dispute with Leonardo's half-brothers.

November 30

Leonardo records that he believes that he has solved the problem of squaring of the circle. This proves not to be the case.

1505

February 28, March 14, and 30 April

He is involved in the actual painting of the *Battle of Anghiari* in the council hall.

Expenses for Leonardo's scaffolding and painting are reimbursed, with the names of his assistants recorded on the list of expenses: Raffaello d'Antonio di Biagio; Ferrando Spagnolo; and Tommaso di Giovanni Masini, who "grinds colors" for Ferrando.

June 6

Leonardo records that when he started on that particular day to paint in the hall, the weather became extremely severe. During the torrential storm, the cartoon is torn.

August 31 and October 31

More payments are made for his work on the painting of the *Battle of Anghiari*.

At some point in 1505 or 1506, Leonardo ceases painting the *Battle of Anghiari*.

Around this time or somewhat earlier he begins the *Salvator Mundi* (Louvre Abu Dhabi).

During this period he also begins to paint *Leda and the Swan*, probably not finished until after 1513 (now lost).

Second Milanese Period (1506/7–1513)

1506

February 13

Leonardo designates Giovanni Ambrogio de Predis to represent him in the dispute with the Confraternity of the Immaculate Conception in Milan, and arbitrators are appointed. On April 27, de Predis comes to an agreement with the confraternity regarding the *Virgin of the Rocks*, which is still unfinished.

An agreement between Leonardo and the Signoria of Florence indicates that Leonardo can visit Milan for three months.

August 18

Charles II d'Amboise, French governor of Milan, writes to the Signoria in Florence requesting Leonardo's services. On August 19 and 28, the French arrange for the Signoria to permit Leonardo to go Milan.

Early September

He sets out for Milan, where Charles d'Amboise commissions him to design a suburban villa and garden.

October 9

Piero Soderini, Gonfaloniere of Florence, accuses Leonardo of breaking his promises to paint the *Battle of Anghiari*.

December 16

In a letter to the Signoria, Charles expresses his satisfaction with Leonardo's work.

1507

January 12, 14, and 22

In letters involving the Florentine Ambassador to France, the Signoria of Florence, and the French court, it is agreed that Leonardo should stay in Milan to serve the French.

March

Leonardo returns with Salaì to Florence.

July 23

He seems to be back in Milan.

July 26

Florimond Robertet requests on behalf of the king that "our dear and well-loved Leonardo da Vinci painter and engineer of our trust" should serve the king in Milan.

August 3

An arbitrator is appointed in a dispute between Leonardo and Giovanni Ambrogio de Predis about the *Virgin of the Rocks.*

Leonardo produces stage designs for *Orpheus,* a play by Angelo Poliziano, with a set that has a "mountain which opens."

August 15

Charles d'Amboise demands that the Signoria permit Leonardo to return to Milan "because he is obliged to make a painting" for the king.

August 26

The arbitration decisions regarding the *Virgin of the Rocks* are summarized.

Around this time, Leonardo meets the young nobleman Francesco Melzi, who is to become his devoted pupil, companion, and major heir.

Leonardo returns to Florence at some point in the winter of 1507–8, where, in the winter at the Hospital of Santa Maria Nuova, he dissects an old man who claimed to be one hundred years old (the "centenarian").

Among other scientific work, he undertakes studies of the complex optics of the eye.

1508

March 22

Leonardo stays at the house of Piero di Braccio Martelli in Florence and contributes to Giovan Francesco Rustici's three bronze figures of the *Preaching of St. John the Baptist* for the Florence Baptistery.

April 23

Leonardo is known to have returned to Milan to serve Louis XII.

Probably around this time, he resumes work on the project for a *Virgin, Child, and St. Anne.* The Louvre version was probably not finished until much later.

1509

July–April

He records his salary from the French king.

August 18

De Predis and Leonardo receive permission to remove the second version of the *Virgin of the Rocks,* newly installed in the San Francesco Grande, so that de Predis can copy it under Leonardo's supervision. The version of the painting that finally occupies its place in the confraternity's altarpiece is the one in the National Gallery, London.

October 12

Leonardo authorizes the final settlement for the *Virgin of the Rocks,* and on October 23, de Predis receives a final payment for his copy.

1510

Leonardo continues to work on technological and scientific projects, including anatomy, geology, and geometry. He records that he intends "in this winter" to bring his anatomical work to a conclusion. He has been collaborating with the anatomist Marcantonio della Torre.

He is granted an annual salary by the French state.

1511

December 10 and 18

He records that invading Swiss soldiers have started fires near the city of Milan, breaking the French domination of the city.

Leonardo and his household reside for a time at the Melzi family villa in Vaprio d'Adda outside Milan, where he plans a canal to bypass a rocky section of the river at Tre Corni.

Roman Period (1513–16)

1513

September 24

He records that "I departed from Milan to go to Rome" accompanied by Melzi, Salaì, and two other members of his household, probably passing through Florence on the way.

In this year he undertakes some of his major studies of the heart, its valves, and motions of the blood.

December 1

He is in Rome in the service of Giuliano de' Medici (brother of Pope Leo X), with a workshop in the Belvedere Courtyard of the Vatican Palace.

1514

Residing in Rome, Leonardo also travels in the service of Giuliano in connection with military and civil engineering, including the draining of the Pontine Marshes near Rome. He works on burning mirrors for Giuliano, which occasions a dispute with a German mirror-maker.

1515

January 9

He notes that Giuliano de' Medici departed at dawn from Rome in order to marry in Savoy.

July 12

For the entry of King Francis I into Lyons on his return from Italy, a mechanical lion by Leonardo is presented as a gift from Lorenzo di Piero de' Medici.

November 30

Pope Leo X makes a triumphal entry into Florence; Leonardo and Giuliano de' Medici are among the papal entourage.

Leonardo plans a new palace for Lorenzo di Piero de' Medici, opposite Michelozzo's Palazzo Medici.

December 7–17

He may have traveled to Bologna, where the Pope is to meet the French king.

1516

He records the solution to a mathematical problem.

March 17

Giuliano de' Medici dies, and Leonardo writes that "the Medici made me, and destroyed me."

French Period (1516–19)

1516

Leonardo goes to France as *peintre du Roy* for King Francis I. He is accompanied by Melzi and Salaì.

1517

Ascension Day in May

He records that he is in Amboise, living at the Château de Cloux (Clos Lucé), the manor house of the royal residence.

October 1

A letter describes a celebration for King Francis I in Argentan, at which Leonardo's mechanical lion walked forward to open its breast, "and in the inside it was all blue, which signified love."

October 10

As an ornament of the court, Leonardo receives a visit from the touring party of Cardinal Luigi d'Aragona. One of the secretaries, Antonio de Beatis, records the event in his diary. They were shown three paintings, a portrait of "a certain Florentine woman done from life at the request of the said magnificent Giuliano de' Medici"; a young St. John the Baptist; and a Virgin, Child, and St. Anne. They were also shown manuscripts, most notably those that dealt with anatomy. Because of a paralysis on Leonardo's right side, "he can no longer paint with the sweetness of style that he used to have, and he can only make drawings and teach others."

December 29

De Beatis visits Leonardo's *Last Supper* in Milan, noting that "although most excellent, it is beginning to deteriorate."

Leonardo spends time in Romorantin for the project to build a great palace complex for

Francis I, which would involve substantial hydraulic engineering.

For the years 1517–18, he is in receipt of a very substantial stipend from the king for two years, with Melzi and Salaì also receiving good salaries.

1518

June 19

In celebration of the marriage of Lorenzo di Piero de' Medici to Madeleine de la Tour d'Auvergne, niece of King Francis I, a revised staging of the *Feast of Paradise* is held at Cloux with a representation of the heavens designed by Leonardo.

June 24

He writes that he has left Romorantin to go to the manor house of Cloux at Amboise.

1519

April 23

Sixty-seven years old and ill, he draws up his will, which includes a provision for the saying of masses. Melzi is the beneficiary of Leonardo's written and drawn legacy.

May 2

Leonardo dies at Cloux and is buried in the cloister of the church of Saint-Florentin at Amboise (destroyed).

June 1

Francesco Melzi writes movingly to Leonardo's half-brother Ser Giuliano da Vinci to notify the family of Leonardo's death.

Detail of *"Val d'Arno" Landscape*, c. 1473.

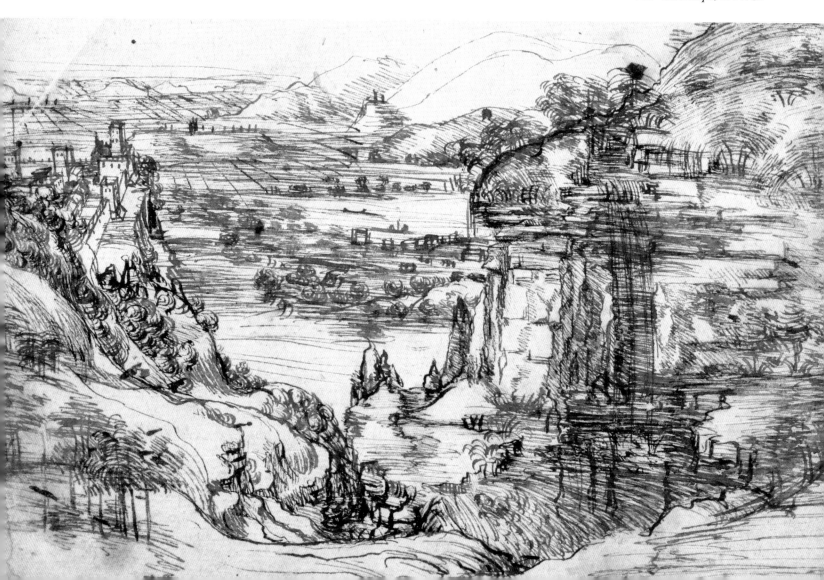

BIBLIOGRAPHY

Any manageable selection from the vast bibliography of Leonardo is bound to omit things of significance. A number of the works below direct the reader to the primary sources and to those that provide extensive references to the literature.

The annual publication *Raccolta Viciana* provides bibliographic updates. See: https://raccoltavinciana. milanocastello.it/en

A valuable service is provided by the Biblioteca Leonardiana at Vinci, which also provides digitized versions of the manuscripts: http://www.bibliotecaleonardiana.it/bbl/bb-leo/bb-leo-home.shtml

See also the bibliographies by Frank Zöllner, and by Claire Farago and Matthew Landrus, at Oxford Bibliographies: http://www.oxfordbibliographies.com

A good resource on the internet is: http://universalleonardo.org.

For the documentation of Leonardo's career, see Edoardo Villata, ed., *Leonardo da Vinci. I documenti e le testimonianze contemporanee* (Sforza Castle, Milan, 1999); and *Leonardo da Vinci: la vera immagine: documenti e testimonianze sulla vita e sull'opera*, eds. Vanna Arrighi, Anna Bellinazzi, Edoardo Villata (Giunti, Florence, 2005).

Also Carlo Vecce, *Leonardo* (Salerno, Rome, 2006); and Martin Kemp and Giuseppe Pallanti, *Mona Lisa: The People and the Painting* (Oxford University Press, New York, 2017).

A good point of reference for Leonardo's paintings is Frank Zöllner with Johannes Nathan, *Leonardo da Vinci* (Taschen, Cologne), available in a number of editions, most recently in 2017 (*The Complete Paintings*).

Kenneth Clark's monograph remains a fine introduction: Kenneth Clark, *Leonardo da Vinci*, ed. Martin Kemp (Penguin, Harmondsworth, 1988).

For the great stock of drawings in the Royal Collection, see Kenneth Clark, *The Drawings of Leonardo da Vinci in the Collection of Her Majesty the Queen at Windsor Castle*, 2nd ed., with Carlo Pedretti, 3 vols. (Phaidon, London and New York, 1968); and more generally, A. E. Popham, *The Drawings of Leonardo da Vinci*, ed. Martin Kemp (Pimlico/Random House, London, 1994).

For Leonardo's own writings, the anthology by J. P. Richter is still fundamental: *The Literary Works of Leonardo da Vinci,* 2 vols. (Phaidon, Oxford, 1970); and with commentary by Carlo Pedretti, 2 vols. (Phaidon, Oxford, 1977).

A selection of Leonardo's writings on painting is Martin Kemp, ed., *Leonardo on Painting: An Anthology of Writings by Leonardo da Vinci with a Selection of Documents Relating to His Career as an Artist*, trans. Martin Kemp and Margaret Walker (Yale University Press, New Haven, 2001).

ADDITIONAL READING

Bambach, Carmen C., ed., et al. *Leonardo da Vinci: Master Draftsman*. New York: Metropolitan Museum of Art, 2003.

Brown, David Alan. *Leonardo da Vinci: Origins of a Genius*. New Haven: Yale University Press, 1998.

Beatis, Antonio de, ed. J. R. Hale, *The Travel Journal of Antonio Beatis*. Translated by J. R. Hale and J. Lindon. London: Hakluyt Society, 1979.

Delieuvin, Vincent et al. *Saint Anne: Leonardo da Vinci's Ultimate Masterpiece*. Paris: Officina Libraria, 2012.

Farago, Claire, ed. *Leonardo's Writings and Theory of Art*, 5 vols. London: Taylor & Francis, 1999.

Galuzzi, Paolo, ed. *Water as Microscope of Nature: Leonardo da Vinci's Codex Leicester*. Florence: Giunti and Le Gallerie degli Uffizi, 2018.

Keele, Kenneth D. *Leonardo da Vinci's Elements of the Science of Man*. London: Academic Press, 1983.

Kemp, Martin. *Leonardo*. New York: Oxford University Press, 2011.

————, ed. *Leonardo da Vinci: Artist, Scientist, Inventor*. With essays by E. H. Gombrich, Jane Roberts, Philip Steadman, and M. Kemp and catalogue by M. Kemp with J. Roberts. London: Hayward Gallery, 1989.

————. *Leonardo da Vinci: Experience, Experiment, Design*. London and Princeton, NJ: Victoria and Albert Museum, 2006–7.

————. *Leonardo da Vinci: The Marvellous Works of Nature and Man*. New York: Oxford University Press, 2006.

————. *Living with Leonardo: Fifty Years of Sanity and Insanity in the Art World and Beyond*. London: Thames & Hudson, 2017.

Kemp, Martin, and Domenico Laurenza. *The Codex Leicester of Leonardo da Vinci: A New Edition*. Oxford, UK: Oxford University Press, 2019.

Marani, Pietro C. *Leonardo da Vinci: The Complete Paintings*. New York: Harry N. Abrams, 2003.

Menu, Michel et al. *Leonardo da Vinci's Technical Practice: Paintings, Drawings and Influence*. Paris: Hermann, 2004.

Pedretti, Carlo. *Leonardo: A Study in Chronology and Style*. Berkeley and Los Angeles: University of California Press, 1973.

Syson, Luke et al. *Leonardo da Vinci at the Court of Milan*. London: National Gallery, 2011.

Wells, Francis C. *The Heart of Leonardo*. London: Springer-Verlag, 2013.

PICTURE CREDITS

INDEX

OPPOSITE **Detail of *Head of a Young Woman Looking Outward,* c. 1483–84.**

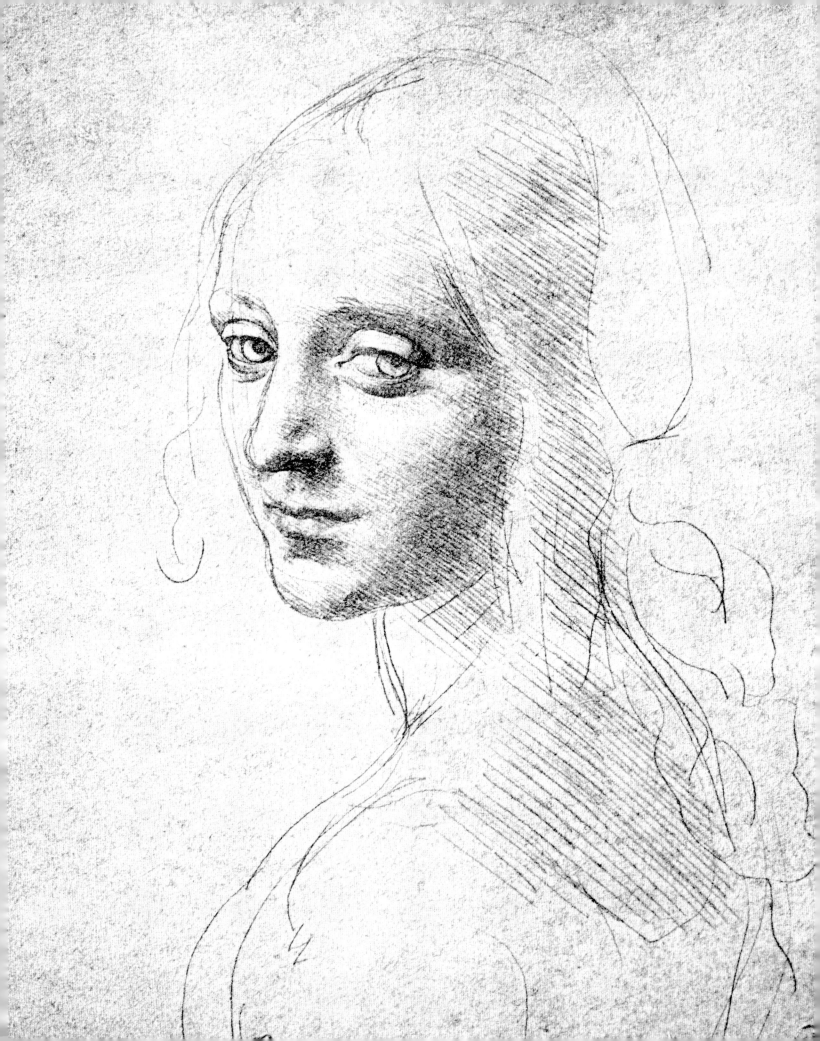

A Note on the Type

Leonardo da Vinci: The 100 Milestones is composed largely in the popular font known as Adobe Garamond, a family of old-serif fonts based on roman typefaces designed by French printer Claude Garamond (known as Garmont, c. 1510–61) and italic ones by Robert Granjon (1513–89/90), also a French printer and type designer. This Adobe serif face was created by award-winning American type designer Robert Slimbach (b. 1956) and released by Adobe in 1989.

The display fonts in the front and backmatter are in Jupiter Pro, which is inspired by ancient Roman letter forms and created by Patrick Griffin, the founder of Canada Type studio, in 2007.

The sans serif Astoria, designed by British type designer Alan Meeks (b. 1951) and based on Gill Sans, appears on the half and title pages.

Caption directionals are in Avenir, a sans serif face by Swiss type designer Adrian Frutiger (1928–2015) released by Lintoype GmbH in 1988.

Leonardo da Vinci is printed on 140gsm Kinmari Matt art paper.

Printed and bound by Versa Press, Inc. in the United States.

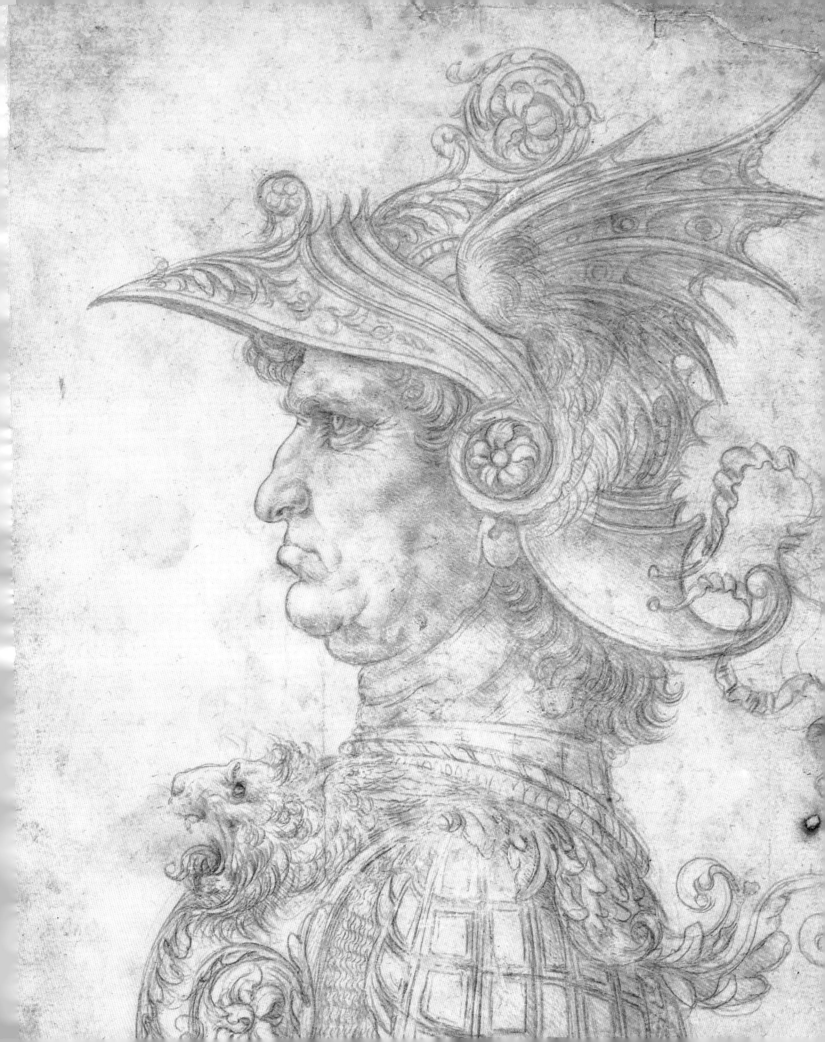

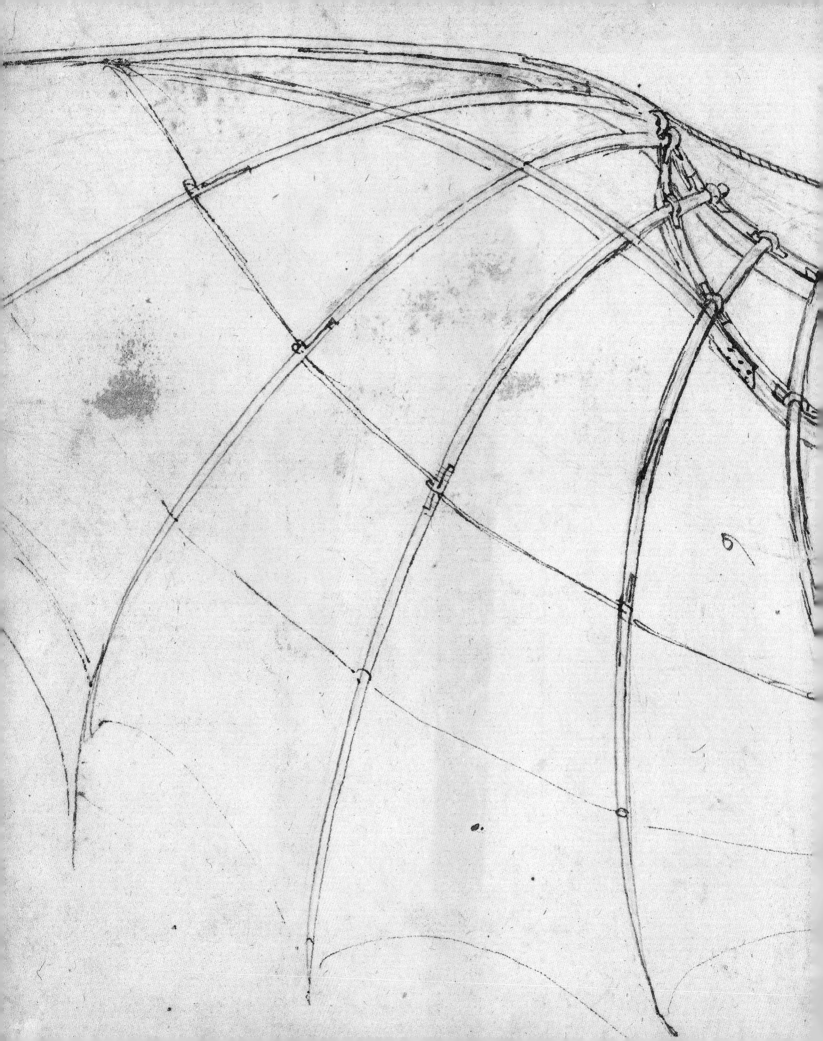